American Portraits

Reiner Leist
American Portraits
1910–2001

Essays by Vicki Goldberg,
Claus Leggewie, Christoph Menke

Interview by Susanne Baumann

Prestel
Munich · London · New York

I owe my utmost gratitude to all participants involved in this project. Without their time, trust and patience to share their personal photographs and thoughts, this project would not have been possible. My family, friends and many individuals provided sustaining encouragement and support. They never tired of granting me their time, opinions and advice.

Peter Axer, Alison Crosby, Mark Dawson, Wolfgang Ellenrieder, John Gossage, Rudolf Herz, T.O. Immisch, Felicitas Klein, Hans-Jörg Klein, Yumi Kori, Peter Langemann, Reinhard Maiworm, Beth Noveck, Chris Pichler, Maya Ishiwata, Matthias Reichelt, Jonathan Santlofer, Horst Sauerbruch, Joel Sternfeld and Birgitta Unger-Richter helped at crucial stages. Financial support was granted by the German Academic Exchange Service (DAAD) in 1994–95 while the School of Visual Arts, Photography and Related Media Program in New York provided a fruitful context for the beginning of this project.

Many individuals and institutions gave of their invaluable time and consideration. Mario Kramer, Museum für Moderne Kunst, Frankfurt/Main; Emila Kabakov; Andrew Pham; Judy Irving; Alison Hood; Christine Shuler; Allan Goodrich; Jolene Babyak, author of *Eyewitness on Alcatraz*; Colleen Breeze; Theresa Cimino and Susan McFarlane; Donald Davidson, Indianapolis Speedway Hall of Fame Museum; Bruce M. Stave, University of Connecticut, Center for Oral History; Glen Talley and Rick Walmer, Mount Rushmore National Memorial; Sheila Low-Beer and Sabine Kammerl; Ron Baraff, Steel Industry Heritage Corporation; David Loehr, James Dean Memorial Gallery; Doris Noveck; Sheila Flanagan; Mike Stops, Little Bighorn Battlefield National Monument; John Shea, World Museum of Mining; Joanne Kendall, Harvard University; Robert Vickers; Darrell Norman, Lodge Pole Gallery; Mike Columbo, Rome News; Nancy Matthews; Lawrence Spencer; Sharon Smith and Duane Sneddeker; Peggy Wilkins; Tom Pohrt; Lynn Spriggs. Sue Davidson Lowe volunteered her Stieglitz portrait, a wonderful gift. The photograph of Thomas D. Graham as "Little Lindbergh" is reproduced by permission of the Missouri Historical Society, St. Louis; the photograph of John F. Kennedy is courtesy of the John F. Kennedy Library Foundation, Boston. I sincerely apologize to those whom I have not been able to mention here.

My friends and colleagues at the Elizabeth Foundation for the Arts Studio Center in New York, the Visual Arts Program at MIT in Cambridge, and Galerie Walter Storms, Munich have been a constant source of support and inspiration. I am honored by the contributions of Vicki Goldberg, Claus Leggewie, Christoph Menke, and Susanne Baumann. The entire team at Prestel Publishing has been tremendous. Especially Curt Holtz and Meike Weber deserve much credit for their outstanding attention to detail and the quality of this book. My heartfelt gratitude goes to publisher Jürgen Tesch, without whom *American Portraits* could not have taken shape the way it did. R.L.

Texts by Claus Leggewie and Christoph Menke translated from the German by Christine Shuttleworth; interview by Susanne Baumann translated by Jackie Guigui-Stolberg
Copyedited by Curt Holtz

Library of Congress Control Number: 2001093008

Die Deutsche Bibliothek – CIP-Einheitsaufnahme
Ein Titeldatensatz für diese Publikation ist bei der Deutschen Bibliothek erhältlich

© Prestel Verlag, Munich · London · New York, 2001
© of all works illustrated: Reiner Leist

Prestel Verlag · Mandlstrasse 26 · 80802 Munich
Tel. +49 (89) 38 1709-0; Fax +49 (89) 38 1709-35

4 Bloomsbury Place · WC 1A 2QA London
Tel. +44 (020) 7323-5004; Fax +44 (020) 7636-8004

175 Fifth Avenue, Suite 402 · New York, NY 10010
Tel. +1 (212) 995-2720; Fax +1 (212) 995-2733
www.prestel.com

Prestel books are available worldwide. Please contact your nearest bookseller or one of the above Prestel offices for details concerning your local distributor.

Design and typography by Reiner Leist and Meike Weber
Lithography by Reproline, Munich
Font: Sabon
Printed by Sellier, Freising
Bound by Conzella, Pfarrkirchen

Printed in Germany on acid-free paper

ISBN 3-7913-2484-5

CONTENTS

Facing America

Vicki Goldberg

Photography's invention was peculiarly timely, occurring as it did just as the human life span was expanding and the prospect of an afterlife shrinking. Life expectancy slowly rose throughout the nineteenth century in the western world, especially for the upper classes, but the promise of a life after death began to be nervously questioned as religious faith wavered and came under attack. Into this atmosphere of a simultaneously expanding and contracting future, the new medium of photography inserted both a visibly extended past and a visibly extended future.

Within years of the announcement of Daguerre's and Talbot's processes in 1839, large numbers of people could know for certain, and for the first time, what they looked like when they were young and whether they resembled their dead ancestors. What's more, their own appearances suddenly had much longer futures than their bodies did.

The new medium magnified life's inherent poignancy, preserving the promise of childhood long after it was dashed, the loveliness of youthful good looks that age had long since stolen. The portrait of Dorian Gray served its owner's time for a while—a metaphor for the powerful identification of portrait and subject—but for the rest of us, no bargain with either the devil or the camera can ward off the years so effectively.

Yet childhood persists in photographs to delight and mock us and summon up regrets. There is history in our wallets and albums (and now, on video tapes or disks), intensely individual histories but inevitably framed in larger stories of time and place and circumstance. Reiner Leist's pairing of old and new, childhood and adult photographs is a novel means of setting out an idea that is common enough but hard to convey in pictures: that a country's history, character, even definition can be located not just in the look and activities of its citizens but in their life experiences. These they relate here in their own words, photographs being too limited to do the job well.

Robert Frank and all the photographers since who have photographed the American people looked for concentrated moments with radiating meanings. What radiates between the then-and-now images of *Reiner Leist American Portraits* are lives and thoughts. The pictures become points on the map of individual lives and of a nation: keys, indices, signposts. Personal tales fill in the topography and the routes that run across the country, creating a kind of anthropological guidebook made by a photographer who makes no claim to objectivity and by the subjects themselves.

Once these subjects had picked out family snapshots (or portraits by studio photographers) that meant something to them, Leist took portraits that echoed their early postures. Then he rephotographed the childhood pictures in an identical size, with the same camera, on the same paper, to achieve a kind of equivalence between the two. The resulting diptychs fuse and compress the lives as they have been lived to date.

The notion of comparative portraits made over time is hardly new. All family albums are just that. (One of Leist's subjects remembers that she and her brother and sisters were photographed every year and the results put up on the wall.) Biographers dig up baby photographs to show how a life progressed and, perhaps, how it was implicit in its beginnings.

Alfred Stieglitz thought he could make a true portrait of someone by photographing him or her over a lifetime. He started with his infant daughter but stopped when his wife complained that the child couldn't have any fun if she had to hold still for the camera at each delightful moment. Later Stieglitz photographed Georgia O'Keeffe over a number of years, unaware when he started that it would end up a portrait of her growing independence and their dwindling intimacy. Nick Nixon has been making yearly portraits of his wife with her three sisters since 1975; it has become a record of aging as well as of relationships. Richard Avedon took successive pictures of his father as illness leached the old man's life away. Serial portraiture always turns out to be about something more than likenesses. Leist's portrait diptychs, not exactly serial, bracket his subjects' lives, jamming a long interval between two images. Words take over where hints leave off, cumulatively piecing together a whole larger than its parts.

Portraits in themselves are boring or compelling partly because we think that we can decipher them. We tend to believe—rightly or wrongly, but as a way of getting along in the world—that we can read something of character and experience in faces. This transfers to photographs, where we maintain a strange trust in the medium's ability to convey some fact, some recognizable truth, despite all the ink that critics have spilled saying this is not so.

There is also a long-held belief that images of the citizenry will reveal something important about the nature of the country. Genre pictures of costume and profession in the nineteenth century were a kind of bald introduction to the customs of other lands. In the early twentieth century, August Sander thought he could delineate the German character by photographing every profession and walk of life objectively, without comment (or so he thought). Maybe he came too close; at any rate, his results did not match the Nazis' formidable insistence on a pure "Aryan" state, so they stopped his project cold.

No matter how strenuously a photographer tries to eliminate his or her own personality from the picture, personal preconcep-

tions and expectations creep in. Reiner Leist made his the armature for his project. What would someone born in Germany after World War II have known or seen or thought of the U.S. when he was growing up? Leist (who moved to America in 1994) had a kind of list, and asking everyone he met what America meant to them, he heard Americans and foreigners mention virtually the same things, as if the nation wore its CV on an identification tag.

What would America's CV include? Internationally reported events, of course: the Nuremberg trials, McCarthyism, the Vietnam War, the civil rights and feminist movements, student radicals, the moon landing. Certain facts and legends and words are probably automatically bundled with the country's name: cowboys and Indians, the Civil War, slavery and racial discrimination, Lindberg's flight, JFK, immigration, Hollywood, Disney—and democracy, liberty, freedom, opportunity, capitalism, commercialism, violence.

This history, these qualities, these dreams are sent abroad through the news and then in massive doses through the movies, and TV, and movies in reruns on TV. The cinema is one of the most vital of all-American exports and a chief means of propaganda. Hollywood still freely offers visas to its version of the United States, long after *Dallas* and *Dynasty* began granting theirs, and American citizens pay attention.

So Leist came looking for Jimmy Dean and found the man who'd been raised with the future star. He found the woman who lives in Disney's boyhood home. And a man who was stunned to realize that New York taxis were yellow; they were always gray in the movies. As for Marilyn Monroe, Leist located a brutalized boy who said he'd been saved by her infectious, available joy on the silver screen, and a woman who made a career imitating Marilyn in the burlesque theater but had to give that up for a more standard strip act when Monroe died. Today, well into her seventies, this Marilyn of Burlesque happily shows off her legs and her panties, bringing the past bluntly into the present.

Leist had in mind a new world in a dual sense: a continent that Europe thought it had discovered, and the new world of adulthood everyone immigrates to upon leaving the homeland of childhood. The passage from childhood foreshadows the kinds of transitions that occur when war changes both inner and outer worlds, or disillusion sets in, or something like Marilyn's presence on the screen opens up possibilities unknown before. Life everywhere leaps, lurches, sidles from experience to displacement to accommodation, but America, a nation founded by immigrants and still a magnet for them, a country also constantly on the move, has transition embedded in its psyche.

All this would be a lot of baggage for photographs to carry— they could not manage much of it without the text—but it is impossible to look at pictures of the same person from two such different ages without thinking about the nature of life and wondering how much of its passage is visible in both faces. How hard Henry Kissinger the boy tried to be ingratiating in his photograph! He was still trying, less strenuously, for Leist's camera, though that had scarcely been his professional posture. How sultry the Marilyn of Burlesque was at the age of 10, how disconsolate Flavin Judd both as a boy and as a young man. Benjamin Ferencz, dressed like a little businessman in 1926, looks exactly like one again in 1999, though he has spent his life prosecuting the Nazi *einsatzgruppen*, negotiating treaties, directing a program to obtain restitution for Nazi victims.

Photographs say more than one ought to expect. Sometimes they do not say enough. And yes, sometimes they lie. Studio portraits are meant to lie or flatter at the very least, and childhood snapshots may be too. "If you'd just see that picture," one woman says, "you'd think I was a normal kid—but it was so far from the truth—it was really hell."

True, false, treasured, misinterpreted, photographs from childhood are sometimes the only basis for memories that have already slipped the traces, sometimes the basis for the stories we tell ourselves to fix a recognizable trajectory across our years. The past is not merely captured but created by old photographs.

Leist himself says that some of these childhood pictures are stronger than anything he can do. Old photographs, after all, gain force with the years. They have history in tow, in clothes and poses and attitudes—the glum family posed in 1913 on a crescent moon that is much happier than they are; the boy in the Lindberg outfit in 1927; the boy in an embroidered cap with a big, soft bow at his neck in the USSR in the 1930s. So many children, boys mostly, are got up as little adults—and nostalgia coats them all like a patina.

Of all the powerful photographs ever taken, of wars and disasters, celebrities, comets, the suffering poor, probably no photographs have quite the impact that family photographs have on family members. All of memory and personal experience, all longing and desperate disappointment, love and hate are bound up in images from the most personal past. Some small measure of this heavy investment can transfer to these strangers' images under the pressure of the comparison of now to then, which anyone can identify with, and the resonance of some of the personal tales.

And although this is at best a spotty history of America, a lot of that history clings to the edges of these pictures. There is a woman who grew up without electricity in Mississippi among relatives who kept the children whipped up about the Civil War. An American Indian whose great uncle was a scout for Custer, and a white man whose relative was killed at the Battle of the Little Bighorn. A man who remembers traveling with his mother early in the twentieth century when it was unheard of for women and children to travel alone. A black man who recalls that in the 1940s on-

ly "preaching and teaching" were open to blacks and who had to find work early because his mother and father were dead and his grandmother a maid. "My family was not dysfunctional," he says, "it was just short of staff."

There are Jews here who left Europe, Russians who left the USSR, Vietnamese who left Vietnam. A number of Asians, a number of Hispanics, some of mixed blood: what we used to call the melting pot and would now call multicultural. The United States has been multicultural at least since the first white man encountered the first native on these shores, and the country has been in one degree of transition or another, acknowledged or not, ever since. In recent years the process has shifted to warp speed, as we repeatedly enter another new world and yet another.

National history then, international too, even a glance at the history of photography: a portrait by Stieglitz himself and pictures of photographers like Robert Adams, Duane Michals and Charles Traub, who write about the meaning and meanings of the medium. The larger history of photographs that played a major role in the life of the last two centuries creeps in here too, with people speaking of baby pictures that won prizes and pictures of parents who died young, celebrity photographs and the borrowed fame of photographs taken with a star. Ultimately there are the photographic media—magazines, film and television—which have welcomed a few of the people here and evidently validated their achievements, if not their very existence.

When a parent takes a picture of a child, both a wish and a dream ride on the click of the shutter: a wish to record one's own offspring who will be someone else tomorrow, and the dream of a good future that this happy moment ought to portend. Portraits of adults have somewhat less of the dream about them (except in wedding pictures, actors' portfolio shots and advertising) but plenty of wishes still. The adults in American Portraits, queried by the photographer, have a stake in the great American dream. Mostly, they love this country and are certain it is the best of nations. Many mention the freedom, the opportunity, the liberty it stands for. Enough freedom and liberty so that no one hesitates to criticize it either, and many say it has declined, sunk into the swamp of consumerism, where so much that was good about America has disappeared into the muck.

This may be correct. It may even be true (though every age has probably said something similar). The nostalgia that gathers like dust on old photographs gathers on recent history too. Both represent an unrecoverable past, as the photograph taken today represents an unrecoverable present. Somewhere between the past and the present you might find a picture of America, or a story about it, or a life that was lived in it and a face that grew old between its borders.

The Eye of the Sociologist and the Visibility of Society

Claus Leggewie

How can an image of society be formed? Most sociologists probably have one, but "the field" is very reluctant to become involved with the pictorial quality of the social world. The theoretical is stored in texts, and data banks contain scarcely any visual evidence. Images, above all moving images, are even suspected of hindering total perception, that is, in their seductive superficiality and symbolism, missing what actually holds societies together "deep down." Photographs are undervalued as "observations of the first order," and rarely does one find in sociological treatises visual material that goes beyond the mere illustration of the written or spoken word. The established culture of writing has over the centuries developed an impressive apparatus of textual and source criticism, but has never given the appropriate attention to the "image as text." How much effort is expended on linguistic decoding, and with what laxity is visual material employed as a "study aid," often even accompanied by tirades about the alleged "flood of images!"

This *déformation professionelle* is seen as a shortcoming in an increasingly visual culture, since the mass media, above all, now disperse "powerful images" of society, about which experts, afflicted with blindness, have little to say. The self-imposed ban on images by social science has already been challenged by Gisèle Freund, the pupil of such great German sociologists as Karl Mannheim, Norbert Elias and Theodor W. Adorno. The category "visual sociology" appeared at the turn of the last century in sociological periodicals and textbooks; at that time photojournalists were documenting the misery and the bustling activity of the world and associating themselves with social reportage and social reform.[1] Early sociology was also linked with the "muckrakers" until, in the course of putting itself on a scientific and professional basis, it buried itself in words and numbers.

Photography, however, remains a "self-representation by society,"[2] and many images document (and criticize) its condition "better than a thousand words." Certainly there are "images that lie."[3] There is no need to speak here of clumsy fakes or sophisticated "morphing"; normal openness to interpretation and dependence on the context of photographs, which always go beyond the "impression of reality," suffice. But insight into the social fabrication and subjectivity of images does not justify aversion or abstinence. Certainly photographs can be "manipulated," of course they show what observers "interpret into" them. So it is triumphantly claimed by an image-shy sociology, but it resists the

next step—to recognize that this applies to *all* sociological data, whose validity it unquestioningly assumes.

Luckily this has not bothered the social reporters out on the road with their cameras. Among these are, in the USA, Walker Evans, and Robert Frank, in Germany René Burri and Stefan Moses, whose latest volume of photographs is significantly entitled *Jeder Mensch ist eine kleine Gesellschaft*[4] (Every Human Being is a Little Society). This, the general and collective, is exactly the concern of sociology. The social rules and standards that guide photographers and bring out certain patterns, stereotypes and rituals, are often first evident in the cumulation and classification of the material, from which individual items stand out. Even simple random finds in photographic albums or estates, to the practised eye, clarify social configurations and constellations.

Reiner Leist, too, with his photographic journey into the "new world"[5] (as it has now been called for half a millennium), has sought the general in the particular. As with the Swiss-born Robert Frank, *the* social photographer of America, the autobiographical traces are clearly recognizable. Leist became the stranger with the camera, who induced local people to reconstruct a childhood pattern and at the same time recorded their memories and experiences. He did not obliterate stereotypes such as the omnipresent Stars and Stripes; their thematization contributes more to the understanding of the American household of images than their desperate avoidance, and makes plausible their global supremacy. But the cowboy on the back cover of this book denies all the images that are familiar from cigarette advertising.

Text and image do not simply comment on or illustrate each other in this book, they make each other mutually transparent. We know this from Danny Lyon's *Bikeriders*[6] and Susan Meisalas' *Carnival Strippers*,[7] but Reiner Leist has discovered a particular twist that makes his book so exciting (particularly for sociologists): requested to show a photograph from their childhood or youth, his subjects were drawn back into memories of past times by means of the medium of the image in which a moment, whether definite or random, is stored. Thus there was created a narrative collage, the narration of one's "own life."[8] Of course the photographer knows quite well that the view of his anonymous, or in some cases prominent, predecessor cannot be repeated in the way that photographs can be reproduced. For a social scientist, this tension points to the relationship between individual and society, to a reluctant connection between personal and collective identity.

This interaction between the individual and society is a basic question in modern sociology. "The identification of the human being as a person implies that within the social conditions in which he lives, before he even knows it, he always finds himself in certain interpersonal roles. Through them he is what he is, in relation to others: child of a mother, pupil of a teacher, member of a tribe, practitioner of a profession. The relationship is therefore not an external one for him, but one in which he determines his own self: as this or that."[9] In relation to this, fashions and accents change. While for a long time it seemed appropriate to bring out the "social character mask," more recently interest has focused unambiguously on the difference.

In the case of Reiner Leist, it is first of all the development of the personal ego that is most striking; with many of his Americans it ranges from baby to senior citizen and often spans a whole century, or more precisely, the "American Century." To see facial features ageing and maturing in this way is always a shock, which brings before our eyes the universal features of human existence. In many images a painful sense of something lacking or missing is noticeable, for it is precisely when people take up a similar or identical pose in front of the camera that they appear as though cut out of the model image, amputated out of their own life story. Such losses were often supplemented by collective ones, for example the shutdown of the Montana mines, and with it the decline of a world of work of which the only evidence today is the industrial photograph. Alice Sup on the other hand has extended herself by means of an alter ego, the little daughter in her arms, she too incidentally only one of three children. Allison Mayer, however, gives the impression of being frozen in space and time over the years, although she has a highly turbulent life to report. Others, Henry Kissinger for example, have covered enormous distances, or, like Harvey Shapiro, traveled the whole distance from Brighton Beach to Ocean Avenue.

This reveals the continental scale of American society, whose heartland Reiner Leist has fortunately not omitted. This distinguishes him from the bulk of foreign correspondents and photojournalists, who restrict themselves to the White House and Wall Street, Hollywood and Silicon Valley, or the tourists who stream past the country belt and the Bible Belt and thus never penetrate to Ogallala, Nebraska. In this gigantic span the I-consciousness is transformed into we-consciousness, which unfolds in the mass of photographs both casually and conclusively. Certainly, differences in childhood patterns and social conditions form part of the picture, but immigrants and refugees in particular demonstrate the undifferentiating power of self-persuasion of the "American Dream": their life is driven forward by a firm belief in their own success, and this in turn is anchored in the firm belief that America is the best of all worlds. American symbols, icons and heroes are scattered throughout the volume, but even in this self-confident patriotism the transnational destiny which the United States moulded from the outset and immortalized as the new world shines through. America is the "Great Known," and the high connective capacity of this nation was based not least on its convincing mythology of images.[10]

In this respect Reiner Leist's photo biographies yet again open our eyes. He shows the social researcher that photographs, and of course the act of taking photographs itself, have become important but certainly not yet obvious means and methods of "visual sociology."[11] It would be shallow to see in this merely a further tool for the portrayal and measurement of objective reality, thus demoting photographs to some extent to the status of forms of evidence. The presumed realism of visual presentations is always filtered through preconceptions and distortions, which is not without consequences for the basis of social research itself.[12] Anyone who is aware that images are constructed, and how, experiences their utility value. Here a certain intimacy with the technical equipment and also a minimum of artistic empathy are necessary; in addition all colonial attitudes must be avoided and the observed "objects" drawn into the process of research.[13] Today there is once more a "visual sociology," even if it is on the margin of the mainstream of the discipline. No longer is photographic material dismissed as "unscientific," which can be attributed less to the changes in the images than to the change in the concept of science. The frontiers between visual art, photojournalism, and sociology have become fluid, and this is a good thing—whatever label "image workers"[14] have chosen to describe themselves is unimportant. Thus even a notoriously image-shy sociology can achieve that visual maturity that is indispensable in today's culture.

1. Jacob A. Riis, *How the Other Half Lives* (Dover: New York, 1971).
2. Gisèle Freund, *Photography and Society* (Boston: David R. Godine, 1980).
3. Haus der Geschichte der Bundesrepublik Deutschland (Ed.), *Bilder, die lügen* (Bonn: Bouvier, 1999).
4. Stefan Moses, *Jeder Mensch ist eine kleine Gesellschaft* (Munich: Prestel, 1998).
5. "New World" was the working title of *American Portraits*.
6. Danny Lyon, *The Bikeriders* (New York: MacMillan, 1968).
7. Susan Meisalas, *Carnival Strippers* (New York: Farrar, Strauss, and Giroux, 1976).
8. Ulrich Beck, Wilhelm Vossenkuhl, and Ulf Erdmann Ziegler, *Eigenes Leben* (Munich: C.H. Beck, 1995).
9. Institut für Sozialforschung, *Soziologische Exkurse. Nach Vorträgen und Diskussionen* (Frankfurt/Main: Europäische Verlagsanstalt, 1956), p. 43.
10. Claus Leggewie, *Amerikas Welt. Die USA in unseren Köpfen* (Hamburg: Hoffmann & Campe, 2000).
11. Howard Becker, *Doing Things Together* (Evanston: Northwestern University Press, 1986); and John Grady, "The Scope of Visual Sociology," in: *Visual Sociology*, Vol. 11, No. 2, pp. 10ff.
12. Michael Emmison and Philip Smith, *Researching the Visual. Images, Objects, Contexts and Interactions in Social and Cultural Inquiry* (London: Sage Publications, 2000).
13. Douglas Harper, "Fotografien als sozialwissenschaftliche Daten," in: Uwe Flick et al. (Eds.), *Qualitative Sozialforschung. Ein Handbuch* (Reinbek: Rowohlt, 2000), pp. 402ff.
14. Becker (see note 11).

Image or Life
On Photography and Autobiography

Christoph Menke

"Photography: writing with light." One cannot write with light. Light comes in, light inscribes itself. Light is a medium, not a means. But one can capture it, one can place something here and there in which it is caught.

"Autobiography: writing one's own life." One cannot write one's own life. Life runs its course and continues to write itself. Life happens, it is not a story. But one can capture it, one can place something here and there in which it is caught.

Where to begin? With the artist who wants to write with light, or with the person who wants to write his life? Both need and make use of each other. They are bound together by a pact in which each wants to achieve his own aim and can only achieve it by carrying on the business of the other.

Two photographs side by side are a life. A life seen externally, a life whose innermost and most significant aspects lie in its outwardness, in the surface of the body and its postures. A life is keeping a promise, preserving a faith, cherishing a hope, believing a lie: this is what the persons say themselves, in their texts. The photographs show something different: a life, now as ever, consists in gazing at the observer with the head slightly inclined backwards, mouth firmly closed, eyelids half-closed, and a strand continually escaping from the parted hair. Another life consists in continuing to turn up the left corner of the mouth compared to the right to exactly the same extent that the right shoulder is held higher than the left. A further life consists in inclining the same face with its friendly smile to the right at the same angle at which it was previously inclined to the left, but at the same time allowing the shoulders, with this new orientation of the head, to continue to droop slightly to the right. The way the head is inclined, the eyes gaze, the hair falls, the mouth curves, how the body positions itself, the shoulders droop, the arms are turned, the hands are pointed—it is in this that a life consists.

In the proximity of the two photographs, in the to-and-fro of the gaze between them, a life finds expression in the condition, the being, of a body. My life consists in what my body is. The unity of my life is nature—the mass of my body that outlasts all else. All that time brings with it: the course of events, change, transformation. Everything in which subjectivity is expressed in the conscious course of time seems to rebound, even to be swallowed up by the

continuity of the body, as calm as it is uncanny. After this discovery, these photographs, whose spatial juxtaposition is sometimes spanned by dizzying ranges of time, can create almost an obsession in us. Again and again we search in them for the traces that express in a human life the inhumanly durable present of something of which this life seems to suspect nothing, not because it lies too deeply buried, but because it lies so much on the surface; the foreign element that is its most characteristic aspect.

If we then read what the persons say, only then do we know and see more, and something different: what this body is, that we see at two moments of its life, is not simply what it is; it was made that way. Not only by the camera that captures light and shadow, bright and dark. No, before that, by him who not only is his body, but owns it. Two acts needed to be performed in order for the body to be captured in the photographs, then rediscovered. The first act was a choice: that of the old photograph. The second act was a repetition: that of the old posture. The first act selects what the second is to repeat. In it, the person determines himself as the one which he will continue to be through repetition. The second act repeats what the first has selected. In it the person makes himself into the one he has become because of this selection.

My life consists not only in being this body. My life consists in having selected an image of my body and in repeating it, now and again, and yet again. The continuity of my life does not determine that I am still who or what I was. But again it does not determine that I now still know who or what I was. The bridge that I create from the person I am now to that earlier one is not one of the knowledge that I still have of that earlier one. The continuity of my life rather consists in that I preserve images of that earlier person that I used to be. Preservation is more than, is something quite different from, storing. The preservation of the images of that earlier person that I used to be consists in maintaining them, as one maintains the graves of the dead. One does this to prevent forgetting; to keep memory alive and fresh. Just as we need monuments for the dead, so we need images of ourselves. We live our lives by preserving the images of what we were. And we preserve these images by living them; by noticing how much they are our models, relived by us. Whether we know it or not—but can one really know it as Dixie Evans believes she knows it, and can one really not know it as Gene Mikelson appears not to know it?—we cultivate the memory of what we were by now putting ourselves in the picture anew, following their models. Autobiography, the writing of one's own life, is the performance of one's own life: there is no commemorative writing of our past life that is not its performance in the present; no performance of our present life that is not its continuing commemorative writing or rewriting.

So, two perspectives, two strategies: that of the camera, which turns the continuity of a life outwards, in the being of the body;

that of the person who performs the continuity of his life inwards, in the activity of selection and repetition. In the photographic perspective, life falls into the image, in the autobiographical perspective the image is lived. This is the conflict of the two gazes that cross on the surface of the image: the person's gaze into the camera, the camera's gaze at the person. This crossing over of the gaze is as much a battle as a mutual seduction. For in the reciprocal gaze of both there also lies the knowledge of how much they need each other—the person needs the gaze of the camera on him (to allow him to fall into the image), the camera needs the gaze of the person on it (which brings life into its power). There is no image without life, and equally there is no life without an image. The person cannot live his life without falling out of life into the image. Our life has no continuity except in the maintenance of memorials, of tombs or monuments, of our earlier existence. Only in the preservation of images can we live (on). For this reason, life tries to avail itself of the images, as much as those photographed want to avail themselves of the photographer. And thus they surrender to falling into the image, the transformation of their life into the depicted and observed continuity of mere physical being. Life does not only live; it lives only insofar as it does not live, and becomes an image.

In becoming an image, life turns itself outward, in its outer surface. But there would be nothing there, and thus nothing to depict, if life were not actively performed, in selection and repetition. The image that the camera captures is posed—not by the photographer, but by the person who lives his life. What the image represents is self-representation, the self-representation of the person for the camera and therefore for himself. Like no other art, photography is, and knows itself to be, dependent on what is given to it. For this reason it was considered not to be an art, and perhaps is still not an art—not an artist's art, not art as an instrument and expression of the artist's subjectivity. Photography is art in league with life, in league with life that writes itself. Therein lies both its power and its humility. Its power, because photography for its part takes life into its service. It makes use of the dependence of life on images which it can preserve and portray. Life wants to use these images for its own purposes, but photography appropriates them from life: the images do not belong to life, for in its images life does not belong to itself. In the knowledge of its power, however, lies at the same time the humility of photography—the humility of this photography: it knows that it is nothing and can be nothing unless images are given to it. It robs life of its images, the images that it selects and presents. Photography takes these images, receives them and makes them into something quite different. But it does not triumph over this theft, but is grateful for it: to life, to the person, that allowed them to get away.

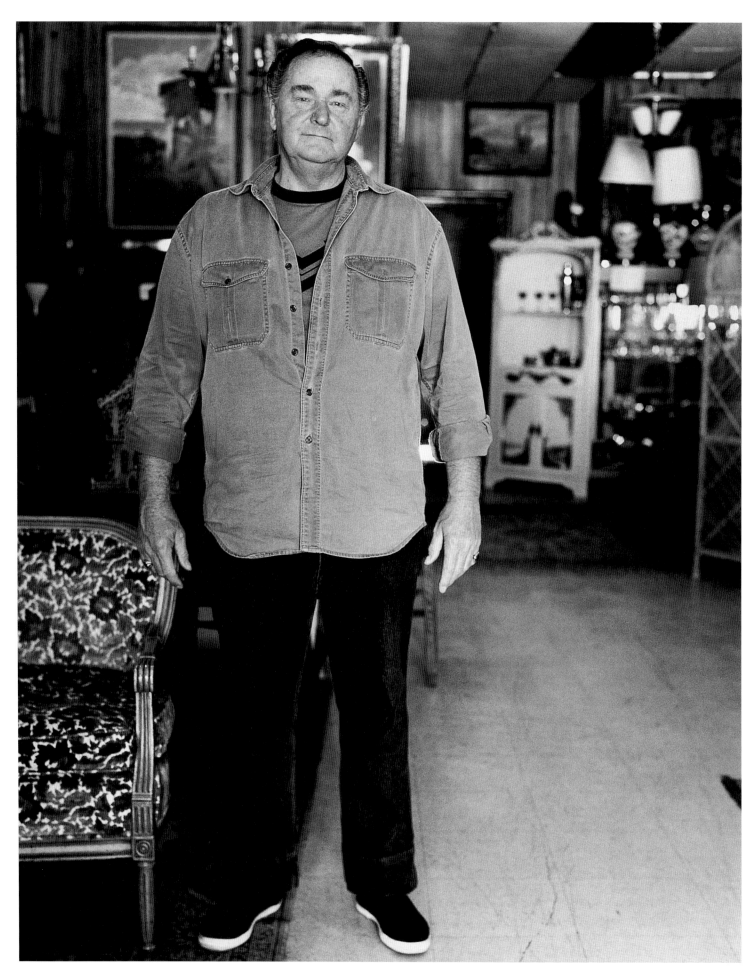

Jerry McIntosh *Metropolitan Avenue, Forest Hills, New York 1995*

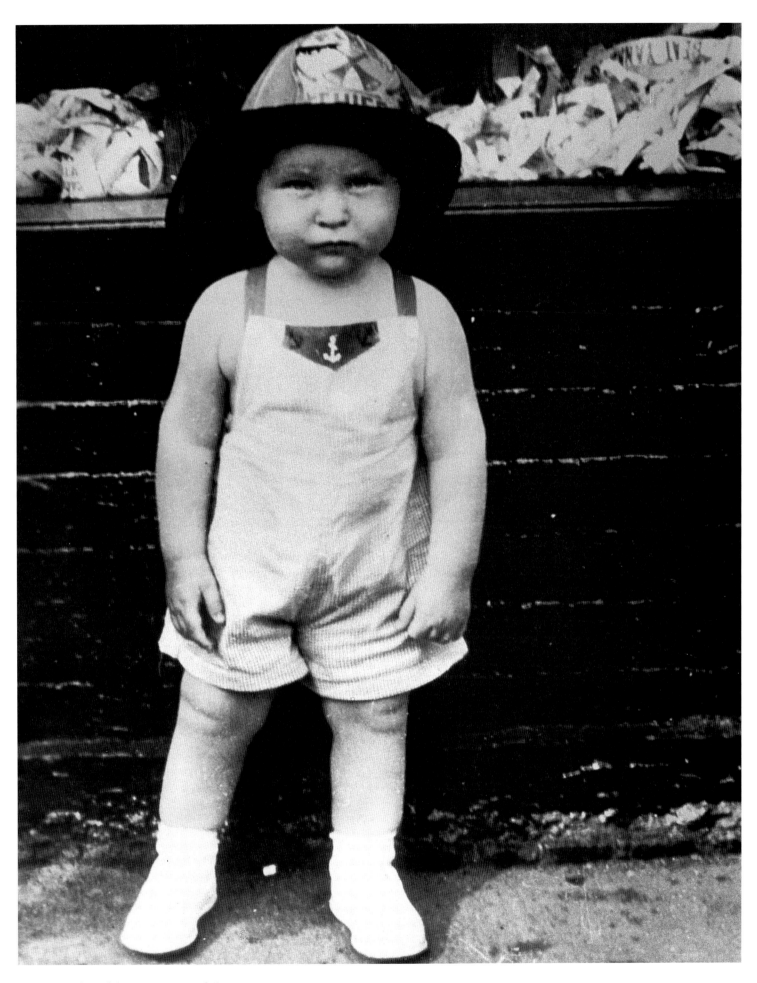

Jerry McIntosh *Eighth Avenue, New York City ca. 1939*

 Jerry McIntosh

Forest Hills, New York 1995
New York City ca. 1939

My name is Jerry McIntosh. I own an antique shop on Metropolitan Avenue in Forest Hills, New York. It's called Black Watch Antiques. I was born May of 1935. My ancestors were of Scottish origin, and before our name was McIntosh it was McDuff. According to some research we have done, the name was changed by Malcolm I who was the King of Scotland at the time. After an uprising was put down by Duncan McDuff and his sons, the name was changed to Macintosh (which means "son of the chieftain") and later changed to its present spelling, McIntosh. As I understand it, the property called Inverness in Scotland was awarded to our ancestors, the first of which came to America as a sailor on the Mayflower. Although I never met the actress Claire Trevor, she is my cousin by marriage. One of our relatives was killed with Custer at the Battle of the Little Bighorn. My grandfather was in the Spanish American War on the USS New York.

The childhood photograph shows my grandfather's store in Manhattan, near Eighth Avenue and 25th Street, which was a combination pet shop, trucking company and general store. He used the trucking company mostly to deliver furs for the various furriers in the area along Seventh Avenue. Further down on 25th Street there was a stable with horses and wagons used by peddlers who sold fruit and vegetables. I knew all the drivers and they used to let me sit on the horses and wagons, and I would help put the horses away for the night. I would also help my grandfather peddle on Saturday. The whole neighborhood was like a family. There was a shoe repair shop, then a barber shop, my grandfather's store where this photo was taken, a building called the Factory Entrance, two old abandoned houses and a laundry shop, and everyone knew everyone. When I was about three, I would sleep in the window of the laundry shop under the warm bags of clean laundry they would place there. My parents knew where I was and they knew I was safe visiting all the stores. At Christmas season my grandparents would sell trees, at Easter, flowers, and at one point my grandmother converted the store into a candy and sandwich shop. Anything to make a dollar; this is what we had to do to survive. But every dollar was earned by honest hard work and we took nothing from anyone. It was a good feeling to be able to take care of yourself by your own hard work. What I learned then is, in a way, how I try to run my life now. I try to use my grandfather's way of doing business.

I will never forget the night my father came home from the war. It was Christmas Eve at about seven o'clock. I was shoveling snow in front of my grandfather's store when I looked up and saw him coming towards me from Eighth Avenue. He had sent my mom a letter that he was being discharged and that was the best Christmas present we could ever have received. Life then seemed to get back to normal. When I was seventeen, I wanted more than anything in the world to play professional baseball. I dedicated my whole life to training, and became good enough to receive five offers to play professional baseball. Unfortunately, a leg injury ended my career before it began. At that point I didn't know or care what direction my life took as far as a career was concerned. I started attending a trade school for tool and die making and ended up spending thirty-five years in a trade I hated. I knew I wanted out, but didn't have an idea of what I wanted to do until I started collecting rare coins as a hobby. When I attended the various coin shows and auctions I became interested enough to start buying and selling coins. After I had gotten good enough at that, I decided to buy and sell gold. This led to my first small store, around the corner from where I am now, where I sold only coins and jewelry. I then gradually got into other collectibles and antiques. I love artwork and wish I had gotten into this years earlier. I really enjoy life now because I love what I do. I love the contact with people—some I don't trust, but some I would let walk out with my whole store for only a handshake. It all goes back to my grandfather's way of doing business. It is not a formal business, in fact my store is known as the Metropolitan Avenue Social Club because everyone hangs out here and enjoys the atmosphere and the conversation. Our store includes a wide range of people from all walks of life and our merchandise covers a wide range of items from the everyday to fine art and old master paintings. This is how my business grew, and this is how it is today. If you are ever in the Forest Hills area, stop in and hang out awhile.

 Flávia de Souza

Brooklyn, New York 1996
Teresópolis, Brazil ca. 1973

I was shy when I was small. I am still shy in many ways. Both my parents used to work in theater and I remember not spending much time with them. The only time we could spend together was at night, when they came back from the theater. As a four-year-old I would go to bed at two o'clock in the morning and wake up at two in the afternoon. I stayed up until they were home and we could go to the playground and play. I never went or wanted to go during the day, when other children were around. I had a hard time relating to other children. I was the only child in my mother's family up until I was four, when my brother was born. I was living in this adult world a lot. My mother sent me to school when I was two years old—before kindergarten. I cried the first days and my mother couldn't of course stand there the whole day, she was working. My grandmother had to take me there and stand there outside, so during the breaks I would go see her.

Then as I grew up one of my biggest fears started to be, to have relationships that were that interdependent, that visceral, and one of my biggest fears in life is still to depend on anybody in any way. At the same time I have very little memory of my relationship to my parents and their relationship to each other. They separated when I was seven or eight and I barely remember the time I spent with them until then. I do remember the adolescence conflicts with my mother mainly because my father was not living at home. It worked kind of the conventional way but with inverted roles. My mother was the educator, a kind of a father figure and I would spend the good times, the weekends or vacations with my father. I think my father also tried to compensate his absence when I was a teenager by taking me on trips and things like that. My parents are still friends, but I never remember them being lovers.

When I was a child I came to Disney World, when I was ten. When you grow up in big cities in South America—I grew up in Rio— North American culture is so much part of the local culture. I think my generation was the first to grow up so completely under this influence. I can't really distinguish what America was in my life, it was so intertwined in my everyday life, but I didn't really have a clear idea. I remember my parents anti-American attitude; my father and mother—during the '60s—sympathized with communism. They weren't in the Communist Party in Brazil, but my father had been in jail a few times for being a "communist" supposedly. In the '60s and '70s there were military dictatorships in almost all Latin America, so it was dictatorship time in Brazil too. So I grew up with this anti-American sentiment at home but,

at the same time, having America so much as part of my culture. The TV, all cartoons, are imported.

America stands for a clear ground. I actually mean New York City. I don't think I would live anywhere else in the United States, I was never attracted to Middle America. I wanted to come to New York to recreate my identity, see my own culture—the place where I come from—from a totally different viewpoint, as a foreigner really and being a foreigner here, too. I am comfortable with that. I think, to use a cliché, it's the land of freedom. I don't mean political freedom so much, but personal freedom. You can do whatever you want, you can walk naked in the middle of the day in New York, no one will look at you because no one is interested in the other's individuality, everybody is alone and self-centered. That's what I was looking for when I came here. I was looking to be alone, to grow up, break my bonds with my parents. I created another bond, this relationship with my boyfriend ends up replacing other relationships that I tried to break up from in Brazil.

I remember little of my childhood. Being an image-maker allows me to manipulate and recreate my memory, not only my own personal history but to create a record of my experience in the world. It's more important than actual representations—records of my true life—of my childhood. I chose that picture because one of the strongest memories of my childhood was that I was shy and that made my parents—my actor father especially—very upset. I wouldn't socialize. I was alone very often, liked drawing, liked cooking—for my dolls, anyway. I was shy and I had such a visceral bond with them and they didn't want me to be so dependent upon this bond. That picture was taken on the day of a family gathering, in my mother's family's country house near Rio in the mountains, and there was a party, I was away from the other children.

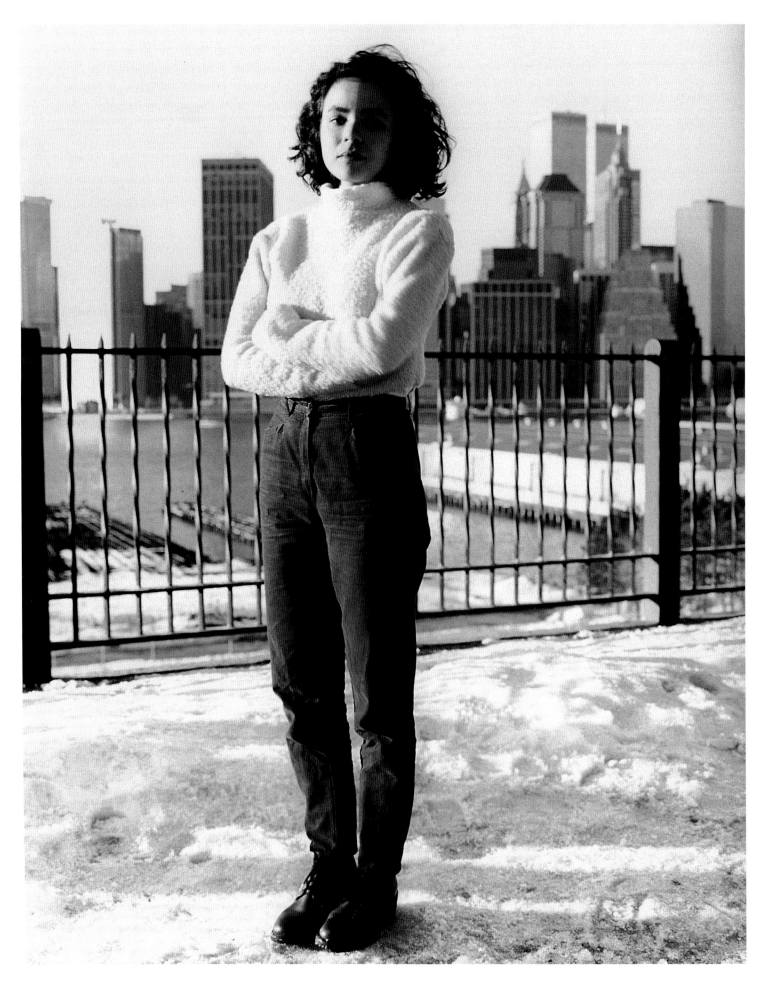

Flávia de Souza *Brooklyn, New York 1996*

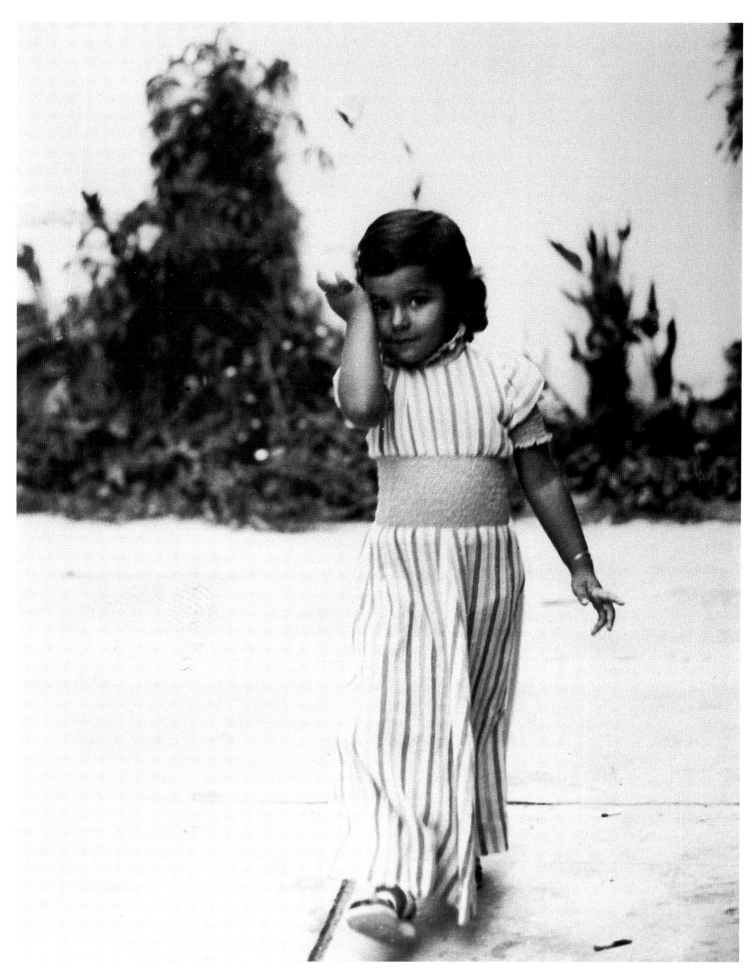

Flávia de Souza *Teresópolis, near Rio de Janeiro, Brazil ca. 1973*

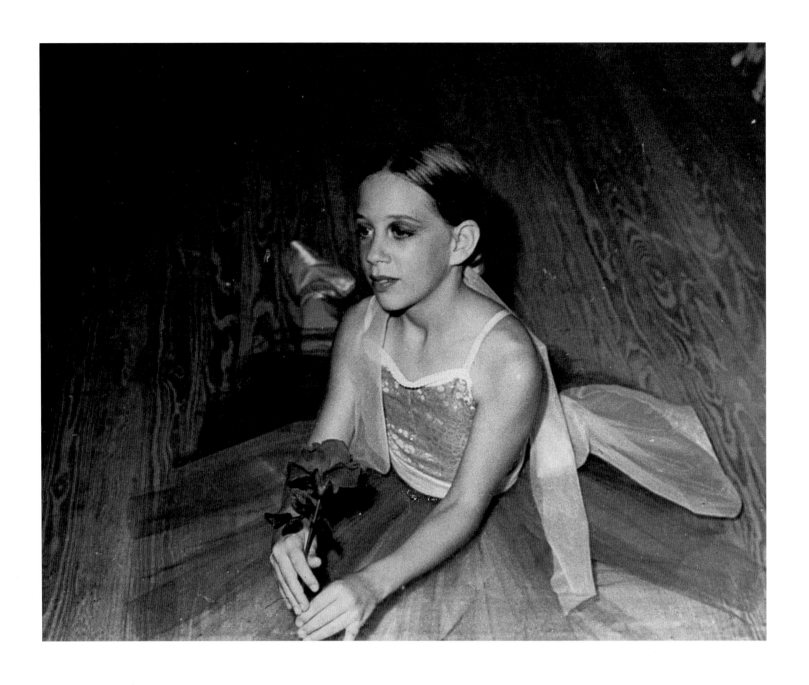

Allison Tradup (born Evans) *Nigodoff Ballet Studio, Key West, Florida 1973*

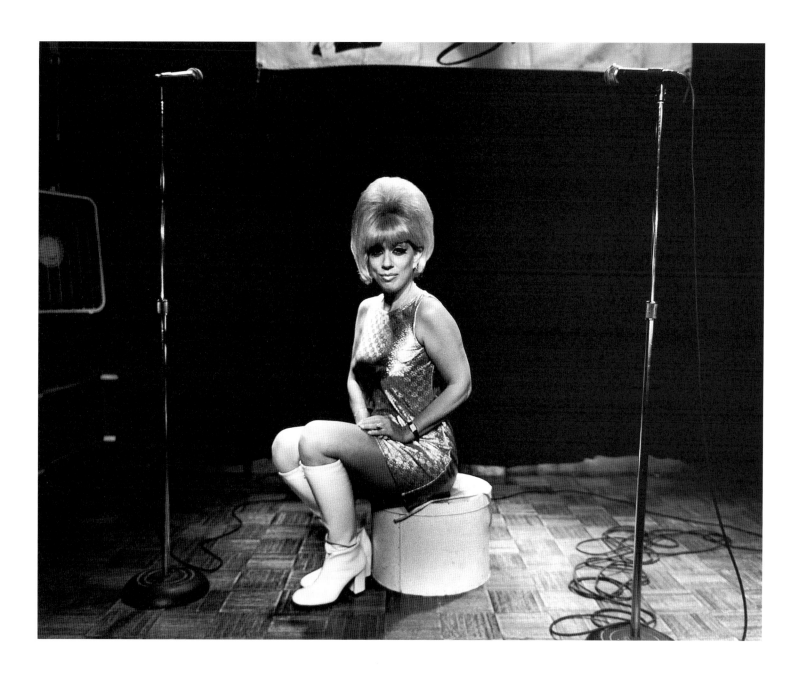

Allison Mayer (born Evans) *Key West, Florida 1997*

 Allison Mayer

Key West, Florida 1973
Key West, Florida 1997

I am Baby Tracy Spectrell. My real name is Allison Mayer. I am thirty-four—a single mother and widow—and I have an eight-year-old son. I have been performing with this group—The Fabulous Spectrelles—for fifteen years. I am a co-founder and one of the lead singers. We've had a number one hit single. It was done in England and it was a dance mix of a Supremes song. It went to number one in Europe and number one on the United States dance charts. But we had really bad representation and when we tried to get paid they pulled the record. We've been to Europe twice and were very well received and we want to go back.

I was born in Columbus, Ohio. I've been raised in Key West since I was about six. My father was in the army in the war and he was a graduate of Cornell University. When he met my mother he owned a restaurant and bar business. My mother was a well-established Jazz musician before she met him. She was valedictorian of her class. So I grew up in the bar and music business as my mother would play in the clubs that my father owned. I got a baby at age 26 and married the father at 27. The father was the owner of Sloppy Joe's Bar. We lost him to AIDS about five years ago and if it was not for this group I don't know how I would have survived this. To feel the support of the audience contributed to my self-esteem. My mother was an alcoholic and as a child I escaped through dancing. My biological father left my mother when I was about four and my mother had a nervous breakdown and sent all the kids to live with different relatives. My three brothers and my two sisters went together. I went to live with my aunt just by myself. So that was the beginning of always being independent. I was a happy kid and always tried to rise above it.

I was escaping from all the turmoil into my little ballet world in that picture. That's where I felt safe. If you'd just see that picture you'd think I was a normal kid—but it was so far from the truth—it was really hell. My father beat my mother and my mother kind of incited the fights but never beat the children. With each fight I was praying that my parents wouldn't kill each other. My mother is an amazing artist and her flaws endear her to me. She had an abusive childhood herself and she was lucky to survive. At her worst she was still loving and I know that her most regretful moments were when she lost her temper with us due to her blackouts in her alcoholism. She is a very good-hearted and spiritual woman who would give you her shirt off her back. In this picture I was ten years old because I have point shoes on and I had a Russian teacher who didn't believe in putting us on point until ten. He saved my life. He put me on a scholarship for dance and he was my escape. I went to that studio every day and it was the only place I felt safe. He taught me everything. Even though I am not dancing, he would be proud of me today that I am doing something with my art and am able to survive on it. I danced in New York with the Joffrey on scholarship when I was about fourteen. I was really disillusioned when I realized that the dance world was political. It was who you were and not how good you were. All those hopes and dreams I had built up over all those years were no more. I became a choreographer for a variety of musicals and shows. The next thing I knew I was a Spectrell and singing.

I was in *People* magazine and on *20/20* because my husband—big scandal—was one of the first heterosexual men knowingly to have AIDS and I was pregnant. He was in denial towards me. I found out because his wife died. I thought he was divorced, but he wasn't—he was leading a double life—so suddenly the press haunted me, throwing themselves at my car; it was horrifying. I had to go to court to find out what his medical records were. I didn't want to have the baby if it was going to be sick and die. It was a horrible time and I learned about the press. When *20/20* did an interview with me they chopped it up and put bits and pieces of it in. I learned that everything is an illusion.

America is the greatest—if you can manage to be free and successful in your own way—you can really have the best. I live in a beautiful house and I have a beautiful son who is not ill—a true gift. In many ways I am very disillusioned with the government, but I still believe that America is the greatest country in the world. You can really achieve what you want to, it's just a matter of wanting to, whereas there are places where you don't have that. Where else can a drag queen make a living? It is a man's world. I have seen really strong women in my life. Their strength is disguised because they are the ones that take responsibility, raise the children and go to work. I think a woman can contribute to balancing the budget, because that's what we do every day in the household. Men are more war-oriented, they know about strategy. The country could be served well if it was run by both. My stepfather took on six kids and raised them and never left—there are those men. But I think that America has lost sight of taking care of the young and the old, where the emphasis should be. The kind of music that we sing is about a time when people really believed in love, marriage and the American way and deep down in my heart I believe in that. What I do on stage is directly related to going truly back to the clean, wholesome time of the '50s and '60s where that really mattered. I am so drawn to this show because that sentiment does not exist anymore. There is a reason for the crowds that we get for this show. Next time you'll see me I'll be on television for my art instead of my tragedies.

 Allan Hooper

Butte, Montana 1999
Butte, Montana ca. 1913

This gentleman now talking to me wants to know my name. My name is Allan G. Hooper, I was born in Butte, Montana. It happened to be January 22, 1911. I was born a little off from Butte itself in Meaderville, a suburb of Butte. I was raised near the mines and as a boy we had to go around the mines to get firewood and we boys used to get copper and brass to make money to go to a show. And then I went to school, the public schools, and graduated from high school in 1929, and then I worked for the railroad for a while and then I got on a big job on the hill for the Anaconda Company Mines. I worked up to a hoisting engineer there. A hoisting engineer is the man that operates the big hoist that moves the cages or elevators up and down the shaft. I never had an accident, oh, I had an accident on the hoist, but I never had a man killed when he was riding under me, nor hurt. You had to have nerves of steel. Lots of time you'd get gray hair because you wouldn't hear from them and you wouldn't know if they're hurt or if someone is killed or what. Because even now there's no way to get radio waves or sound waves through solid rock. We made all of our signals with a bell. It would take us about half to three-quarters of an hour in the mornings to lower the shift. Sometimes it was kind of a lonesome job. You just didn't think of weakness. We have a lot of people who say they don't want mines and yet without mines it's the Stone Age. Myself, I'd have had that heart operation with a medicine man that got rocks for tools. You gotta have mines.

This photo of me with my parents and sister would be around 1913, 1914. I remember vividly growing up as a boy. I see the kids nowadays and I'm glad I'm not a kid now. They listen to TV and a lot of them don't get out of the house until eleven o'clock. We did a lot of hiking around up in the hills, got to know everything and the foremen of the mines allowed us kids to wander around the mineyards with all that machinery and everything because they knew they could trust us. Nowadays I wouldn't let one of those kids within a mile of the mineyard because I don't think they've got sense enough to get out of the way. We were all going exploring things and inventing games, and myself and a lot of us made what we couldn't get. I learned at an early age about carpentry and about soldering a broken toy with a soldering iron and you know all that stuff, we had something to do all the time and I'm glad we went through all that.

Politicians have convinced everyone that women got to go to work and that that's freedom. Sure, now they go to work and they work all day and then they come home and they still got to work and wash dishes and make beds—it's got so that it takes two people to make a living. I think the generation has spoiled it. We have these kids running around now and because of TV you never know if a kid is going to throw a bomb through your window. Now in schoolyards you see shooting. These kids have a hatred for the other side. I think the whole world is gone to hell in other words. Your kids are raised by somebody other than your wife and yourself. I got a bleak outlook on life. I think we saw the best of it.

The Berkeley Pit starts around 1953, 1954. The Berkeley Pit takes over the world. Your Butte mines are still full of copper and metals but the Berkeley Pit is a method where you mine such huge quantities that you can take rock that only got one percent copper in it and you can make it pay because you only got three men, like a shovel runner, a driller, and a truck driver. I think our house is buried up there, and I think I can come within 1,000 feet of it. You see, most of us in Meaderville were living on company land and you paid one dollar a month in rent. But when it come for the Berkeley Pit, all they had to do was tell you to take your house and put it somewhere else and if you didn't like it, that's it.

Of course the loss of my mother and dad was sad, but then the losses of the mines—even though I was ready to retire—that was sad and I still look up to the mines. Two years ago I got permission to go on one of the mineyards to get some lumber. The sun was shining and I said, boy this is where I want to be, smell that sulfur again on the rock, back in the mineyard, that's where I want to be.

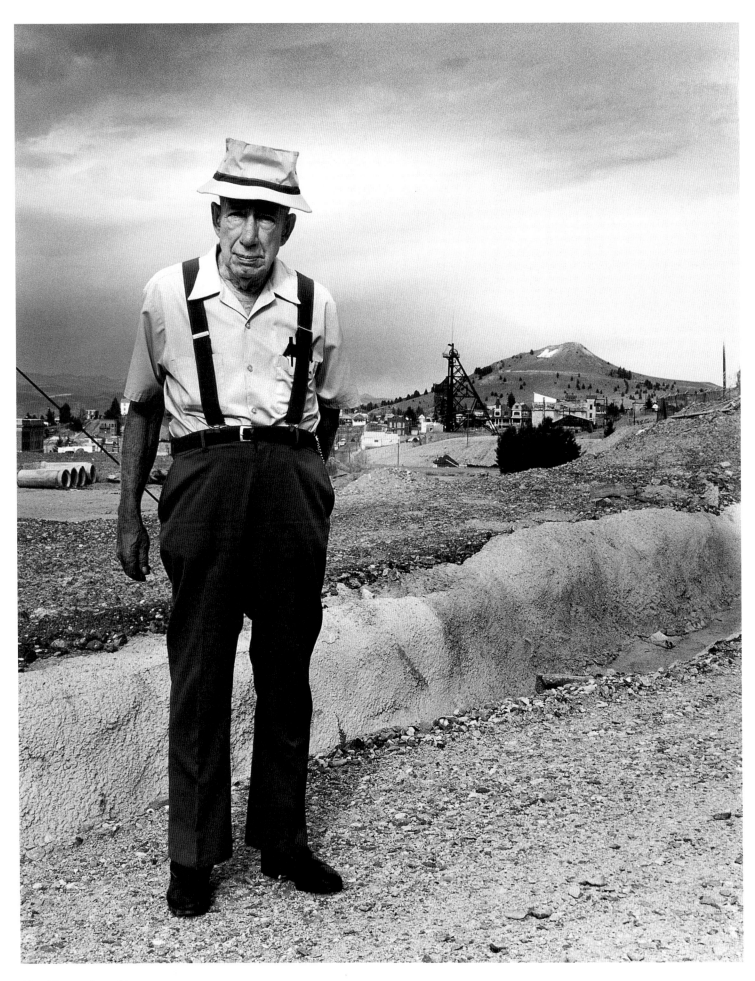

Allan Hooper *Butte, Montana 1999*

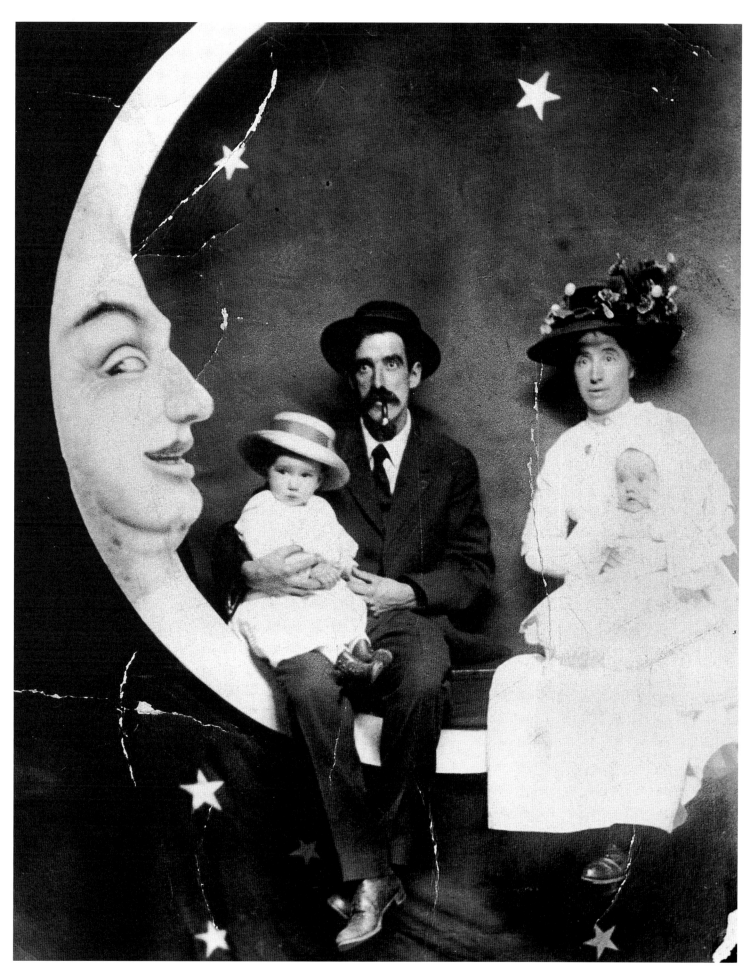

Allan Hooper *Butte, Montana ca. 1913*

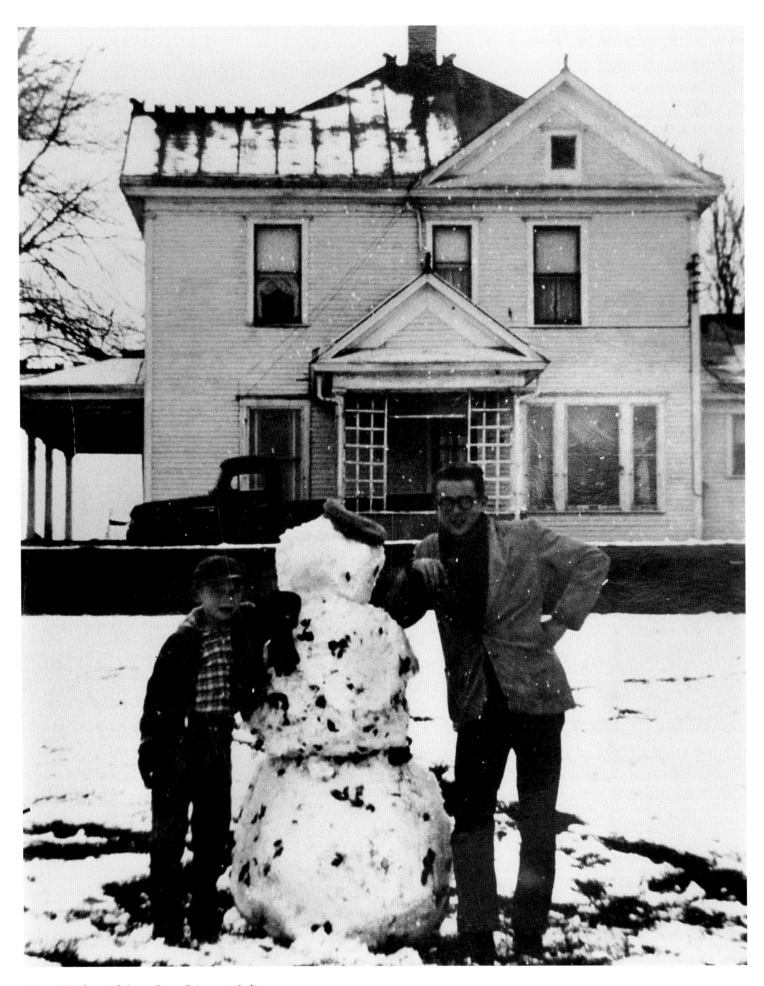

Marcus Winslow with James Dean *Fairmount, Indiana 1955*

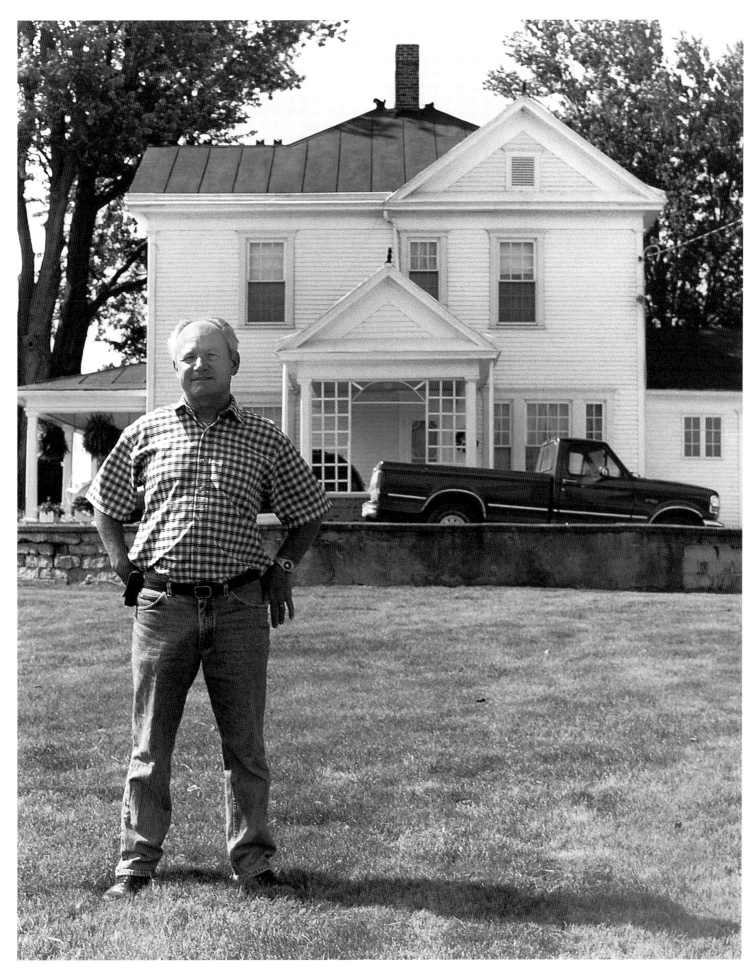

Marcus Winslow *Fairmount, Indiana 1999*

 Marcus Winslow

Fairmount, Indiana 1955

Fairmount, Indiana 1999

This photo was taken by my dad on Jimmy's last visit to our home in Fairmount, Indiana, around February 14, 1955. They had a Sweetheart Ball here at Fairmount High School and Jimmy went to that Sweetheart Ball. It was the last time that Jimmy was home before he died. He brought a photographer with him from *Life* magazine and he took pictures of Jimmy here in Fairmount and then they went to New York and took more pictures. This particular photo here was just a home snapshot, and that's Jimmy and I out here in the yard building a snowman. This is the little cap that he wore when he was here and he stuck that on the snowman. The house still looks very similar to what it did then. It might even look a little better today.

Like any child, I guess you look to your parents and your elders to provide for you and when you get older you get married and get a family of your own and you have to take care of yourself and your family. When this photo was taken, I was eleven years old and at that time I was the only child at home. My parents were very good to me. My parents are both deceased now. I've felt a responsibility to keep the homestead and the farm up in as good a shape as I can and of course, with all the fans Jimmy has coming from all over the world, we try to keep the farm looking as close as we can to when he lived here. Jimmy was interested in things that were free, like animals and trees and things like that. He was a good artist. He liked to sketch and paint things. He didn't like things that were drawn or sketched of confinement, like a jail or something. I think he was probably interested in people from other parts of the world, but I think he was a person who really appreciated America and was proud to be a part of this country. I feel America is probably the best country there is. It's a country that promotes peace and freedom the world over. A lot of people lost their lives trying to make the world a better place. James Dean only starred in three movies but he certainly left an impact on the world. I'm sure he'd be proud of that too. He was very interested in photography and it played a big role in his life. You can find several pictures of him with a camera in his hand. When he was in New York, he got acquainted with well-known photographer Roy Schatt. He learned all he could from Roy Schatt, and I know a lot of Jimmy's friends in the movie industry are pretty sure he would have gone into directing and producing because he liked to be behind the camera and direct the way scenes were done. And he was very fortunate in that *East of Eden* and *Rebel Without a Cause* were both movies where the directors allowed him to develop his character pretty much on his own.

My dad devoted his life to farming. So as a child I helped on the farm a lot. We had cattle and hogs and chicken and some sheep. Now we only have cattle on the farm but back when I was a kid, it seemed like the farms all had a pretty big variety of livestock, and of course I'm still here on the same farm that I was raised on. It has been in our family for over one hundred years. I have worked in a farm implement dealership, a factory and I was a township trustee assessor for twelve years. I'm still very much interested in farm life. I've had a lot of happy moments in my life. I have a good wife and two boys that are very good boys. I've been fortunate, through Jimmy, to meet people from all over America and all over the world that have come here to Fairmount because of him. I know that Jimmy's played an important part in a lot of people's lives and he's influenced a lot of people's lives. I'm proud that my folks raised him and they apparently did a good job. I know he felt like my folks were his own mother and father. He always looked to me as a little brother and I looked to him as an older brother. Of course it was a sad time when he died at age twenty-four. I don't think my folks ever got over it but I'm sure that other folks have gone through the same experience. It's always hard when you lose a close family member and I guess the difference between him and a lot of people is, when you have a death, you're usually allowed to grieve on your own. With someone well-known like Jimmy, there are always a lot of people continually reminding you that his life was important and I think that does make a difference in accepting their death.

Curly Bear Wagner

Browning, Montana 1999
Seattle, Washington ca. 1950

My name is Curly Bear Wagner. I'm a member of the Blackfeet Nation. It's just over a million and a half acres in size. There are about 15,000 members. What sustains our culture is the land, so it's important that the land is held sacred to our people. Now this land we had to sell in the late 1800s for our people to survive. The United States government paid us in annuities: food, clothing, work horses, chickens and so on. We had to take what they had to offer. The buffalo disappeared in 1883 and 1884 and we were totally dependent on the government for our survival as a people. In the winter of 1883 to 1884, Starvation Winter, over 600 of our people lost their lives. The old agency was out gathering our ancestors, putting them in a footlocker, taking them up here to the train station, shipping them back to the Army Medic Museum in St. Louis. At the close of the '40s, they were shipping them to different museums and universities around the country for study. In 1986 I found out that our ancestors' remains were in the Smithsonian Institution. The Elders were quite angry. I said we've got to do it in a spiritual way. Now, after a four-year battle, I received a letter from the Smithsonian Institution that said that we could get our ancestors out of there and we buried them.

We stopped the mining activities in the Sweet Grass Hills. We want those hills recognized by UNESCO as a World Heritage site like Glacier National Park, Yellowstone—unique land. I have a traditional encampment up there every year and people from all over the country attend. We want to leave this land for generations to come, for all races. I'm also recording the sacred geography of the Blackfeet in an educational project. Our history was written down wrong. There are some things I'll talk about and those I won't talk about. The sacred sites I didn't write up. That's ours to keep within our own people. We are trying to get rid of the stereotype thinking about our people. I'm the fourth generation put on Indian reservations. We're the generation that is making things happen, that fought from Alcatraz Island to Wounded Knee, and is taking initiative for what is rightfully ours. We don't pattern ourselves after the black man. We do things in a spiritual journey. We need to make people aware that our tradition hasn't died and neither have we.

Every morning we leave an offering of tobacco to the sun, giving something back to the sun that the sun gives to us. In our religion, everything is real. The sky, the clouds, the moon, the stars, the mountains, the trees, the water, the rocks and all things are living and we're part of that relation. The white man has no concept of land. All he sees is a money figure. It's sad to say, but when he came over from Europe his culture was snapped in two. They'll never understand the land because they'll never have the patience to sit around and look at the beauty of America today. My great-grandfather was Red Crow, his uncle was Seized-from-Afar, very famous men—they were warriors. This has been passed on to me. Hopefully we educate them to have a better understanding. We're the only people in this country that maintain their culture. We didn't go to church on Sundays and pray. Our people are nomadic people—we would pray constantly when we were moving across the Plains and moving across the water. The sweat lodge is like the womb of Mother Earth. You are in complete darkness and when the rocks are brought in and water is poured on them you hear a hissing noise. It's like an energy force coming from there. When you see light, it's like you're being reborn. The pipe is one of the most important instruments of our people. The bowl of the pipe is made of stone so it represents the universe. The stem of the pipe is made of wood so that represents living things on the universe. The smoke is like spirit. It disappears. We don't say it's wrong to practice the Catholic, Methodist or the Jewish way. That's their ways. We don't want to be disturbed in our ways because they were given to us by the creator. I was raised in the traditional way among our people. Tourists, white people, always wanted to take a picture of us. We were unique, we lived off the land. I stayed with my grandmother, she was a great storyteller, so I'm a storyteller today. I travel all over the world speaking. I'm on the front cover of the *National Preservation Magazine*. I'm featured in the *Smithsonian Magazine*, I do documentaries for the Discovery Channel and CNN.

Photographs tell a story. I was in the heat of Vietnam for eleven months and twenty-eight days. Coming home I said I'll never complain where I sleep or where I eat. I am thankful to be alive. At home I started seeing the prejudice in America. But if we hate people, we are controlled by them. We pray for those people. You give that hatred to the sun.

The photograph was taken in Seattle, Washington where I was born. That was during World War II. That is where my mother got sick. She died of arthritis because of the climate and that's why we came back to the reservation when I was five years old. You see some curly hair.

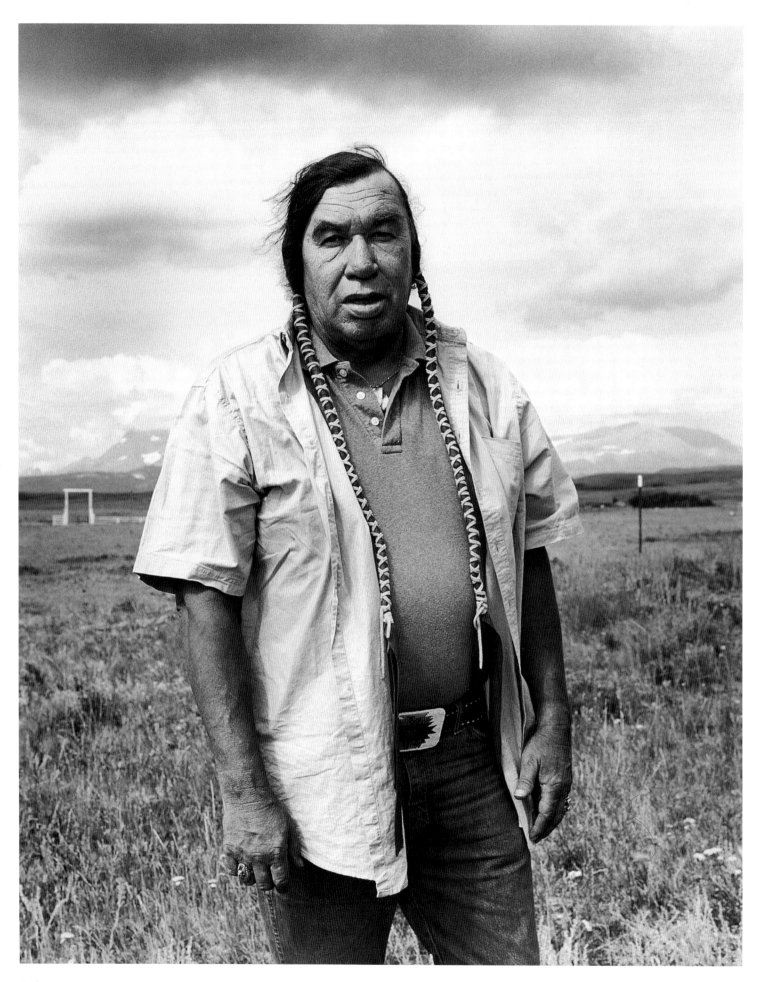

Curly Bear Wagner *Browning, Montana 1999*

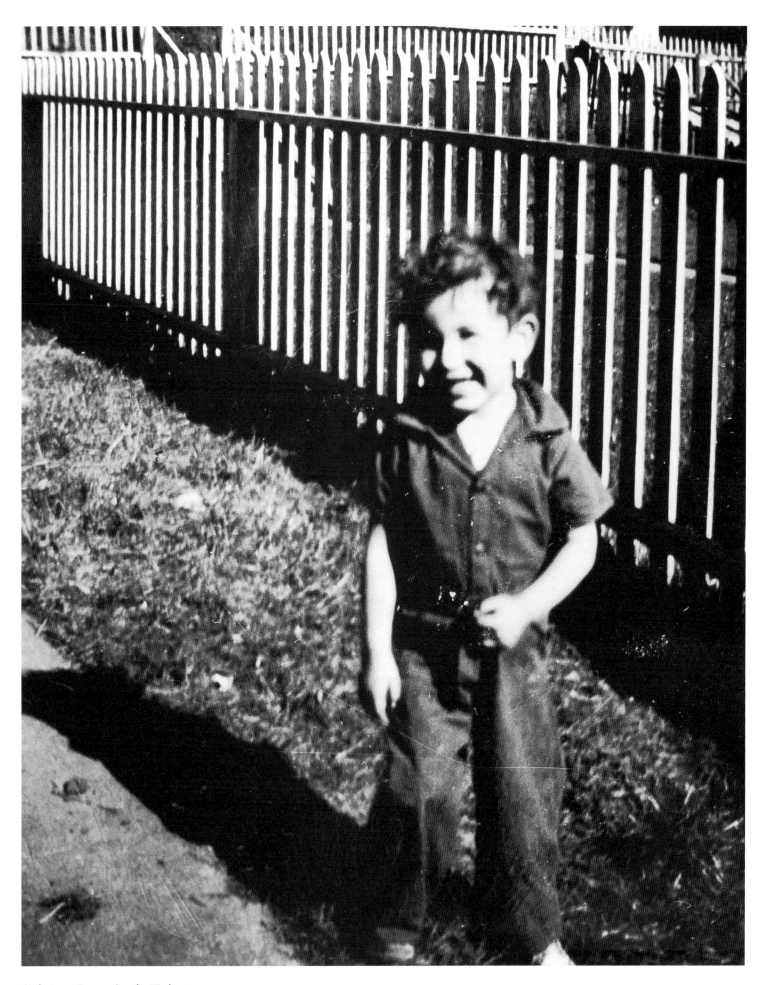

Curly Bear Wagner *Seattle, Washington ca. 1950*

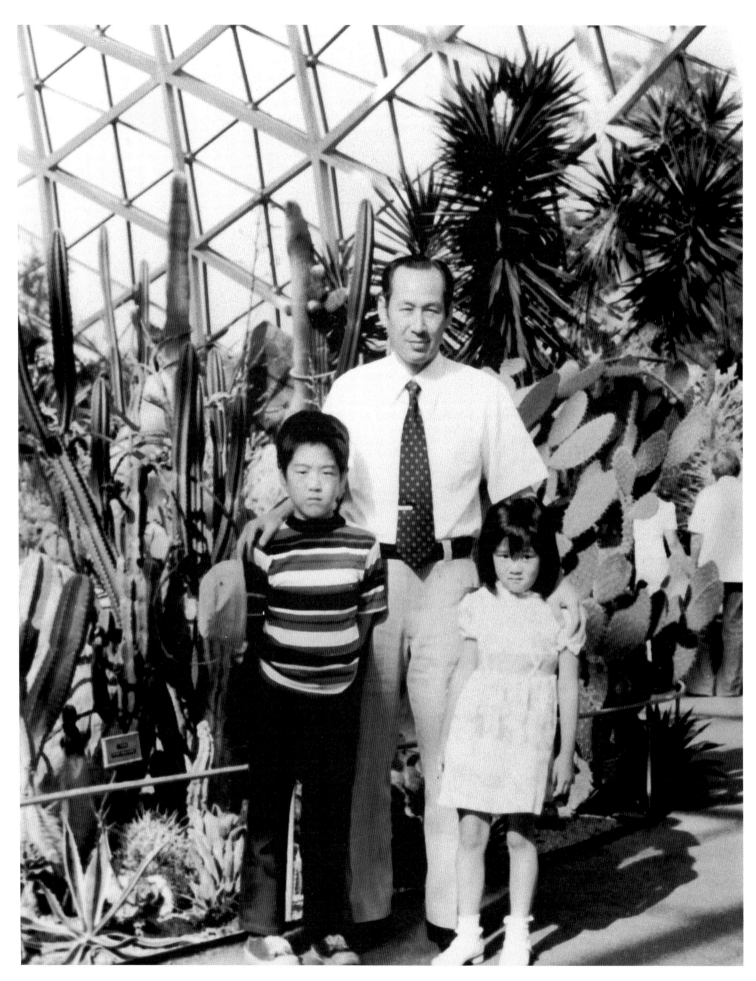

Jenny Chung *Mitchell Park Conservatory, Milwaukee, Wisconsin 1975*

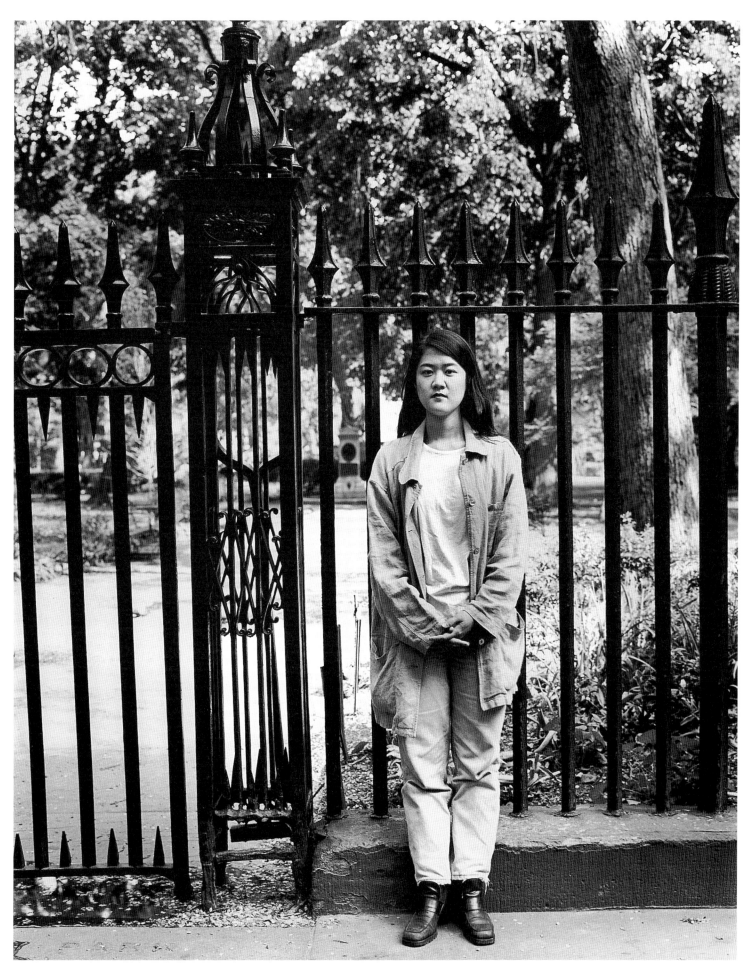

Jenny Chung *Gramercy Park, New York City 1996*

Jenny Chung

Milwaukee, Wisconsin 1975
New York City 1996

I don't actually remember this particular photo being taken. Whenever my grandfather, Mr. Sam Bo Eun Kim, came to visit our family in Beaver Dam, everything became a special occasion. I'm certain our family (including my brother Glenn), decided to drive over to Milwaukee and visit the Mitchell Park Conservatory for his benefit, and I'm sure this picture was taken to commemorate the visit. I remember how unpleasantly hot I felt in the greenhouses, and how bored I was looking at plants. I'm sure I was excited, however, that my grandfather had come to visit—he always brought us really great gifts and he was our only grandparent who spoke English. I'm not sure why my younger sister Jullie was not in this photo— she would have been quite young at the time and may not have been very accommodating in her attitude at that moment. Jullie would have been three years old, Glenn eight, I, five. Jullie was the only U.S. citizen in our family, having been born in Michigan; the rest of our family were not naturalized until the following January.

The biggest change since I was a child is in the way I think—I understand now that it is not OK to think only about myself. My nature is to be extremely self-focused—when I was a child, I frequently lost my temper and manipulated people to get what I wanted, and if I didn't get it, I held grudges and hated people easily. I was always convinced that my ideas were the best, and if others didn't agree, I treated them as inferiors, totally unworthy of my company. If I ever did get along with others, it was usually either because they were doing things my way, or because I was hiding my feelings of contempt in order to have someone to play with. I constantly reaped the consequences of my arrogance and insecurity: intense loneliness, stunted and stifled relationships, and an increasingly debilitating perfectionism. All of these effects were tempered a great deal by the unconditional and selfless love my mother showed me, but I developed a personality of extremes, expecting perfection of others and of myself, and completely discounting the value of any effort that evidenced a flaw. Ironically, as I became less and less able to produce anything in my life that matched my expectations, I usually lost patience altogether and began faking it as best I could. I spent years of my life collecting top honors and admiration, all the while contributing less and less effort and usually throwing things together at the very last minute. My lack of character and discipline would be rewarded time and time again, but I became a self-perpetuating fraud, and I missed out on connecting with people because I feared exposing the truth about my weaknesses. It only got worse the longer it went on. It took until I was in my twenties for me to finally overcome the fear of being

honest. The only thing that could break me out of my paralyzing cycle, and its resultant sense of hopelessness and denial, was coming to understand the passion of a God who was never fooled by my desperate pride and would risk having me hate him for his insistence on my need to face the truth. It was at the point of my deciding to trust and risk everything that I finally grew up. One of the defining characteristics of a living relationship with God is that of selflessness, and it meant a scary but exhilarating change for me.

I was born in Korea, but I arrived in the U.S. about two months later. My earliest memories are of life in suburban America—plenty of green grass and unlocked doors and the occasional outdoor barbecue. America, to me, meant my home—not the wider country itself, but the suburban life that I knew. I thought the rest of America was a bunch of other suburbs and maybe some cornfields, since I had seen some of those outside our little town. I knew there were cities, but they were no more or less threatening to me than our local shopping center, which was the busiest area that I knew. It was just as scary to get lost in a shopping center as it was to get lost in a big city. I thought all of America was very rich, like we were (although I later discovered we were desperately poor). As kids, we always talked about what kind of job we wanted when we grew up, not whether or not there would be jobs. I didn't understand that not everyone is able to, or wants to, go to college. I assumed everyone got Masters degrees, and if they didn't, it was because they had kids and had to take care of them (like my mom did). Then at least the husband (since nobody in America got divorced except people with tragic and mysterious problems) was sure to have some kind of graduate degree. Even the farmers we knew. I was also very uncomfortable with things from the Korean culture, other than certain foods that my mom prepared. This included my Korean-speaking relatives—unless, of course, they spoke English.

When I hear the word America now, once I decide we're talking about the country and not one of the continents, I think of a rich and diverse fabric of cultural backgrounds and ways of thinking, marked by both an incredibly adventuresome spirit and a short-sighted and materialistic desire for instant gratification. America does suffer from a confusion of its own identity, and while that blurring of boundaries allows for free thinking and dynamic creativity, it also seems to result in an ever-increasing suspicion of the unfamiliar, which in turn feeds the greed to further one's own purposes with no thought to the cost for either side. I know firsthand that it can be a land of incredible opportunity for the industrious and the teachable. I also know that it can be a land of prohibitions and horrible injustices for those who don't seem to fit in. It remains in a state of flux, full of paradoxes and sad ironies. Nevertheless, to me, it still means my home.

 Melvin Gene Mikelson

Julesburg, Colorado 2000
Julesburg, Colorado 1935

This town, Julesburg, Colorado, was noted for its famous wagon trails: the Pony Express, the Oregon Trail and the Overland Stage. The Union Pacific came through here in the late 1860s. I am proud to be born and raised within half a mile of Julesburg, Colorado and I have grown up with this history. My grandfather was a historian and I followed his stories that came from men that had actually talked to people like Buffalo Bill and Jules Beni—they named the town after him in 1860. I am on the pastoral committee of the same church my mother's parents worked with when they first came to this town back in the early 1900s. I was with the American Legion during the Korean war. I have been in law enforcement 45 years and I spent about 27 years as city manager and chief of police. I've been the Sheriff of Sedgwick county for eight years and retired. Charles Parell and Mayor Bradley in Los Angeles presented me with the Seven Hats award which I've got hanging on my "brag me-wall" and I feel great for what I've gotten to do. I am proud of everybody I got to serve.

A memorable incident from my days as sheriff happened in '89. I was just south of Last Chance, Colorado, which is on Highway 36 east of Denver, traveling along, and the radio kept announcing they needed any law enforcement officer in the area of Anton, Colorado. I wasn't sure where that was so I picked up my mike and asked. "We just had an armed robbery, they held up this store and were headed west on 36 going towards Last Chance." Immediately my heart flipped over. I went back to Last Chance, and stopped at the Walden Milk Shop. That's about all that's there besides a filling station and I got myself a milkshake. I headed north on 71 and I came into Woodrow, not more than a post office, a filling station, and a farm house and I saw this car sitting in front of the gas station. I climb out not having my gun, I left it in the car and I said, "what are you guys doing?" All of a sudden they spun off. I got in front and waved my arms trying to get them to stop, but they weren't gonna stop so I jumped out of the way and they went onto Colorado 71 and turned right back south towards Highway 36. There comes Trooper Roth who must have been checking the road and he got the message from me waving, made a u-turn and headed south following that car. I was chasing that car and he didn't read the dead-end sign. We went for about a mile down a rolling hill and here is the dead-end with the farmer's yard down in the bottom. I slammed on the breaks and when I pulled in there was Trooper Roth still in his car. I pulled up alongside, jumped out and grabbed the driver of the car and pulled him out and it was a girl. I didn't understand there was a girl involved but young people

I took her back and handcuffed her. The guy was on the other side of the car with a shotgun bringing it down on both Roth and me. The one reason that kept him from trying to shoot us was his girl-friend alongside of me on the car. I had out my little stub-nosed .38 caliber pistol and hollered at him, "Don't you do that. I am putting this hole right between your eyes," and he backed up and pulled his gun under his chin. At nine o'clock that night with spotlights shining down on there—I never saw so many cops in my life—a guy from Fort Morgan negotiated with him until he gave out. We took him to a cafe to get him something to eat and to drink. I sat down at the table with him and couldn't believe what I was in just a couple hours before. As far as I know this boy is still in prison for the armed robbery.

That early picture was taken of me back in 1935 during the Dust Bowl days, the latter days of the Depression. I was born in '29 and I can remember the terrible dust storms that would come up and I was frightened being a young boy. My mother was running around with flower sacks, dropping them in water and hanging them over the window to collect the dust as it came through the window sills. My parents were having a hard time paying for anything they bought, including the clothes that I wore to an old country school. I still remember we used horses to do our disking and plowing in the field and when dad got this old case side mounted tractor I always thought that was so neat that I could ride on that. It had dust all over, you could hardly see were you were going. I remember that we went to school and it was an honor to place your hand over your heart and pledge allegiance to this flag that meant so much for everybody. To think today how people react that have not had the hard times to grow up in and can run down the country and give so much criticism for everything that's done.

We used to say prayers in school and I think it's important to be taught, no matter what religion, and have this feeling of knowing God. I am proud to be an American and this is where I learned it. I learned it out there in those dirty '30s when we didn't have nothing. I begged for a dime to go to a picture show, a nickel to get in and nickel for a sack of popcorn so I could watch Hop-Along Cassidy, my hero. But my great big hero of all of it was John Wayne. I got to meet him in Tucson, Arizona when I was on vacation and he was there in a movie. I have pictures of him and video tapes of all the old movies. I have been on television myself a couple of times here in Colorado for my history and I think photography and movies are a great thing. I am often looking at these old-time pictures. I was proud to serve America during the war. I received honors and it makes me feel great that I was able to do this. Yet today when I talk about all this I get a chill through my body to know that I was part of this great country.

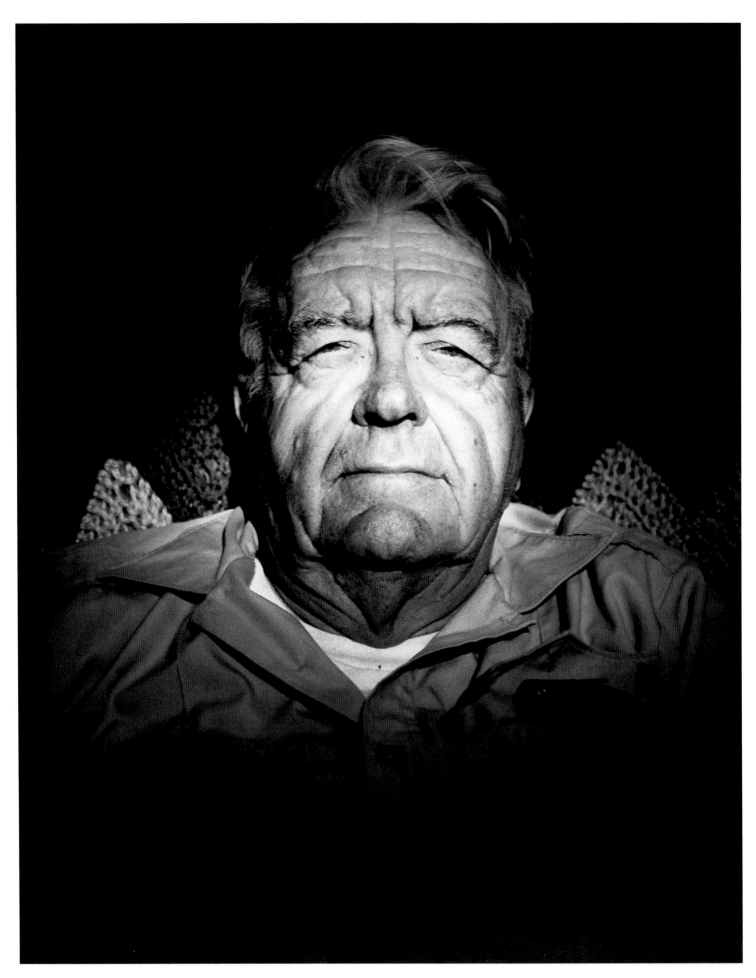

Melvin Gene Mikelson *Julesburg, Colorado 2000*

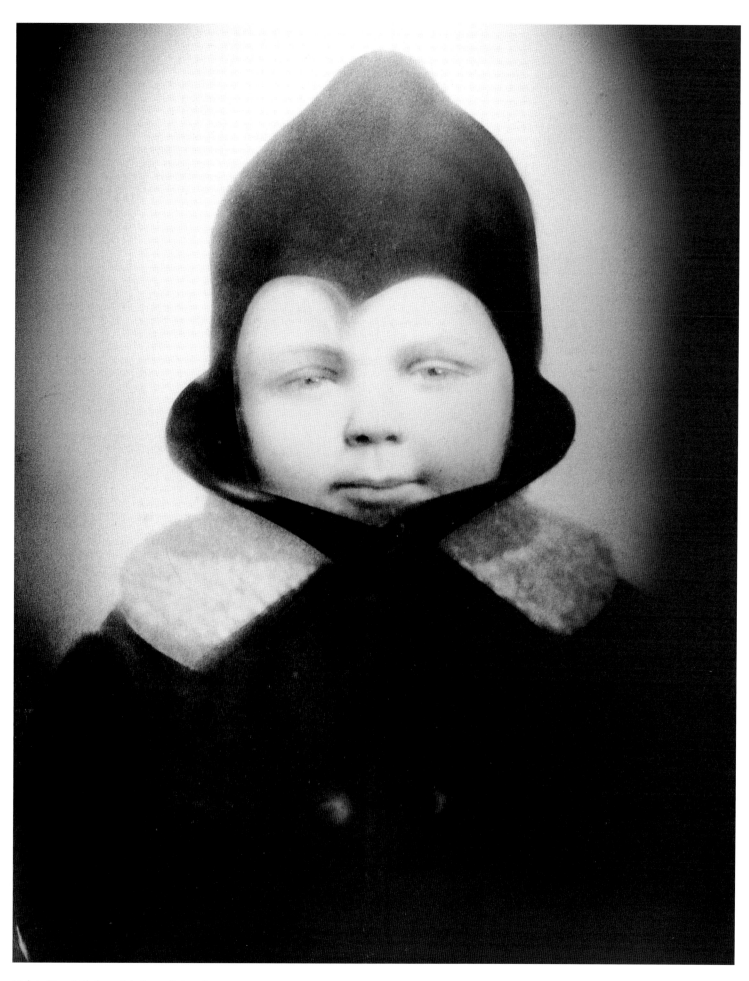

Melvin Gene Mikelson *Julesburg, Colorado 1935*

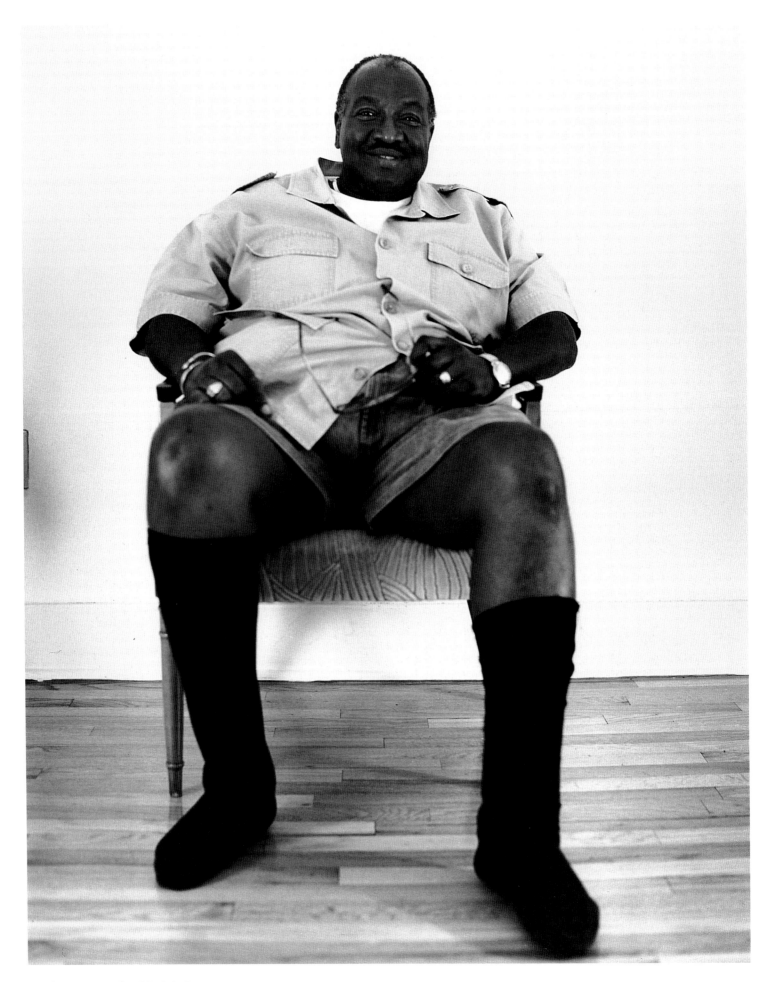

Joseph Frazier *Natchez, Mississippi 1997*

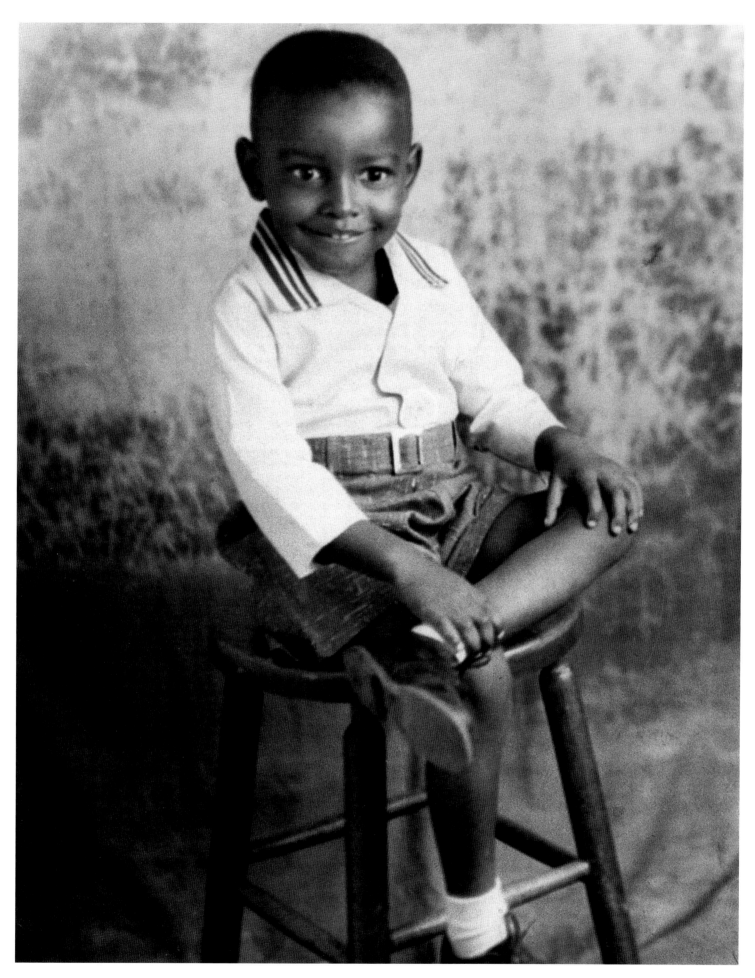

Joseph Frazier *Natchez, Mississippi 1938*

Joseph Frazier

Natchez, Mississippi 1997
Natchez, Mississippi 1938

When I was six, my mother, Odille Brown, and father, Ed Frazier, were killed in the worst fire that ever happened here—the Rhythm Nightclub Fire. And so my sole rearing fell to my grandmother and grandfather. Like the African proverb says: "It takes a village to raise a child." Most families were touched by that fire on April 23, 1940, so there were people in the community who took us kids, who had lost our fathers and mothers, under their wings. There was a Mr. Earl Reed who printed the only black newspaper in town. What the *Natchez Democrat* or some others wouldn't carry, this paper carried. Reading to me was a way to find things out in a way I had never experienced. If it was done in a book and I could involve myself into it, it was just like I was doing it. I always knew I wanted to do something that was going to benefit somebody—not just for money. At the time I was growing up, there were only two professions that were open to black folks readily. They were preaching and teaching. I didn't think I had the temperament for the former, so I took the latter, and got into teaching. I was the only guy at the school who wore a suit and tie. There were very few men teaching in elementary schools and so they were principals. Some young boys went through school and they never saw a man at school other than a janitor. I guess I was first selected as assistant principal to be a role model. When I headed for a store downtown, I was always "Professor." It was a way to show respect without them having to give me the title of "Mister." I worked in the Natchez Public School System and in the surrounding counties for almost fourty years.

I was raised by my grandmother, Carrie Young, and grandfather, Sidney Young. My grandfather was one of the few black interior decorators in Natchez; he was also a painter. Everybody called him "Painter." My grandmother worked as a maid in some of the finer homes of the well-to-do people. She would not work in any place where she could not bring her grandson. So I grew up with a lot of the powers-that-be in this city. There were all the white kids: Joe Joe and Jimmy and there was this little colored boy with them— me. I couldn't go to the park if I was alone. But because I was with them, I could go to the park. I could go into a lot of places because those were Mr. So and So's children, and he is with them. The only thing that was different was the swimming pool. When the white kids were swimming I would have to sit on the side and watch them swim. When we ate, I couldn't go to the table in the house, but most of the kids would follow me out on the sun porch. I did a lot of things that helped me as I grew older because it was not just anybody's kids that when the police stop you in the gang, the police

could say, "That's Carrie's kid. She works for the So and So family." I am not saying that braggingly, I am saying even then, it was who you know and whose family you were close to at that time.

I wanted to do something with books and education. I wanted to help children get the same enjoyment from reading as I did. I bought my children a set of encyclopedias, and we used to do what was known as a "one page a day" plan. They would say, "Everybody else is playing and you got us with these old books." The Lord has allowed me to live long enough to see them succeed. My son graduated from Georgia Tech. He owns his own computer company and my daughter has her master's degree and is a technical writer. I'm blessed to have touched the lives of a lot of kids. Many of my former students come back and tell me what an impact I had on them; it makes me feel like I made a difference. I have accomplished some things in my life I set out to do, but I always wonder how it would have been had I pursued—and if my family had the money—for me to go into medicine. Like I said, my grandmother was a maid and my mother and father were dead, so I had to do things that could get me into the work field as a wage earner as soon as possible. My family was not dysfunctional, it was just short of staff. I kept a job loading gravel for maybe two or three summers. My grandmother would say, "We are saving this for your education," and we would save the two dollars a week extra that I had for my education. My kids went off to college with refrigerators, microwaves, stereo sets and everything. When I went to college, everything I had was in a handgrip. I think it's hard for them to conceive what I've gone through. So I used to throw in a saying that my grandmother would throw at me. That was: "All you got to do is live. All you got to do is live!"

The photographer was scheduled to come. He took his black clientele to one of the funeral homes. My father wanted me to wear a suit and tie with a hat turned to the side like Al Capone. My father was a restaurant owner before he passed away. And he always had the idea of looking like a businessman, so I guess that's what he wanted me pictured as. My grandmother and mother wanted me pictured as a little boy. There were no conflicts about it, but there was a sigh of relief when they all decided that I would take this picture as a kid in a sailor suit. That was in 1938 because I was five.

America to me was Natchez. And I guess the epitome of America for me was what went on here in Natchez at that time—the good and the bad. And there were pretty bad things that I would hear the grown people talk about. I came through the Depression, and I came through some times when people were not working, but I thought that everybody was living just about the way we did. But then one day, I had an argument with a kid, and I didn't know

what was wrong. He blurted out, "Just because you're getting a chance to ride in a car and none of us can, you think you're something!" I said, "That's not our car. That's the Merrick's car. They're our neighbors." It seemed there was a sigh of relief that that was not my car, because a car separated the "haves" from the "have-nots," and that put things in perspective that I had not thought about before.

Because it was prohibited for us to read and write, our history has mostly been written by somebody else. And most of our history that is recorded is either done on a cash sheet, because we were property, or it was done from the church's point of view. We had no churches, but they allowed us into the large white churches, either in the upstairs or down in the basement. From the owner sheet on the plantation, it was known how many slaves were owned, which ones worked in the house, which ones worked out in the field, and then, how many kids were born to this particular family. Because if you can't write, the only way you're going to have history passed down would be oral history. That was done, but as with anything else, as you tell it orally, it changes from person to person. It's not exactly as you saw it or observed it before. That's not so with writing. You have to be mindful what you write, because it's there long after you're gone.

America today I see as a promise land. It still has promises to fulfill. There is no, nor has there ever been a perfect society. There are enough good-willed people who want to see this experiment in democracy work that they keep hammering at it and keep doing something to let everybody know that the dream is not dead. The violence in the streets with our young kids is getting worse, because many of our kids are taking the wrong role models. You get kids younger and younger with guns. Is there a drug problem? Yes. There are more young black men in jail than there are in colleges. And when you imagine that, you have to think about the young ones, the young kids who are out there without a male role model, any father figure. A lot of mothers are facing the fact that there is a vanishing father. It's a rough situation, it's a rough situation.

Flavin Judd

Baja, Mexico 1972
Marfa, Texas 1996

I spent my fourth birthday in the Baja desert with my father Don, and his friend, Jamie Dearing. Don had mysteriously procured a small cake for the occasion and that was our supper. Later that day, possibly because of the sugar overload, I fell backwards into a cholla cactus and for the rest of the evening the two grown men plucked slender quills from my backside. This might explain the rather sullen face. I like the time in my life that photo represents and I suppose that it looks as if the kid has nailed the camera and not the other way around. Photographs are odd. They are defined by the frame, by what is not in them, by what is left out and not remembered. They're annoying but I like them anyway.

I also vividly remember the look of the sea after driving through the dry desert. The smell of salt air, dust, and the rubber mats in the Land Rover have never been forgotten. Obviously a lot changes when one grows up. I suppose that while I am of course the same person as I was in that photo, I consider him to be someone else. Except for little pieces and feelings, tendencies, there's just too much time in between to really connect them. I think my outlook on life has darkened a bit while at the same time I'm learning the Zen acceptance I seem to have mastered at that age. Probably I was smarter then too, not that I can tell though. I grew up thinking I was from Texas, not America. Now I'm even more confused. I still want to see the Pacific Ocean rising out of the sand and rocks.

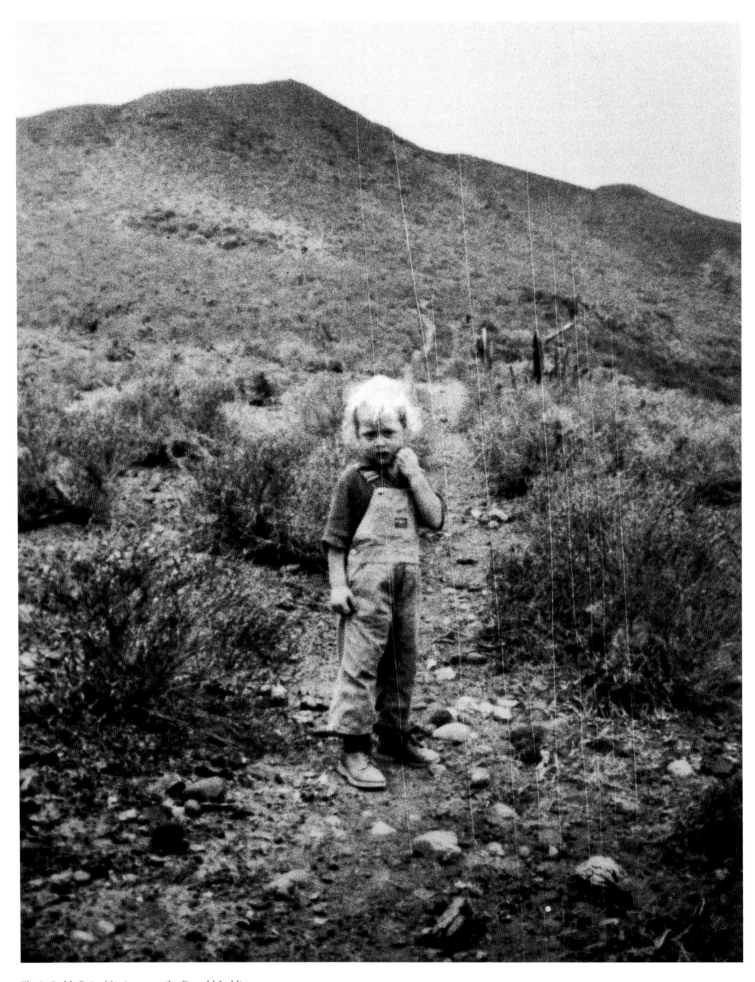

Flavin Judd *Baja, Mexico 1972* (by Donald Judd)

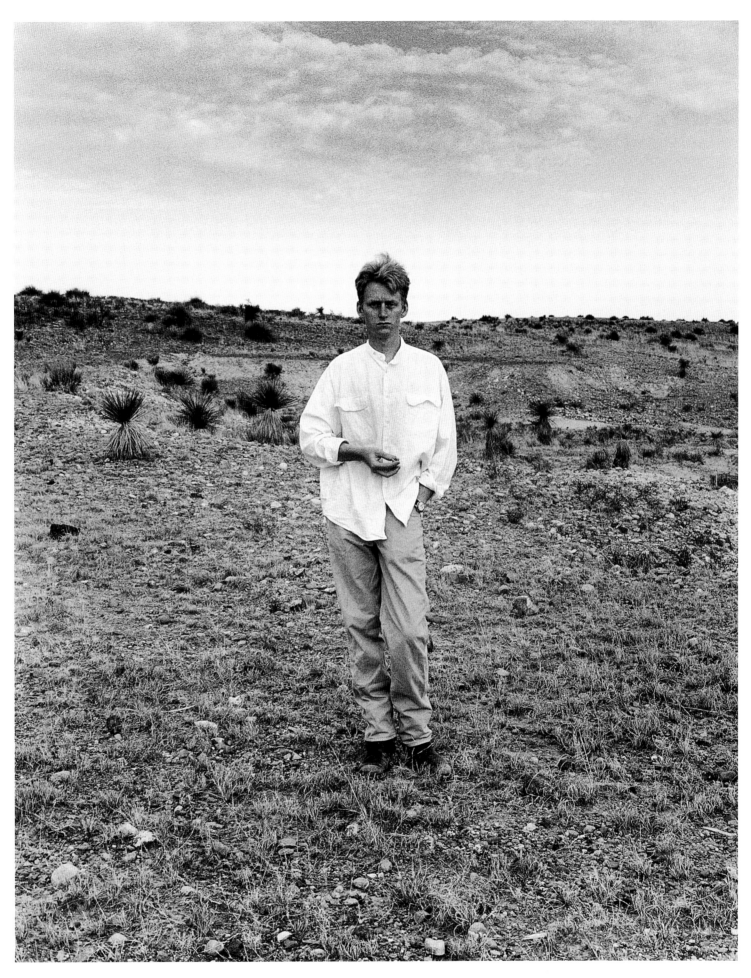

Flavin Judd *Marfa, Texas 1996*

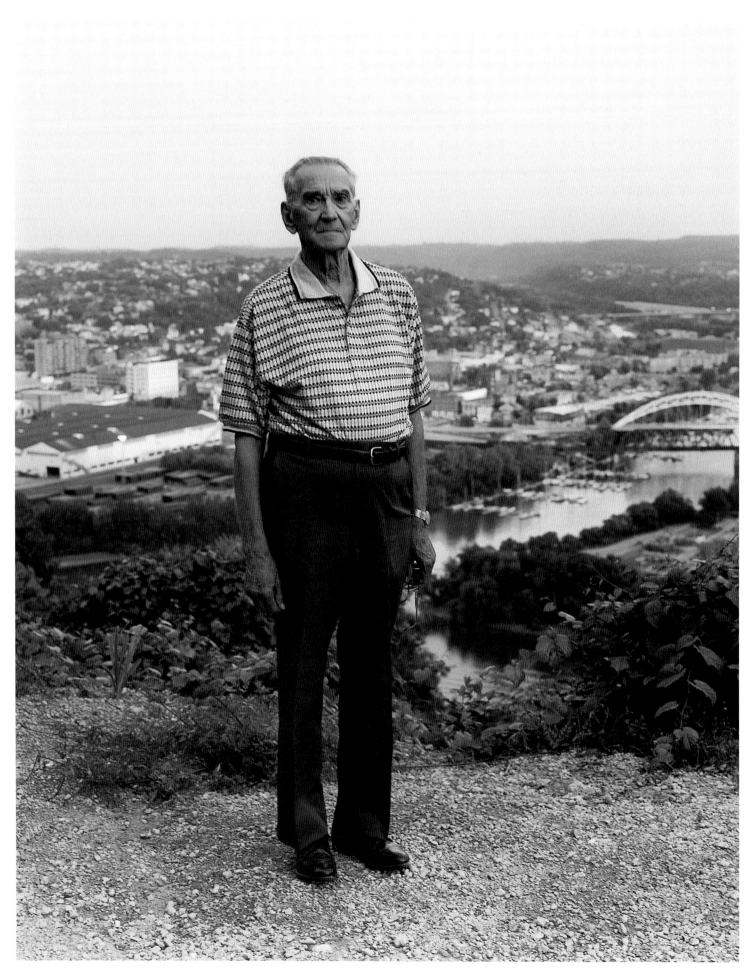

Leonard Fleming *Steel Valley, Pennsylvania 1999*

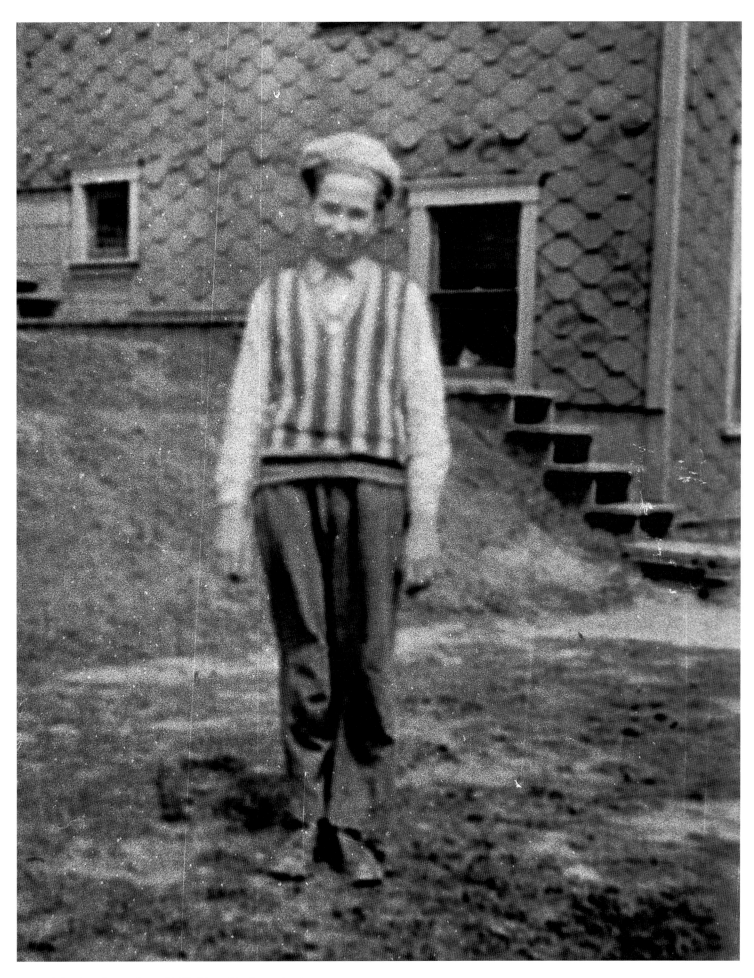

Leonard Fleming *Harvey Street, Mifflin Township, Pennsylvania 1930*

 Leonard Fleming

Steel Valley, Pennsylvania 1999

Mifflin Township, Pennsylvania 1930

 Henry Louis Gates Jr.

New York City 2000

Piedmont, West Virginia 1957

I started in the mill as a messenger boy, carrying sheets around. I started to work at U.S. Steel in October 1936. From rolling order clerk, I went to assistant head clerk, then to mill foreman at the 32-inch mill. I came back up into the 42-inch mill about a year later. We rolled material, tank armor, we rolled stainless, we rolled alloy, we rolled from 10 to 48 inches wide. We rolled from quarter to 15 inches thick, a base plate for the girders on the bridges. We rolled single-length plates that would take four flat cars to load. My job was to keep the mill rolling, the foreman job. I scheduled the men, for vacation and also their turns. We rolled for the space shuttle, but we rolled more for bridge work and for railroad cars, because our edges were smooth, they weren't sheared. I was mill foreman for twenty-some years. I worked for forty-two years, until 1978, and the 48-inch mill shut down in 1979. I saw the growth and the change. I saw Lindbergh after he flew across the ocean.

In the Homestead area, the steel valley was a meeting place. Saturday night, if you didn't keep moving on the sidewalk, people would push you, it was so crowded. Sunday, the churches were filled. The payday in the mill was the boom for the merchants. Some of the women would meet their husband at the pay-line, because if she didn't meet him down there, there would be no money. They would wait for their husbands to come out of the mill with that guilt and it was sad, but that's the way some people live. When they started to tear the mill down, it was just like someone had taken a part of your life away. It was a different thing altogether, you didn't have a payday. You didn't know where you were going to work. It was a sad thing to see the mill being torn down, little bit by little bit, by little bit.

When we were growing up, America meant America. Whenever there was a parade, your flag was out, but you could see the change coming. I saw it in the mill. People didn't like to be told what to do. They wanted to do what they wanted to do. And you can't let this guy do something and that guy can't do it. In the mill, I treated everyone the same. If they did their job, fine!

Where I live now, it was mostly farms. My dad dug coal in this area. My grandfather was born here in 1846, he was eighteen when he went into the Civil War for the North. I have his discharge papers. That to me is history. The picture was taken in 1930, when I was fourteen. If you don't have photographs and books, you don't have history. It's just all word of mouth.

I was in the second grade, which means that I was seven years old, and it was a time of great security and nourishment for me. There were two dominant women in my life. My mother, who I loved like life itself and who loved me like that. And my second-grade teacher, Mrs. Mellor. When I think of the pivotal educational experiences I've had, no single one shaped me more profoundly than the experience with this woman in the second grade. I was made to feel I had intellectual gifts and promise.

The experience with my mother was continuous. Every day I'd go to school, my mother would make me the same breakfast. She would fry ham, lean ham she grilled, with cheese on toast. Then she would squeeze fresh orange juice. Every day I would eat that breakfast and I'd walk to school. I would leave one womb and walk into another womb, and the womb was school. After that marvelous year in many ways the life I've lived since became inevitable. I felt that was the year of my programing or at least when I became aware of my intellectual programing. I will recall that as the happiest year of my life without a doubt: the Year of Little Rock 1957.

I always liked "Cowboys and Indians." I used to get toy guns—I had a huge collection of derringers. I would go to school and wear one strapped to my leg, some days. I had a cowboy hat to wear with this shirt in the photograph. I grew up in the country where we got real guns. When you turned twelve you got a shotgun. My outlook on life hasn't changed. This little boy in the photograph is an optimist and this little boy here is an optimist. Basically I am a happy, upbeat, energetic person—I am the same person that I was right then. I've been to a few more places, but I am basically the same person without a doubt.

There has never been a time of greater opportunity for all people in America than right now—it's wide open. Any immigrant understands this, it's just like the Wild West. If you can think of it, work hard enough and are willing to defer gratification, which is important, you can do well. Of course it's got racism, sexism and all that, but this system is the most open system for intellectual potential and for energy. Many Haitians came here ten years ago, basically swam on planks. They didn't speak any English. Now they own their taxis, their own duplexes, they rent out one half, their kids are going to Harvard. It's great. They just figured out the system. I like that. It's not going to happen in Switzerland or Germany. It's too hard to make it in those places. In 1957, despite the fact that the objective reality suggested that our potential was limited by racism,

we were not made to feel that way by our parents. We were taught if we were ten times smarter than white people—it was always ten, you got to be ten times better than the white boy—we could make it. I said okay, if that's what it took, that's what it took. As Cornel West put it once, it was completely absurd for our parents to believe in the American system the way they did. Yet they made us believe that we could absolutely make it—isn't that amazing? So we worked. I didn't go to bed and think of white racists. I went to bed thinking about Mrs. Mellor, how I was going to answer all the questions the next day, raise my hand instantly and go right to the top—it's very interesting to me.

Today there is less objective racism than there was then, but in a much larger black middle class than we could ever dream of back then. There is more of a class split within the African American community. We have the largest black middle class we ever had in our history, but the percentage of black children who live at or beneath the poverty line is almost the same as it was the day Dr. King was killed and that is a big difference. That means there are two Black Americas, one rich—one poor, one comfortable—one not. Nothing in this world prepared us for this because we all thought we were all one class—and it was black. It's like a figure of speech called synesthesia. If someone says, you heard her, you ain't blind, that's a synesthesia when you mix up two senses. This is sort of the intellectual equivalent. We are all in one economic class—black. In a way it was true because under *de jure* segregation it didn't matter if you were a black Harvard graduate or a black maid—you still couldn't go to the Hilton Hotel, you couldn't go to the restaurants, you couldn't even go to a little diner, you couldn't pee, you couldn't drink water out of a fountain. Now the class differentiations are unbridled and that is very different.

I studied photography in my junior year at Yale. It was one of the two most important courses I took as a university student. The instructor's name was Tom Brown. What I learned was how to manipulate shades of gray on a piece of photographic paper, a piece of film. We learned the "zone system" by Ansel Adams and Minor White. This is not a photograph of this cute little boy, it's a photograph that reasonably well registers its subject in a sufficient number of zones. I learned how to see formally—one of the most important things that ever happened to me. You would have an assignment and put your best three up. You just had to stand up there and be quiet and then they would tear you apart. I put my first pictures up and they were beautiful—smoking. The instructor said to me, "Why don't you tell us what you think the subject of your photographs is?" and I said, "This is a poor black man who is a janitor being exploited by Yale University, working over in the post office." He said, "No, this is a photograph where you have ab-

solutely no detail in your dark zones and all your whites are bleached out." How cruel. Did I not so graphically depict this beautiful, kind face and unbroken spirit within the context of economic exploitation? I thought about that. I could quit the class or I could learn the zone system, so I learned the zone system. You have to master your medium before you can make a contribution to your people or your politics or whatever your particular agenda. There is an element of art that has nothing to do with anything except technique and craft. I learned in photography that a work of art or a text can create meaning in an infinite variety of ways and its ostensible content, while interesting, might not be the most interesting thing about it. There is manifest and latent content, like Freud. I became a formalist when I finally understood that. Form does signify, form is content. It's not all the content, but its message and you can't separate form and content. Shoot a photograph and develop it—you understood on some level that they are inseparable. My janitor doesn't exist outside of how I represented him on a sheet of paper that's got nine shades of gray. That's fascinating to me, that's brilliant, it's amazing. I got the worst grade I ever got in my life. At Yale I did very well and I graduated with all kinds of honors, but everybody in the class got a C—it was the best C I ever had.

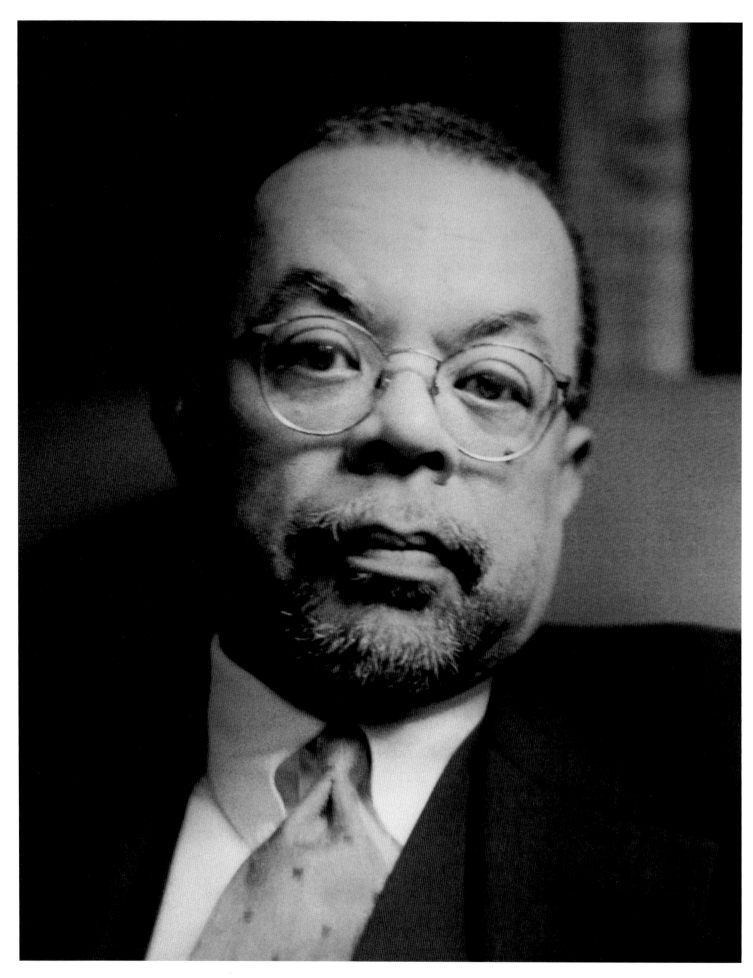

Henry Louis Gates Jr. *Harvard Club, New York City* 2000

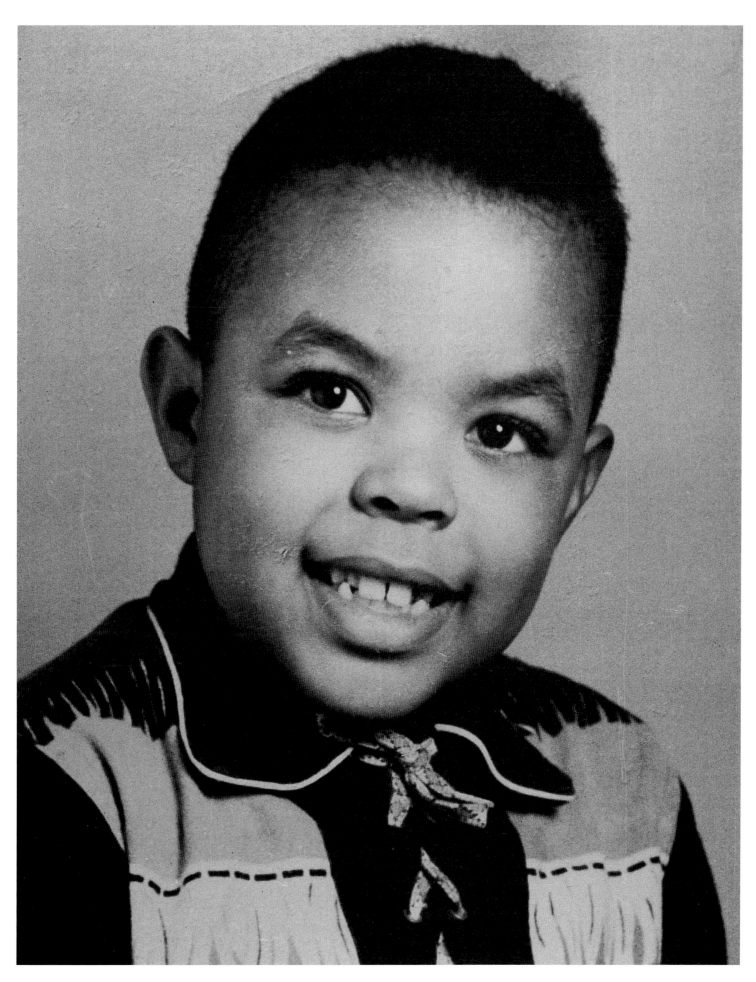

Henry Louis Gates Jr. *Piedmont, West Virginia 1957*

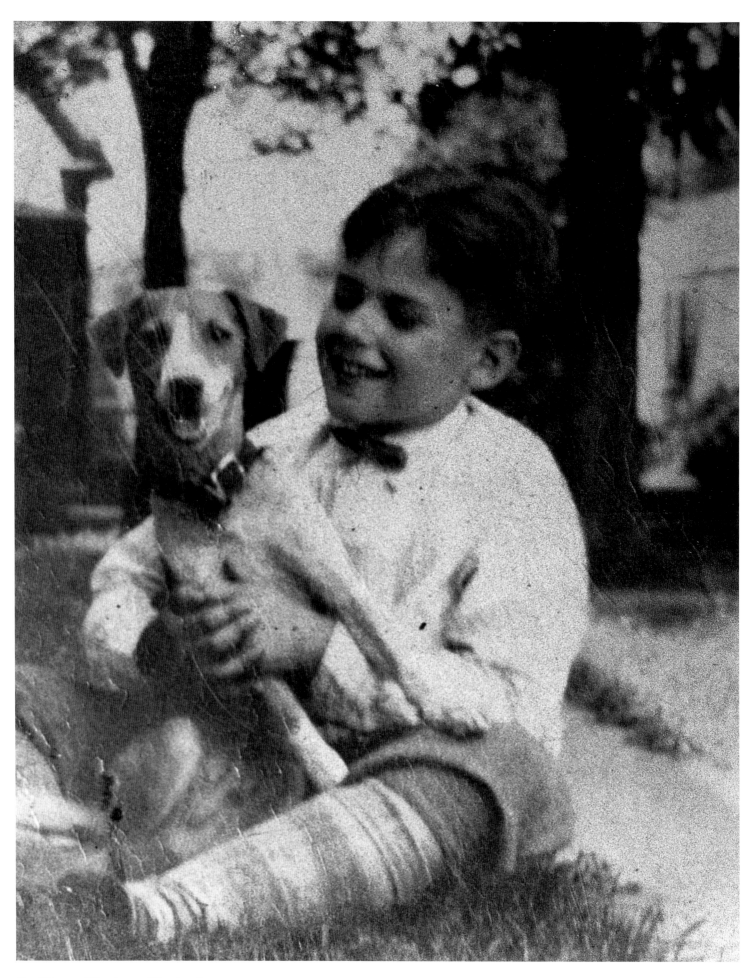

Carol Kenagy *Riber Avenue, Waterloo, Iowa 1924*

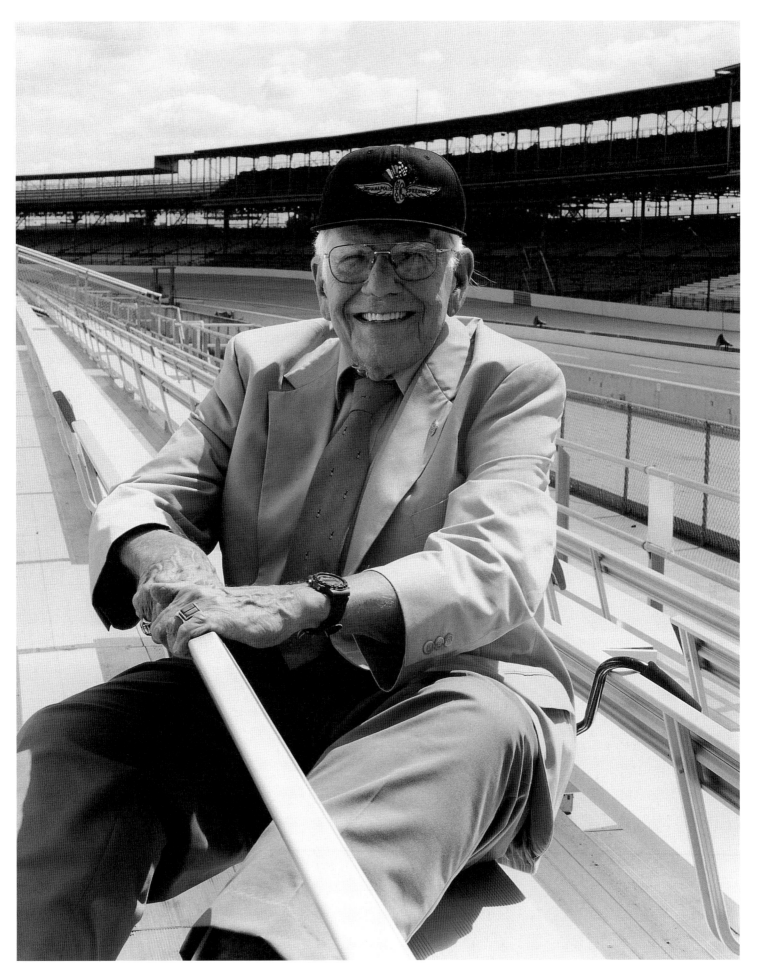

Carol Kenagy *Indianapolis Speedway Race Track, Indiana 1999*

Carol Kenagy

Waterloo, Iowa 1924
Indianapolis, Indiana 1999

I have two names. Tom Carnegie, that's a professional name, but I was born Carol Kenagy in Norwich, Connecticut. I started first grade in Waterloo, Iowa and that's when I really got interested in radio. I would listen to President Reagan, he was doing baseball games on a radio station in Des Moines, Iowa and that's how he got his start. I so admired the way he described baseball games and that's really what put the thought of doing something with my voice. My father, being a Baptist minister, did a lot of public speaking. He encouraged it and so that's how I got started.

I have been the official announcer of the 500-mile race for more than fifty years. For some thirty-odd years I was sports director of a television and radio station in Indianapolis and so I worked in the early days of television. When we had a picture of a race driver in that era it was an 8 x 10 black and white photograph that we'd put on a card and take a picture of it and show it. I was part of the station that televised the first 500-mile race in 1949, I was part of the master of ceremonies for the first national telecast when Bill Vukovich won the race and appeared that night on NBC. I did a half-hour show on the great Jim Clark of England called *The Flying Scott*. Pictures played a very important part in my life, it's really been my life's work. Words and then eventually pictures and the recording of them. As you look back on it you wish you'd saved more. You are in history, but you don't really realize it, you are living it, you don't realize its importance at the time.

That photograph was probably 1924 or '25, I was five or six years old, starting in the first grade in school at Waterloo, Iowa. I always remember Tippy Neo, that was my first dog. The picture was taken at the side of the house where we lived, looking across the street. My dad and I used to play catch in that area and I envisioned myself as someday being a baseball player and being a catcher. I love baseball and still do. At that time in my life I kept rabbits in the backyard and they were called Amos and Andy after the popular radio series at that time. It was simply a matter of growing up, doing as well as you could in school, getting bigger and doing the things we loved to do. The grocers delivered then and I thought that would be a pretty good, fun thing to do. These fellows who did this were a little older than I was, so you look up to older boys.

The first money I earned came about three or four years after that picture was taken when I started delivering the *Saturday Evening Post*. I did a lot of speech work, extemporaneous speaking, debate, oratory throughout my high school and college years. So when I graduated from college, I went back to what I thought about years ago when that picture was taken and that was radio. I accepted a job in Fort Wayne and three years later came to Indianapolis when World War II ended and the 500-mile race started in 1946. Wilbur Shaw, three-time winner of the race, who was general manager and Tony Halman, who bought the track, heard me do some work. I felt it was ten years before I really was adequate in my knowledge of the event and what it is and what it means and the equipment involved and the people involved before I could speak with any assurance. No matter where you go in the world, the Indianapolis 500 has a great reputation, sort of like the Kentucky Derby in horse racing. It's the winner in Indianapolis who becomes a world celebrity, like Mario Andretti did because of his early victory at a young age. I love announcing the race. I am still excited about the race. I look forward every year to the competition, when they head into that first turn in a field of thirty-three with 500 miles to go, the hair on the back of my neck still stand up. I'd like to work it, as long as I can do a credible job, and not make mistakes. It's a fabulous event and if you can visualize some four hundred thousand people gathered around this two-and-a-half-mile oval and standing at attention for our national anthem and waiting for the command, "Gentlemen, start your engines!" You get some idea of the picture of it. There is nothing I like more than the singing of the national anthem at a sport's event and especially the 500-mile race where it's done so beautifully year after year.

I have a great feeling in my heart for the United States of America, the pledge of allegiance, the flag and all it represents. We had freedoms and a government that was interested in us, caring and considerate for the most part.

 Dave Jones

New York City 1997
Detroit, Michigan ca. 1969

I was about three years old. This is my grandparent's house in Detroit in about 1969. Maybe my mother took it. You know how parents are, they like taking pictures of their children so that's probably what she was doing. I would imagine one of my aunts is standing behind me. It's probably my Aunt Mary. I think the hat belonged to my mother. My mom used to go to work and when she would come home I would put her stuff on. She had these boots, and whenever she came home and took them off, I would put them on and walk around the house. It was just so funny. She even has some pictures of me in the boots.

When you are two or three years old you don't have too many cares, do you? You are just being a kid that age. I remember playing with the son of my uncle who is six years older. I was the baby of the family at the time so it was a lot of fun. Good memories, that's what I have about it. Some things change and some things don't. Relationships with people are still important, having good times with your friends is still important. An important thing that has changed is maybe dependency on other people. I am not at home any more, I am going for myself. The reason I left Detroit was just that I needed a change of pace, a change of people, a change of scenery. One thing I learned in Detroit; if you choose friends and have relationships with people, you have to choose them carefully.

I can't really say America changed a lot. Going from a teenager to an adult what you learn—especially being black—is what a prejudiced country this is. As a teenager I didn't really know because most of my classmates in Detroit were black. When you go into the workforce you are not necessarily dealing with all black people, sometimes even more white people depending on what you are doing. In spite of all the strides we are supposed to have made as a race of people in this country you learn it's a long way to go. A lot of times as a race we are stereotyped the wrong way. We've been hated by a lot of the Europeans, a lot of the Americans, sometimes it seems even by foreigners that come into the country. Back at home in Detroit it was Arabs. In New York I can't really say, but it just seems a lot of times there is bad blood between people. We have a bad reputation in this country. You know people associate us with being gang members all the time, or drug addicts—it's crazy. But that's what I've learned and that's what I fought over the past years. I see things for what they are and it's not always a pretty picture.

I am in the airline business and I like my job, I like what I do. Living here in New York is a different experience. I have no set routine other than work and then you take it as it comes, you do what you want to do. Many weekends I leave town. I remember being a child and people teasing me a lot because I was close to my mother. I can kind of understand, and I guess being a boy, but I didn't grow up with a father so my mother was all I had as a child. I have had disagreements with my mother and it was because of some of these why I left home, but my mother is still important to me. I try to go back at least once a month and see how she is doing and how my sister is doing because it's really all the family I have left. I find that aspect of life very important maybe because I have such a small one. A lot of the relatives I had died recently. I guess recently I've tried to be a bit more self-confident, because people can make you feel bad about yourself. You can't always worry about what other people think, you have to do what is best for you and I am starting to act on it. It's not that you are selfish, you have to look after yourself, because if you don't, who will.

Friends and family are the biggest things that carry over from childhood to now. My mother taught me—that's one reason why I travel—that as a race we are not alone in the world, as a country we are not alone in the world. I still find that important. I like to make friends with other people and see what their lifestyles are because we can learn from each other. I have gone to places and learned from people and I like to think sometimes that they have learned something from me. What you hope to do changes; honestly, as a little boy I wanted to be a garbage man. I used to go out into the alley when the garbage men came by and liked to watch them operate the truck. That looks like something that is fun. You get older, you say—not that you are turning your nose on them because I do think they are making good money—but to me there is more to life than doing that.

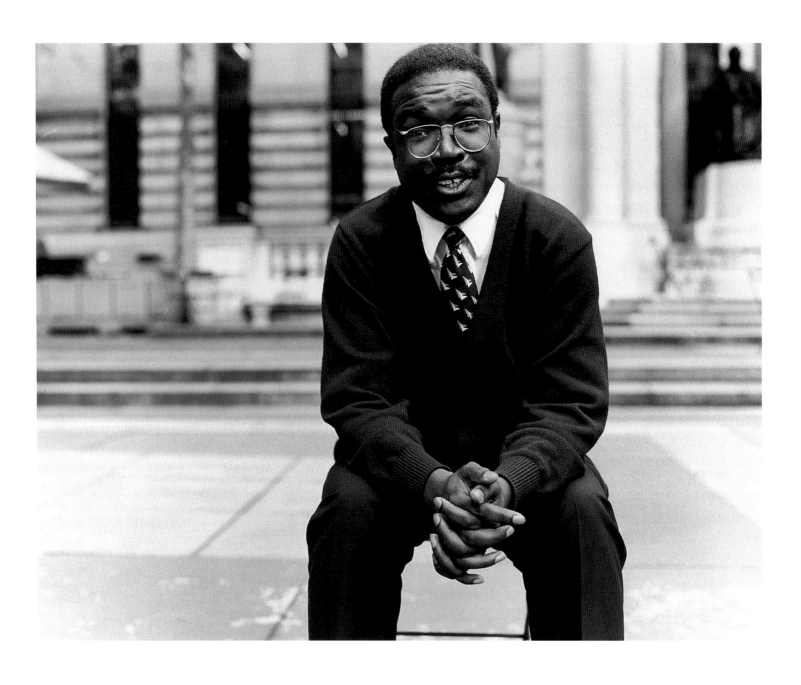

Dave Jones *Bryant Park, New York City 1997*

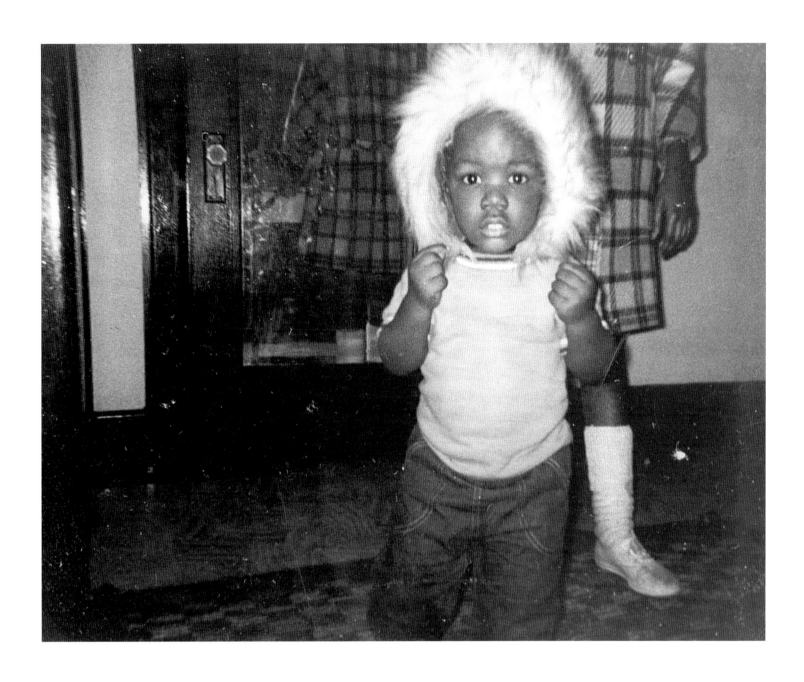

Dave Jones *Detroit, Michigan ca. 1969*

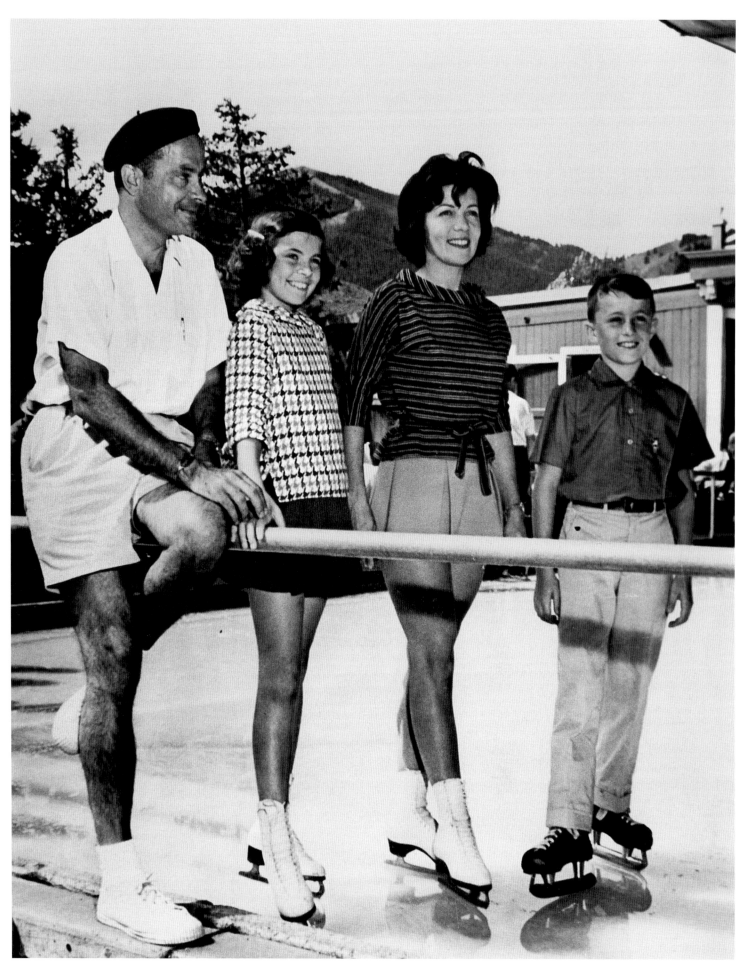

Nadine Strossen *Sun Valley, Idaho 1961*

Nadine Strossen *Riverside Drive, New York City 1999*

 Nadine Strossen

Sun Valley, Idaho 1961
New York City 1999

America and civil liberties dominate my life now and always have, as far back as I can remember. I had the basic concepts of individual freedom and human dignity even before I had the terminology to describe them—let alone the tools to defend them. I remember being outraged at every kind of injustice that came to my attention. I remember at an early age seeing a television show about racial discrimination. Minnesota, where I grew up, is mostly Scandinavian and German, so I wasn't that conscious of other races. It was also a very tolerant, liberal community which is easy to be when you're very homogeneous. I was really shocked and upset. I still remember crying in front of the TV, vowing to myself, I'll dedicate my life to doing something about this. It was really part of a larger sense of injustice. I was always conscious of when my own rights were being violated too. I didn't understand so many rules at school, not letting me talk—censorship, looking in my desk—violating my privacy I would say now. Teachers discriminating in favor of some students, against others—all this always struck me as wrong. The next stage was when I learned that you could write. I wrote my first letter to a senator when I was eight years old and my first letter to the newspaper when I was twelve years old. I started standing up for rights in little ways within my own school.

When I was in high school I was a debater and we had a very active, successful debate team, we were constantly winning the state championship. One year we had a debate topic that was a legal issue. So I started going to the University of Minnesota law school library to do research. I was just fascinated by the issues, but it never occurred to me that I could be a lawyer. In fairness to myself I didn't know any professional women at all—that just wasn't done in the '50s and early '60s in Minnesota. To cut a long story short—I went off to Harvard College and immediately got involved in the reproductive freedom cause. Abortion was then completely illegal all over the United States. I got involved in the movement to overturn the anti-abortion laws but that was always part of the overall civil liberties issues that were important to me, basic human freedom. We use "freedom of choice" as a slogan for abortion rights, but for me it also sums up all human rights. It was a cliché at the time among student activists that law is a tool of social and political reform—justice. The truth is that it really has been throughout this century and throughout my life. Every time I see an outrage now, I don't just cry the way I did when I was a kid. I really can do something about it and it's the most exhilarating, empowering, exciting experience. Our organization can do a tremendous amount but we cannot do anything if there are not individuals who are will-

ing to stand up for their rights. Those people—our clients—are the real heroes and heroines. It's one thing for a lawyer to go to court as a professional, but for a non-professional, ordinary citizen to stand up for rights and against the government and the community, to take the risk of being isolated at best, attacked at worst, that never ceases to inspire and amaze me.

I have been very involved in the international human rights movement. I was on the executive committee of Human Rights Watch before I became President of the American Civil Liberties Union. On the whole I would say rights are more strongly protected in the United States than anywhere else. There are obviously huge exceptions—anything to do with criminal justice or the death penalty, we are off the charts. We are the most punitive, retrograde country in the "civilized" world, executing people and incarcerating them for life and treating juveniles like adults—it's insane. But I have been to many repressive countries where the overall human rights situation is far worse. One summer I participated in a mission to the Philippines because half a dozen human rights lawyers had recently been assassinated even though Aquino was in power—at best, the government didn't provide protection for them; at worst, there were allegations that at least some factions of the military or government were actually behind some of the attacks on these lawyers. In the U.S., the "sacrifices" made by human rights lawyers are that we don't make as much money or we get criticized in the press—how does that possibly compare to government-sanctioned assassination? I truly believe the reason that things are better here is because of the constant agitation by civil rights organizations. So I do think the most effective use of my time and skills is to continue that work right here in the U.S. As Thomas Jefferson said, "Eternal vigilance is the price of liberty." So I am never going to be out of things to do. We have a lot of success, which is encouraging, and a lot of wonderful allies. In human terms as well as professional terms it's just been an incredibly satisfying life.

I give my parents a lot of credit. My mother was a traditional housewife. She was very bright and her father was from the old world and very conservative in his social views—girls don't go to college. My father wanted to be a doctor, but being what Hitler called a "half Jew" living in Berlin, he was pulled out of medical school and put in the forced labor camp at Buchenwald. He came to this country when he was liberated by Americans. He had to earn a living. He was sending money to his family back in Germany. So both of them were people who were deprived of educational opportunities because of violations of their human rights—my father because of his Jewish background and my mother because she was a female.

The photograph was taken in 1961 in Sun Valley, Idaho. When I was a child, my mother started figure skating and became quite a good ice dancer. Since we lived in Minnesota, my brother was of course a hockey player, so there he is with his hockey skates. I wanted to do nothing but read. My mother said, "No, you've got to have some physical activity," so she got me started on skating. I fell in love with skating and wanted to be a competitive figure skater or even in the Ice Follies. Then my mother decided that I was getting too much into skating and pulled me back from that because, "No, you are going to college." Nobody is perfect. My parents affirmatively inspired my civil libertarian commitment in some ways, but they also inspired me negatively by restricting my freedom of choice in some ways. I like this photograph because it was a very happy family vacation. I was extremely close to my father. I like this picture because he is tickling my hand, helping to make me smile. It was as with all families, some strife and problems, but also happy moments. This photograph captured the best of family life, a moment where, I think, we were at our happiest as individuals and also together.

I became interested in art when I went to college. My college boyfriend for a number of years took up photography. He studied with Minor White, Ansel Adams and a famous French portraitist who recently died. I spent a lot of time with him, not only looking at photographs that had been taken by other people, but also looking at his proofs. I felt blind in comparison to him. What I really miss is the gift he had in going out into the world and really seeing what's there. He'd show me what he saw, and it was like veils pulled off from over my eyes. I have this humble sense of seeing through a glass darkly compared to photographers or other visual artists. I know there are other things that I see that other people don't. So we all have different senses of sight or insight. But, thanks to those personal experiences, I have a real respect for photography and I love portraits the most.

Alice Sup

Omaha, Nebraska 1967
Ogallala, Nebraska 1996

I am Alice Sup. My husband Ray and I own and operate the Midwest Motel in Ogallala, Nebraska. This childhood photograph was taken at the Sears store in Omaha, Nebraska. My mother had yearly photos taken of us, my brother and sisters and I, and placed them on a wall in our home, where we enjoyed seeing how we changed over time.

When I was a child I enjoyed a warm home, plenty to eat, three TV channels that ended at midnight, summer vacations, school sports, motor and bicycling, playing piano and stereos, and my own car at sixteen. I'd dreamed of being a horse owner, a motocross racer, a professional musician, an actress or a high school coach for girls sports. After high school I attended two months of college towards music training, but lacked the enthusiasm to continue. I also twice owned a horse. My dreams were not laced with "what it takes to get there!" After trying a variety of occupations I met my husband Ray and ventured to work on their family hog farm in Albion, Nebraska. We soon married and began our family of three girls, Halley, Rudi and Markie. When Markie was born, we moved to Ogallala, Nebraska opening the Midwest Motel.

Even though I've not done all those things I dreamed about, my desires have been filled and my dreams have a changed perspective.

As a child, America meant the stars and stripes of our flag, the pledge of allegiance quoted daily at school and every Fourth of July celebrated at Grandpa and Grandma Olson's farm, with family and friends, food and fireworks. These reminders did not mean much until I was older. Now I also see our freedoms threatened, too many taxes, overpaid politicians, loss of moral values, excessive greed by all, and lack of truth spoken when it hurts. But grace, love and mercy still abound, love thy neighbor as thyself still works and I believe God still knows best. In that, I can still find that same heart of a child in myself and others.

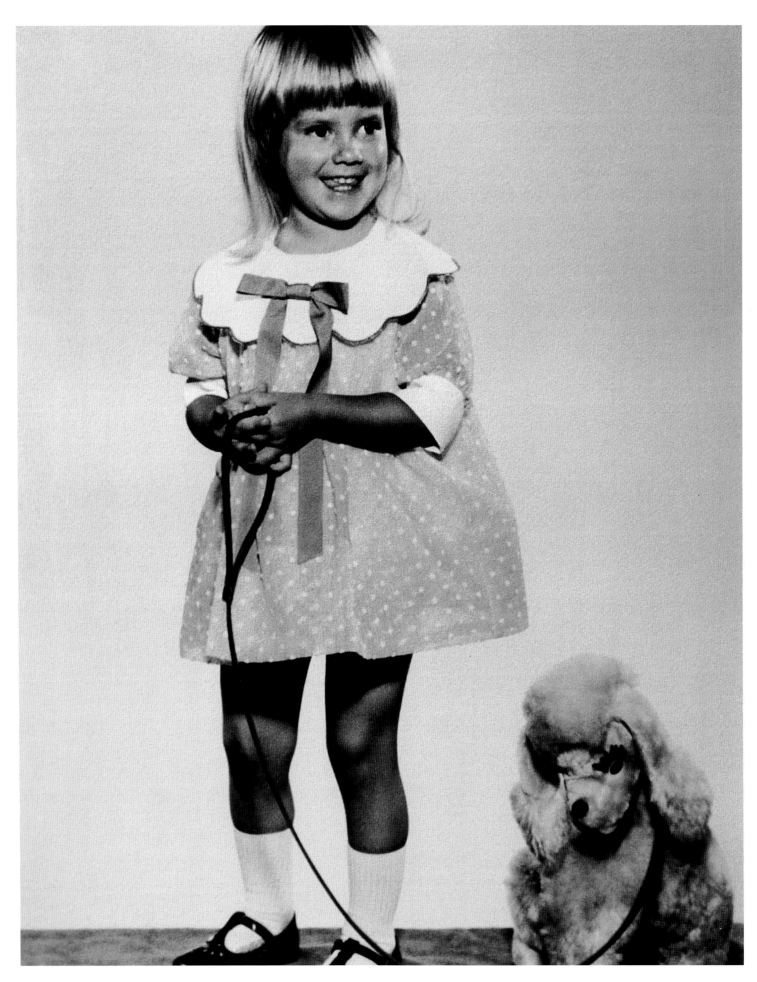

Alice Essink *Omaha, Nebraska 1967*

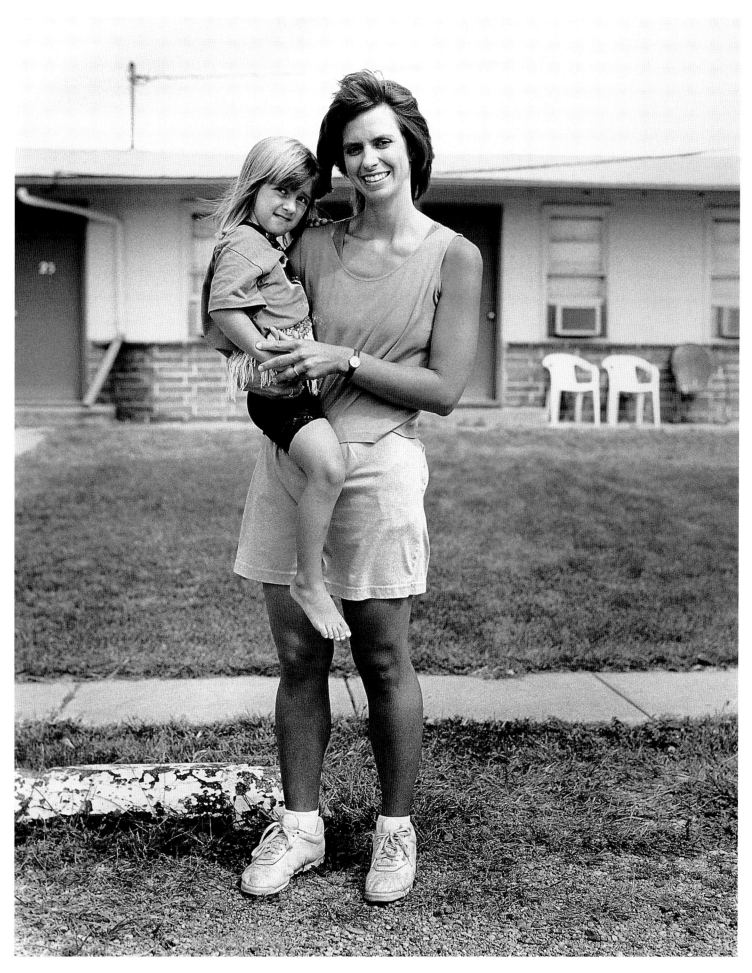

Alice Sup (born Essink) *Midwest Motel, Ogallala, Nebraska 1996*

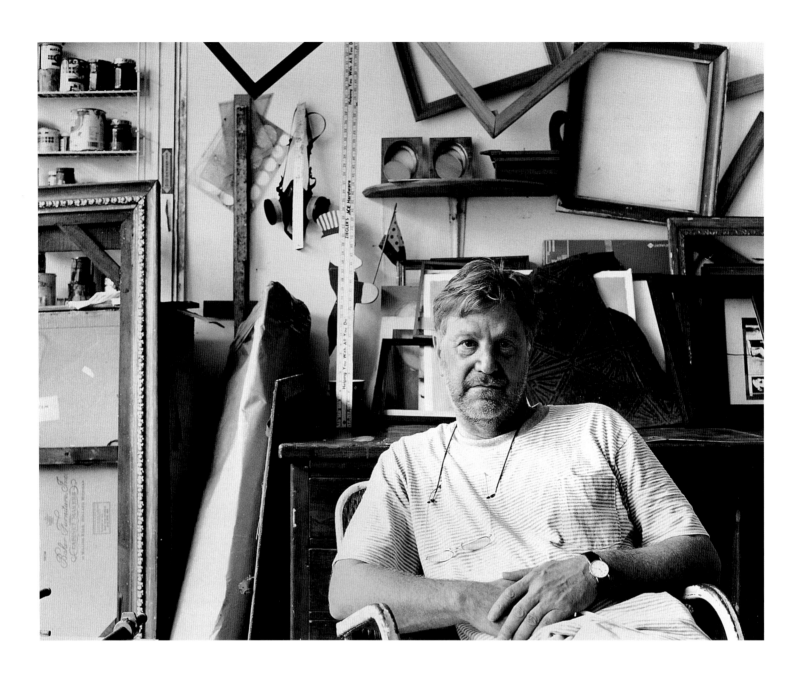

Charles Traub *New York City 1996*

Charles Traub *Louisville, Kentucky 1951*

 Charles Traub

New York City 1996
Louisville, Kentucky 1951

The question of how anyone understands his childhood is predicated upon an always changing perspective because one's memory is faulty and our childhood is so complicated, particularly seen with the layers of knowledge we gain in retrospect. There are good and bad things and a great deal of gray. People tend to make their childhood into myths because they haven't a clue what it was all about. If you are a mature serious person you will spend a good deal of your adult life analyzing how you grew up.

The family picture was taken when I was about four years old. It is an ideal looking picture of a lovely American family. My mother is quite beautiful surrounded by three happy children but she also seems protective of some unknown vulnerability. My sister, attractive and confident, doesn't reveal the tragedy of her weight problem that in later years would cause diabetes and kill her. My brother today is still very much the dreamer he appears to be in the picture. He fantasizes a construct of a world he is unable to build as an architect. And me in the Eton suit. How cute and uncaring; safe with my mother's touch from my future fears. We look happy and connected? But where is my father? Psychologically this is disturbing even though I know the picture was made for him as a birthday present to put on his desk. A family picture without a whole family? My father indeed was often missing from my life. He was a doctor busy at work and aloof from the daily activities of our household. Prophetically he would die young and I would grow up feeling I hardly knew him. Though I was quite young I remember the situation clearly; my first encounter with professional photography—a very exciting and formative moment—one of my first vivid memories. The photographer was very grand and personable. He allowed me to look through the camera glass upside down and under the dark cloth. He showed me the darkroom and the childhood wonder never left me. What a great experience loaded with history, meaning and memories all wrapped up in one object—a symbolic gift for an absent father whose presence is latent in the image and the memory of my experience.

As I reflect, my childhood was as nice as any American could have. The house I grew up in was similar to the Ozzie and Harriet house of '50s TV. Inevitably every family has its difficulties, but out of them also comes its uniqueness. Our distinction was that we were Jewish in a city that did not have many Jews and we were also unusual in our Jewish heritage. Our relatives settled in Kentucky in the 1830s, so we were an established part of the community and not really identified as Jews, yet we were outsiders in this Southern city. We were caught in a role of compromise required to balance our political, social and historic identities in the rift between North and South, Jew and Gentile, small town and big city aspirations.

Raised as a liberal in a neighborhood of conservative Republicans, I had beliefs and freedoms that my friends did not necessarily share. I felt that Louisville was a provincial place that I had to break from by doing something special but I had no idea what that would be. I grew up with learning disabilities. Sadly, in the first grade I was sent home because my teacher thought I was retarded. Fortunately for me, my father knew differently and I was tutored. Nevertheless, I felt great trauma and emotional confusion over the fact that I could not perform as well as other kids. I knew I was bright, had a great sensitivity and the kind of presentation of self that had power. I stressed over what I would become.

The '50s and the media that grew to power at that time formulated my ideal of America. My father, like so many, came back from World War II and created a good life for his family. Though he made us mindful of our privilege in his concern for the human condition, he shared little of his own personal struggles. I remember being proud of him and of being an American living the way we did. After all, my Middle American life was quite different from the experience of most people in the world. Every few years in our neighborhood people got new cars. As children we looked to the future with a sense that everything would be better in the following year. And in fact it usually was! Technology wrought new wonders in all the conveniences that made for the postwar suburban American dream we were living. Despite our good fortune my understanding of the world was not sheltered; the media revealed a less privileged life in the chronicles of the Civil Rights movement and we learned to be involved. I saw a lot of racism and experienced anti-Semitism, but I was proud that Louisville created a model for desegregation in America. I was in grade school when the Sputnik crisis shook every American's worldview. Why were we behind? Was our educational system good enough to compete in the world? With my learning disability I felt way behind—afraid! The well-being that prevailed throughout America in families like mine completely gave way when President Kennedy was shot. The bubble burst! Our innocence was violated! With the turmoil of the Civil Rights movement and the Vietnam War, our government became suspect and my generation and I retreated from the odyssey we had thought made our country so great.

Today I share the dissolution that most of my generation felt in not being able to fulfill the promise of our fathers. Despite the fact we have a long way to go, I think the Civil Rights movement was immensely successful. The plight of the disenfranchised of the '50s is

significantly better because of it. We don't have leaders committed to the truth and excellence. However, I see the power of the American democratic energy in the multicultural mix that now drives us and the new technology that allows us to communicate our creative selves. Such is my image of my American life. Each of us learns in our own way through how we decipher mediated experience. I turned away from the word because of my inability to concentrate on the written page. I learned to love illustrated magazines and books and my critical understanding was as much formed by the picture as the word, allowing me to reach a diverse world from that of the confines of my middle America.

My father left another important photographic legacy with me. When I was a child we frequently went on long auto trips to visit my father's mother in central Illinois. I would complain about how ugly the central plain looked as compared to my beautiful Kentucky with its rolling hills. He'd say: "You just can't see it, the beauty is in the horizon, in the place distant where the earth meets the sky." Many years later I went to university in that state. My father had died leaving me a Leica so I decided to take a photography elective to learn how to use it. I had never taken an art course before! When I went to the art building to register, I noticed hanging there a long narrow black-and-white photograph of the Illinois horizon such as I had never seen before. It was by Art Sinsabaugh who would be my first photography teacher. The image captured the vision my father had implanted in my head—I finally understood what he had loved about his native landscape, what seeing was about. I experienced the power of photography to be expressive. That single picture ironically connected everything about my missing father, his heritage and my future as a photographer. In course of time I became a photographer and a teacher. My whole life now is involved in making art; trying to define the possibilities of photographic vision and helping students to engage it as meaningfully as I had. It is a most powerful matrix for understanding our culture, civilization and us. Optical observation and capture is the primary form of representation effecting everyone in the twenty-first century.

Mike Murray

Starvation State Park, Utah 1996

Baltimore, Maryland 1959

I am Mike Murray, a park ranger here at Starvation State Park in Utah. I've been a park ranger for about five years and I have been living here in Utah for about twenty years. In the picture, when I was a child, I can see that I didn't have much worries and my family took care of most of the things that needed to be taken care of, and the world seemed like a real nice place. It is still a real nice place out here in Utah. I see all different kinds of people and I know that it's not a rosy image of everything. I see a lot of good people and I see bad people, too. What's probably changed the most is realizing that not everybody is good all the time, but most of the people that I meet are friendly and they go out of their way to help you out.

America stood for freedom and for being able to live our life how we wanted to and to me it still means that right now. I love being outdoors and I love working with people—that's the kind of job I wanted to get and that's the kind of job I got. I think pretty much anything you want to do in America you can try and do it and most of the time you get through and do it.

Pictures really played a big part in my life because at a young age, at eleven, my dad died, so the only time I can remember his images is from pictures, even from young, because when you look back through pictures and things you can remember. A lot of the times when you are younger you focus on how it is and can look back and still remember. Today my family lives back in Pennsylvania, so pictures are important to me because I like to keep up on people and if I don't go back for a couple of years, the most I see is pictures, just to see how they are changing.

I just feel proud that I am able to live in America and have a good job and be able to support myself. This really makes me happy to be outside a lot. I like to see the scenery and I like to see happy people. To me the pictures that people take just represent a lot of good times that they've had like vacations and things. I know myself on vacations, I take a lot of pictures. I don't really tend to take them here, although it's really beautiful here I can go for a couple of months without taking pictures. Sounds crazy, but when you live here you kind of take it for granted. It's just like most of the people that live in Salt Lake don't go skiing and people from back East come skiing, it's the same type of deal.

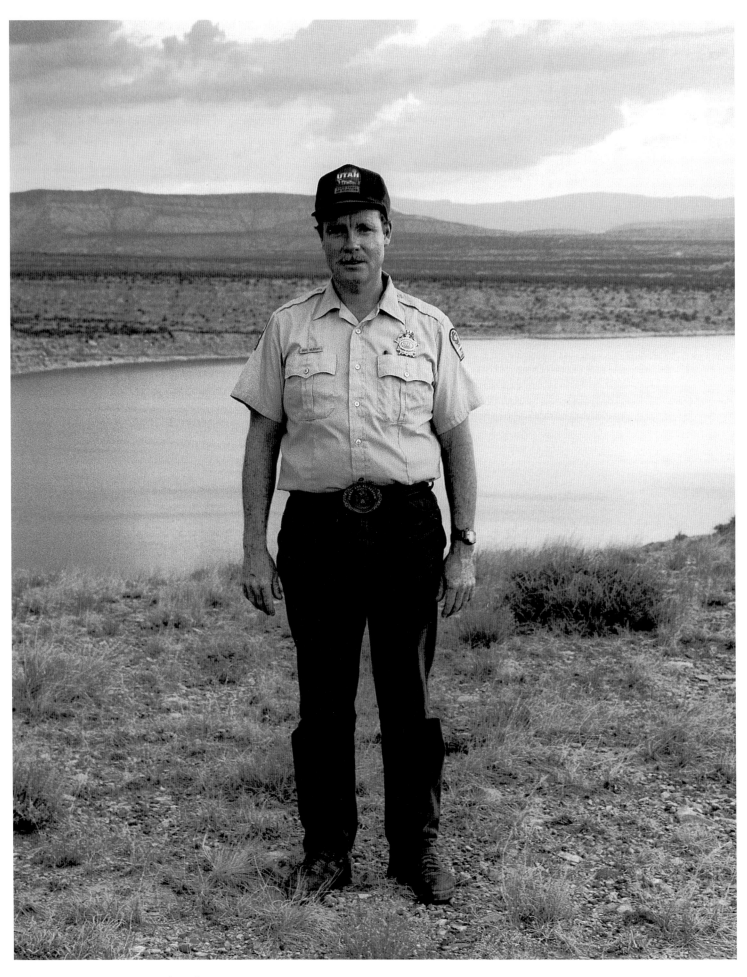

Mike Murray *Starvation State Park, Utah 1996*

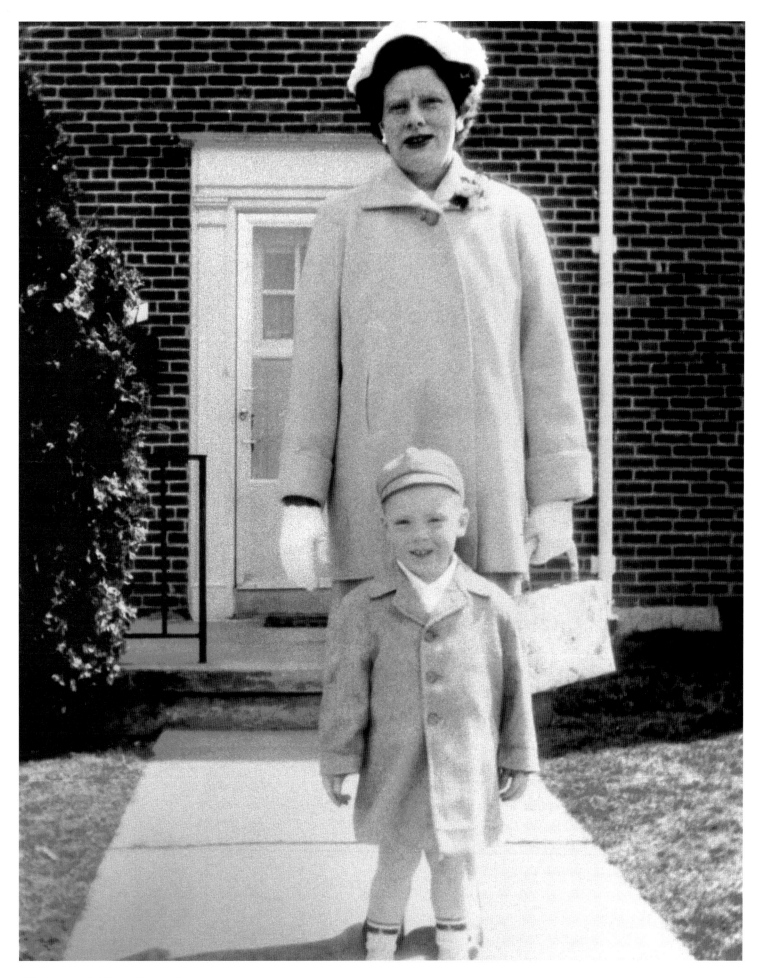

Mike Murray *Baltimore, Maryland 1959*

Melvin Fisher *Key West, Florida 1997*

Melvin Fisher *Filmore Street, Glen Park, Indiana ca. 1929*

 Melvin Fisher

Key West, Florida 1997
Glen Park, Indiana ca. 1929

My name is Mel Fisher. I'm the treasure hunter in Key West, Florida who found the "main pile" of the Atocha Spanish galleon, valued in 1985 at $400,000,000, after seventeen years of searching. I have become world-famous with millions of admirers from all walks of life. I have had thousands of people tell me I am their hero because, when the U.S. government sued me in 1974 and tried to take all of the treasure away from me, I won in the lower courts and in the appellate court and the U.S. dropped the suit. A little guy like me, who went to the Supreme Court of the United States, won, that must mean we have a pretty good system. I don't think the government has any business being in the treasure business, they should stick to government. It would sound like communism to me. I was real proud of America as a child and I knew we had a good country. And after the many years I've been traveling around the world, I think it's the best place to be. I like it here.

Finding the Atocha was a very valuable time capsule for archaeologists and historians, to know all those particular things that existed when it went down in 1622. We just brought up a papal seal. A very historic piece. The Bishop of Peru sealed the letters he wrote to the Pope. Nobody opened the Pope's mail because they wouldn't even stop in purgatory, they would go right to hell. The Nuesta Senora de Atocha is named after a saint. There is an Atocha church, avenue, several bars, restaurants and dry cleaning shops and even an Atocha railroad station in Madrid, Spain. One way of looking at it is "My Lady of Luck," and it turned out that it was bad luck for the people who were on the Atocha when it went down because probably nobody survived—and it was good luck for us because we're capturing all that history and letting everybody in the world study it. Working on the Atocha we found another, the Henrietta Marie, an English slave ship. Even though there is no treasure at all, we worked at it for eleven years and finally brought out a magnificent collection of things which we put in this traveling exhibit, a world-acclaimed piece of history of slavery in this hemisphere.

As a child I enjoyed riding my bicycle about ten miles out. There was a big river that had a lot of tributaries to Lake George. My buddy and I used to go there and swim in all those channels and rivers and lakes. We'd camp out for a couple of weeks, that were the good old days, a lot of fun. We had a boat, fishing gear, we ran out of food. We found some cows on a field to give milk, the first time I'd ever done it. Take apples off an apple tree and they were all green and wormy. We couldn't eat them, so we cooked them all night long. We were so hungry we waited until about three o'clock in the morning when they got soft enough to eat and we had apple sauce dinner. We built a diving gear helmet out of a five-gallon paint can. I sacrificed my bicycle to make the diving helmet. I had made up a couple thousand lead soldiers. I melted them all down and made my first diving helmet to keep me under water. It worked good. It's still here.

That picture was taken in Glen Park, Indiana when I was in grade school, I believe. I think it was right after I was playing a game with my buddy. He was gonna cut my hair and then I was gonna cut his hair. And when he cut my hair he cut my head, I was all bloody. So I put the hat on so you couldn't see all the scars on my head. I imagine I was about eight, maybe six. It was on 4195 Filmore Street in Glen Park. There was all old people there and now it's all black people. My mother was raising tulips in the backyard and sold them. She also had a costume rental house and a dancing school. My father worked in the park service for the city park system and also as a carpenter in the Gary steel mills. When I got out of high school, I thought I was kind of smart and educated and I had my diploma, my gown on my head and I went down to the steel mill and applied for a job. It turned out they wanted to know what my experience was and I didn't have any. So they said, okay, we give you a job. I was to work from midnight till eight in the morning and it said LAB on there and I thought I am going to be in the lab. I walked through all those huge buildings, quarry, hot metal, welding and cutting and then we stopped and he gave me a great big sledgehammer that weighed 80 pounds. And I said, "What's this for?" He says, "Oh L-A-B means labor, not laboratory." I tried very, very hard, my first time on a paid job. I guess I was about seventeen and after four hours, I absolutely could not lift that hammer again. It was so heavy, and my arms and legs were so tired, I just couldn't do it. So I decided I better go to college, went to Purdue and studied engineering and every course I took in college, I am using now to find treasure.

Joseph Medicine Crow

Little Bighorn Battlefield, Montana 1999
Lodge Grass, Montana 1917

I have known this battlefield ever since I was a little boy. At age 86, I am probably the only person with a long period of association with the battlefield. My people, the Crow Indians of Montana, call me High Bird. My English name is Joseph Medicine Crow. Joseph was given to me by a Baptist missionary. Medicine Crow is the name of my grandfather, the great Chief Medicine Crow. I've heard him tell about that 1876 campaign against the Sioux and Cheyenne around here. He didn't fight around here, but my other grandfather, White Man Runs Him, did. He was my grandmother's brother, my grand uncle, but in a Crow way we call him my grandfather. He was right here in this battle with five other Crow Indian boys, scouts for Custer. I knew them all but one. So they were with him 24 hours a day for those five days Custer was looking for the so-called hostile Sioux and Cheyenne. The Battle of the Little Bighorn is a long story full of controversies. A newspaper in Bismarck, North Dakota came out with a headline, "Custer and 264 Men Massacred." Custer came in with a lot of soldiers and fully armed, so they were not massacred, they were just defeated. When I was about ten, eleven, we would ride all over here and you could still see shoes, saddles and equipment. They are gone, long time ago.

I wrote a pageant about the battle that is based on Indian accounts. I did not try to run down Custer, because he has a lot of fans, somehow fanatics. So that pageant goes on every year in June, just fourteen miles from the battlefield, and people come from all over the world. Right now we are doing a book about what had happened to those Indian people after the battle here. I worked thirty-five years for the Bureau of Indian Affairs and since I retired in 1984, I write books, give lectures and do movies. Custer is still living out there, the mighty seventh cavalry, but everybody has forgotten about the Indians. They were placed on barren reservations where they were starving to death, contracted all kinds of modern diseases. They are still suffering in South Dakota, Pine Ridge Reservation. Sitting Bull himself escaped to Canada and stayed there a while.

I found the photograph in my mother's trunk when she passed away. I am about three with a little coat made out of a calfskin, fur on it. It's a reddish color and white, same as my cap. I wish I had kept my little outfit. I got modern shoes on. I was born in 1913; that's during World War 1. I was in World War 11. When a youngster we were using the term America quite a bit going to school. Songs about America, school books about America and everything

about America. As I grew up, this word America started to have other meanings to me. A Spaniard who came here shortly after Columbus named America, and of course the word Indian was also a misinterpretation. Columbus thought he discovered India, so they called the natives here Indians. I hate to use the word native, that implies uncivilized peoples. I don't like to use the word American Indians anymore. We call ourselves "people on earth" or "first people."

My great-grandfather came from France, his name was Pierre Chienne. Married two Crow women, had a lot of kids. My great-grandmother married a Scot by the name of Robert Frazier, my grandmother is half-Scott and one-fourth French and a little Crow, blue eyes. On my father's side they are full-blooded Indians. For practical purposes, I call myself a full-blooded Crow Indian.

My grandfather was a great chief. There are four requirements to become a Plains Indian chief, each time a risk of life. Touch a fallen enemy—that's dangerous because his buddies may want to use him as a bait. Then combat with an enemy, take his weapon away from him. A third: sneak into an enemy camp at nighttime, bring some good horses back. And a fourth one: the Council of Chiefs will select you to lead a war party, come back successfully, don't loose any men. In case you are being pursued you have to stay back of your men, give them a chance to get away. A lot of young warriors died that way. They are self-made chiefs, not hereditary chiefs. In Word War 11, I was lucky to have completed those four. I wrestled a German soldier, I took his weapon away from him. One time I encountered some horseback riders, Germans. That night we surrounded them and, just before daylight, I went in and opened the gate to the horses, beautiful cavalry horses ridden by SS officers. Fourth, I lead a war party successfully. My company was surrounded and trapped just inside the Siegfried grave. The commander selected me to lead a detail of six men to break out of the entrapment, go back to the allied lines and bring back boxes of ammunition. This dangerous assignment was completed successfully. My company was selected to breach two lines in the canyon separating two nations; Germany here, France there. *Stars and Stripes*, the U.S. Army newspaper, was there with photographers. I was the first soldier to jump into the sacred line.

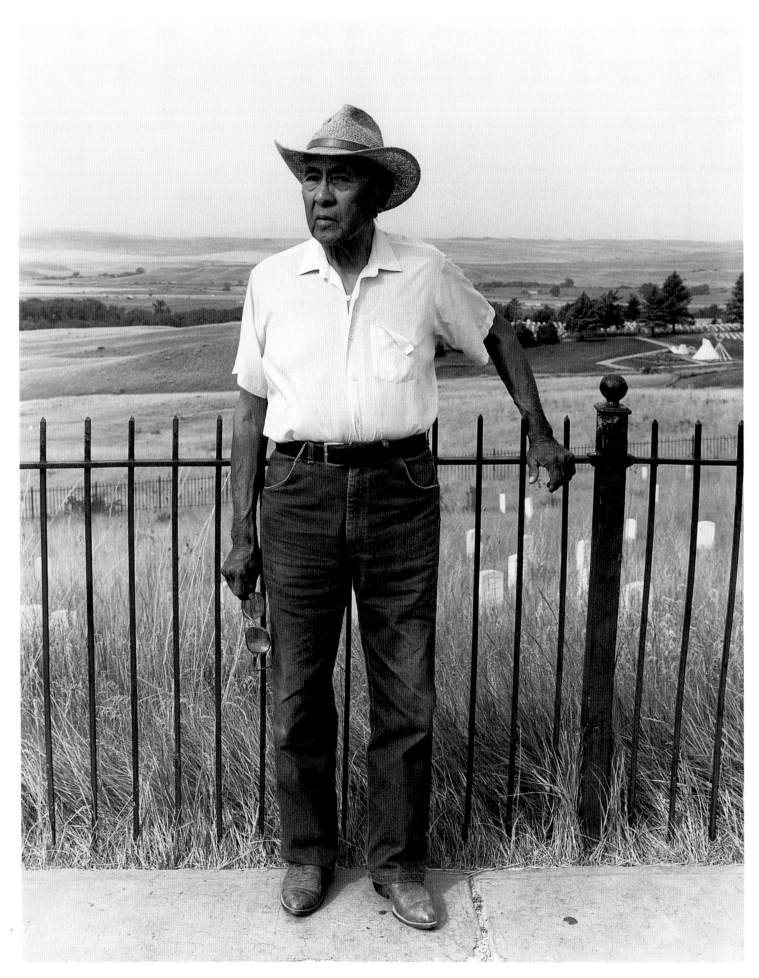

Joseph Medicine Crow *Little Bighorn Battlefield, Montana 1999*

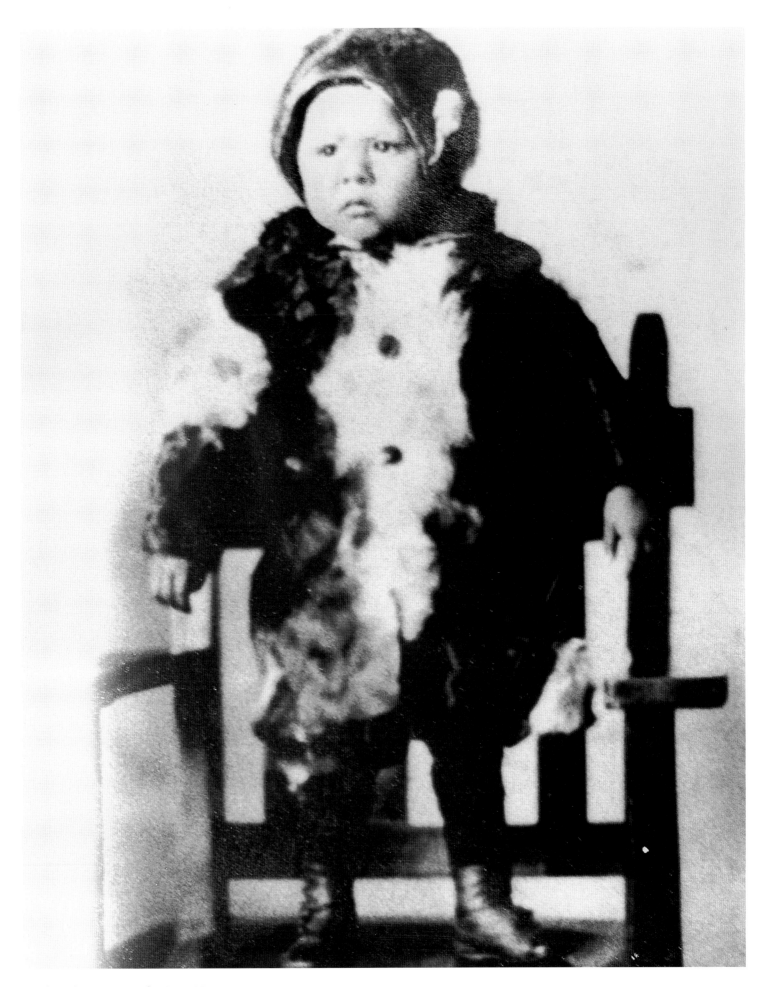

Joseph Medicine Crow *Lodge Grass, Montana 1917*

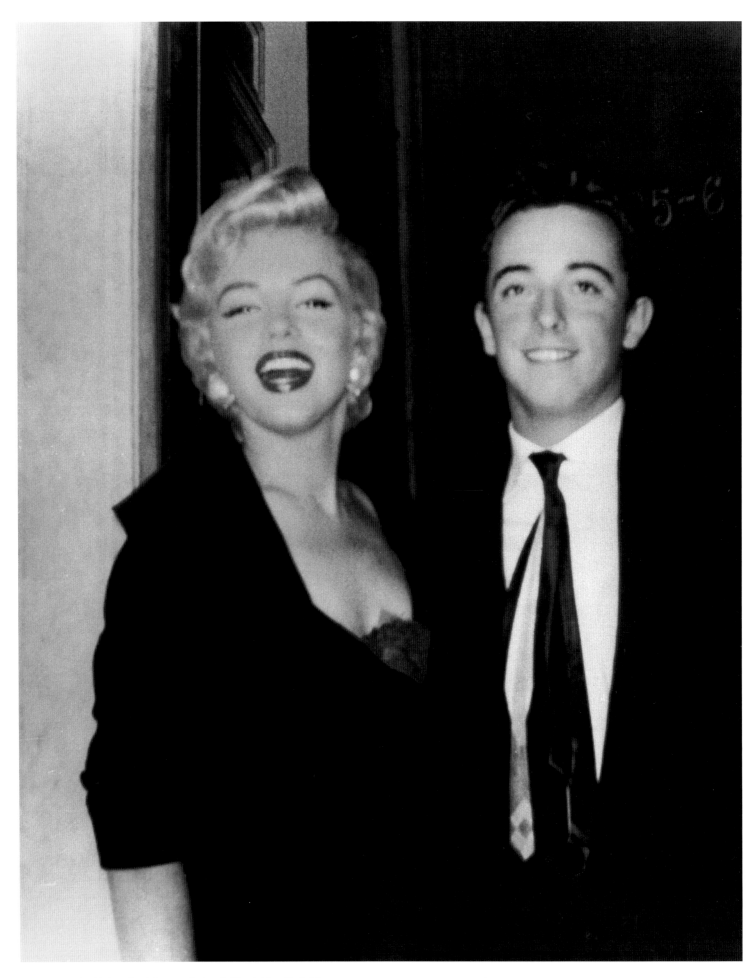

James Haspiel with Marilyn Monroe *St. Regis Hotel, New York City 1954*

James Haspiel *Lexington Avenue at 93rd Street, New York City* 2000

 James Haspiel
New York City 1954
New York City 2000

The picture was taken here at the St. Regis Hotel in September of 1954. I had struck up a conversation with another young man outside the hotel, also waiting to see her. He had a camera and I had a camera with the intention of each of us taking a photograph of her. She was staying on the eleventh floor and we decided to sneak upstairs. We didn't feel any entitlement to use the elevator, we sheepishly walked eleven flights up, scared to death all the way that somebody would open one of the doors and we would be thrown out. We made our way to 1105–06, her suite of rooms, and rang the bell. A man opened the door and we asked if we could meet Marilyn. He said no and closed the door; we had effectively been shot down. My inner person took over. I was not going to walk down eleven floors, I was taking the elevator down, damn it! As we reached the elevator the door opened and Joe DiMaggio walked out and proceeded to walk towards the suite. Of course we turned and were walking behind him. I finally said to him: "Mr. DiMaggio, would it be possible for us to meet Miss Monroe?" We had now arrived at the door, all of us, and he said, "Just wait right here" and went inside. We were prepared to be disappointed again, but he opened the door and he quite literally handed her out to us. Once she was in the hallway he closed the door and left her there alone with us. I took a picture of her with the other fellow using his camera, then he took the photograph of myself and her together with my camera. Obviously there had to be some kind of dialogue but I have no memory of that.

I had had to save up for the suit I am wearing. So when I look at the picture that's a big part of my memory. Where it came from, how expensive it was for me. At the time I was making $28 a week working as a messenger. In 1954 you could get a furnished room for $8 a week, but it meant that you slept on a mattress infested with bedbugs. You would wake up in the morning and they would be on your arms, legs and body, sunk into your flesh drinking your blood. I would sit there in the morning picking them off. The one thing that gave me some kind of strength was a good bar of soap.

Having had no education, no high school, certainly no college, I was limited in what work I could obtain. I never knew how to lie on a job application as everybody else was doing. This seriously impaired my ability to get work. I took a job at Western Union, I was sixteen years old in 1954. One of the other messengers told me that when you delivered telegrams to the Communist Party offices a camera would photograph you. Communism was such a threat at the time that I threw all the telegrams away. Whatever the ne-

gotiations might have been, they never got the messages. I would walk around the block, tear up the telegram and throw it into a garbage bin. I was not going to be photographed entering the Communist Party offices in New York City. I could have been singularly responsible for world peace in the 1950s, ha, ha!

I did not have a father in my life and I had an absentee mother. I had lived on the streets when I was fifteen, sleeping on roofs, relying on friends who would spirit food out of their parents refrigerators for me. Life had been tough. I had been brutalized as a child. I still have lumps on the top of my head from when I was eight years old and beaten with a cast iron pot. Back then I'd felt great affection for actress Barbara Stanwyck: there was a lot about her that was like my mother, except that she was not threatening. I could sit in a movie theater and my mother figure would be there too, but would not harm me. I went to see her in a movie called *Clash by Night* in August of 1952. In that film, in a small role there was a new actress named Marilyn Monroe. That's where the transition happened. Marilyn's buoyancy, her laughter and the joy that came off the screen was powerful to me. I needed joy. I left the theater forever entranced by this woman. So when Monroe came to New York I made my way to that hotel to see her. What took me back many times was the high. Seeing her enabled me to meet the next day; it was such an extraordinary experience, on a daily basis, that I could see her. That saved me. My own children are here in the world because of her. Who knows if I would have made it out of my teens, otherwise.

I was a drowning man saving myself, trying to find my next breath, so I was not thinking about America per se. The 1950s were a time of enormous joy but it has to be viewed in retrospect because while it's happening to you you don't really know this. I love my sons deeply, they were both born before 1968 when the assassinations began. The achievement of my life is not the books I've published, not my friendship of eight years with Marilyn, but rather that I have put two human beings into the space that we all inhabit, who are not judgmental, who don't care about the color of anybody's skin, only the quality of the person that they meet. Had my children not already existed I wouldn't have brought somebody into what seemed to me a negative atmosphere.

We've become far too commercialized. There was a time when you could drive from New York to Florida and see trees. Now you see billboard after billboard after billboard. There is a sadness to me about this. Television is a 24-hour advertisement. Even when you are not being sold something you are being sold something. I am saddened as a father that we are living in a time where a young girl almost becomes obligated to have breast implants. There are so

many things in this society that are not healthy. People are persuaded they must look a certain way, they must have a certain thing. We live in a society where we are told not to be sexual, yet every product on the market is sold with a sexual message attached to it—it's damned if you do, damned if you don't.

Photography as a subject in general is vital because it preserves for us the past. There is a picture of Marilyn standing on the corner of 93rd Street and Lexington Avenue. Every building in this picture is long since gone. The 1955 cars no longer exist, everything about that picture is from the past, but if you isolate her out of the picture you see her natural world at the time. The buildings, the automobiles, the fashions of the people on the street become important. There is too much of a tendency in modern times to dismiss the past. The very people who are dismissing the past don't seem to realize that one day they will be looking back on today, but the children of the future will have no interest in what they are talking about. There is a relevance to saving the past. There was a time when people sat down for dinner and talked to each other, where foundations were laid. Now you have a bunch of young people growing up on television who maybe don't have the gift of conversation at all, because it didn't occur in their growing up, so to speak.

I used to have dinner with a friend of mine, Mark, a wonderful person, but I began to notice, every time we sat down for dinner he would start talking about the miseries of this world and the miseries of his life. I said to him one night, "What was your childhood like, your family?" "The only time we talked was at dinner, my mother and father always fighting. We'd all gather at the dinner table and they'd argue for an hour while we ate." "I've got to tell you something, Mark, I can't eat with you anymore. At dinner time you just bring up the worst things and my stomach starts to turn. I don't enjoy the meal. You have to learn this about yourself, because what you are doing is staying in your childhood," which so many of us actually do. We find a place in adulthood that's comfortable, that really does mirror our childhood, even if it was bad stuff, and we do this over and over again. Perhaps the reason I notice this in other people is because I chose to leave my childhood behind.

Henry Kissinger

Fürth, Germany 1931
Park Avenue, New York City 2000

We lived in Bavaria in the town of Fürth, near Nürnberg, and I was eight years old when this photo was taken. I don't remember anything about the circumstances, but it must have been on a happy occasion. It may have been taken during a visit with my grandfather, who lived in the nearby town of Leutershausen and whom I adored.

Although the Nazi movement was gaining strength in 1931, it had yet to have a significant impact on my immediate family, who considered themselves loyal, middle-class German citizens. My life was that of a typical boy, revolving around school, sports, books and friends, a happy, carefree time within a close-knit and loving extended family. In retrospect, it was probably the last summer that the rising political situation could be ignored. After that, my father was dismissed, as a Jew, from his teaching position, and I could not enroll in the Gymnasium I would normally have attended.

My younger brother and I would watch, puzzled and uneasy, as uniformed Hitler Youth paraded, singing and taunting the Jews. In 1938, my parents made the wrenching decision to leave for America taking with us only what could be packed in one wooden box. My great-uncle and his large family—still believing Germany would eventually come to its senses—declined to leave their homeland of centuries. Thirteen members of my family failed to survive the Holocaust.

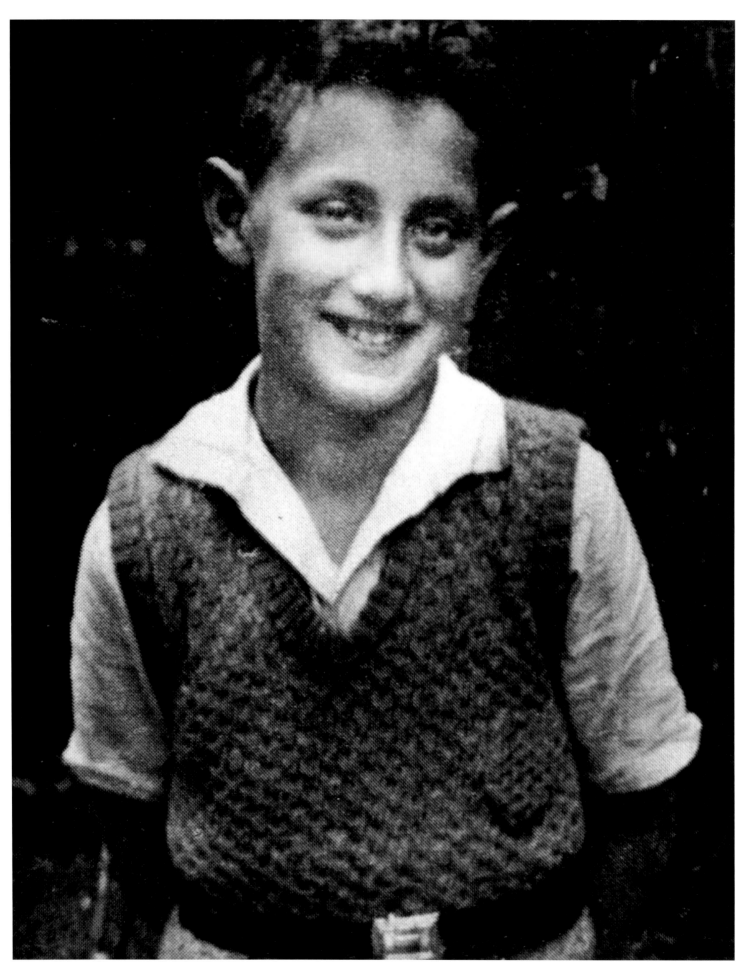

Heinz Kissinger *Fürth, Germany 1931*

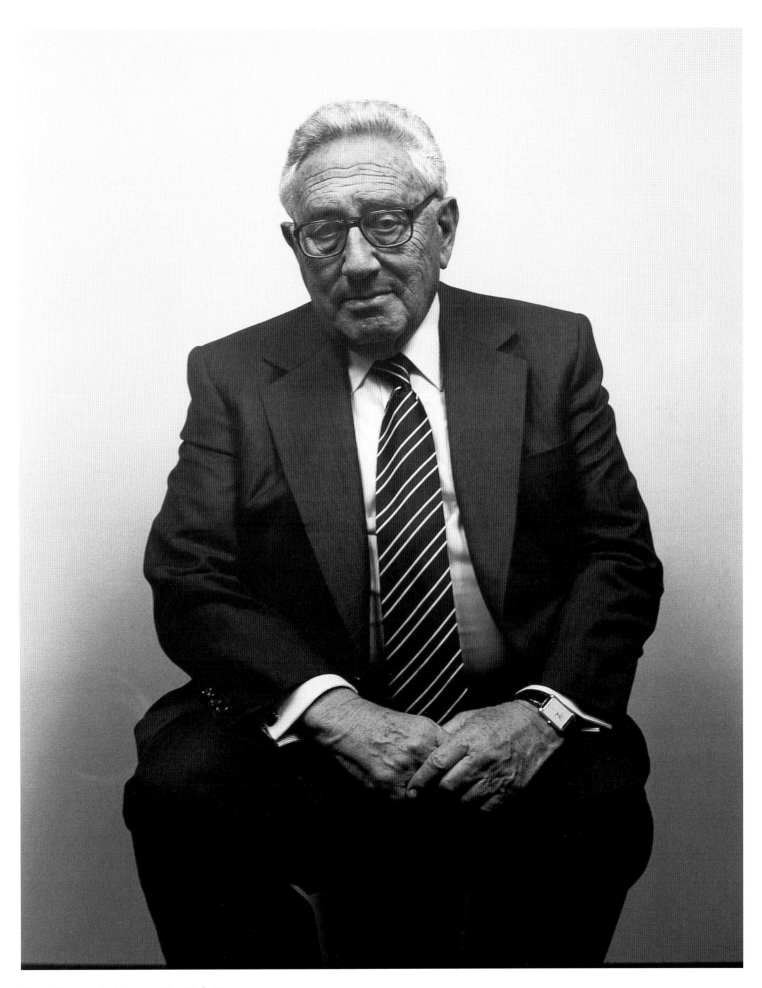

Henry Kissinger *Park Avenue, New York City* 2000

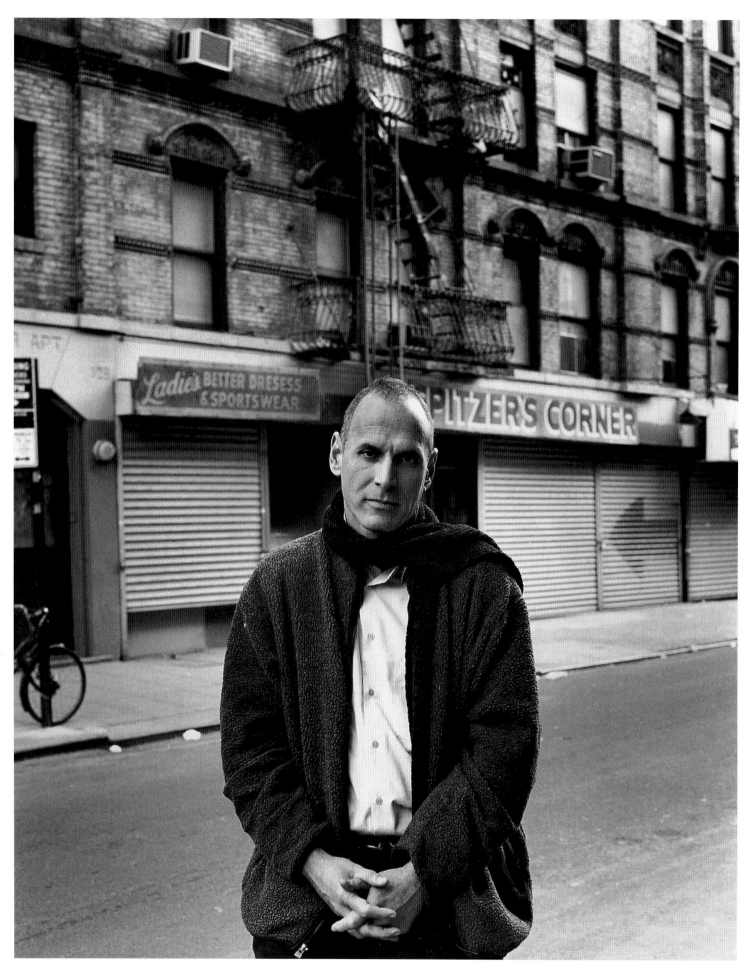

Shimon Attie *Lower East Side, New York City 2001*

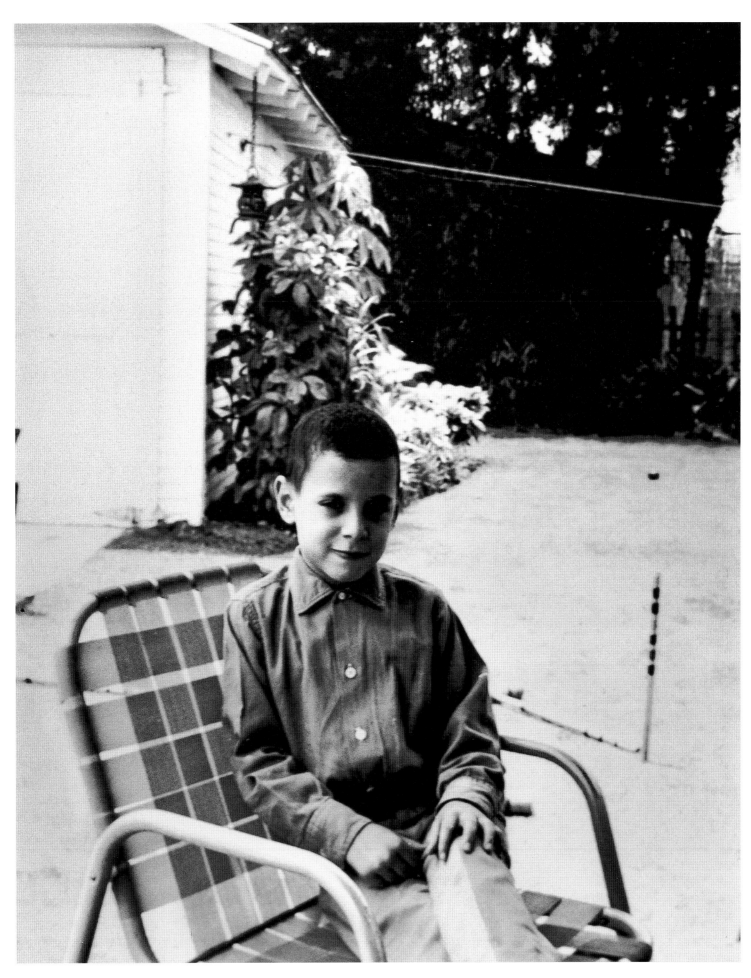

Shimon Attie *Hollywood, California 1961*

Shimon Attie

Lower East Side, New York City 2001
Hollywood, California 1961

Benjamin Ferencz

U.N. Plaza, New York City 1999
Hell's Kitchen, New York City 1926

I have two religions. Art making is one of them and psychotherapy is the other. Interestingly I became a psychotherapist before being an artist but I realized you only live once so you better do what you really want. I was a very sweet child, but I was also very hurt though resilient somehow. I had a particularly bad relationship with my mother. I look happy in that photograph in the backyard of my aunt Lillian, my mother's only sibling. I partly survived by playing piano and violin for hours every day for many years.

Memory has been the engine which has fueled a lot of my art projects. One I did here in the Lower East Side in 1998 was entitled "Between Dreams and History." I interviewed local residents who had lived in the neighborhood for decades and I asked them to write down their memories from their youth like a favorite song or a sleeping dream. There were texts in English, Chinese, Yiddish and Spanish. Lasers were stationed on rooftops and in apartments and the memories were handwritten out and inscribed onto the architecture of the neighborhood in this beautiful blue laser light. You saw writing appearing out of thin air. It would go around archways, follow fire escapes and after a full thought it was unwritten as if written in disappearing ink.

I was a "red diaper baby," meaning my parents were very political, to some extent radical, and lived through McCarthyism. I grew up really seeing the gap between the myth of how Americans like to see themselves—as being a just, equal, democratic society—and the actual true America with enormous injustices and lack of humanity for one's fellow men at times. I took my history classes very seriously and studied the Constitution and the Bill of Rights. It's incredible to see how the most basic aspects of it are completely perverted today. Right-wing extremists are in the majority on the Supreme Court and they are saying that if it's not specifically written in that document from the late 1700s that such and such group is protected, they have no rights. I really wonder if they didn't get basic lessons in American history.

I learned to appreciate certain things about America by leaving it for several years. Americans are risk takers, they are very enthusiastic, while in Europe people are a little more stayed. Living in Germany I started to appreciate America as a multicultural society. There is a recognition here that "the other" exists and the other is my neighbor. Even if I hate him or her, I am aware that he exists. In Germany it seemed even more primitive, trying to deny that the other even exists.

As soon as I got out of law school I joined the United States Army—we were at war. I became a private in the artillery. I hate all armies but I was engaged in every major campaign in Europe. I landed on the beaches of Normandy and I was with General Patton's army right across Europe. I saw warfare, but the most interesting part of my assignment was being part of a war crimes unit. My early assignments were to go into the concentration camps to capture the records or the criminals. American flyers were systematically murdered every time they came down in a German town anywhere. The population invariably came out and killed them. I would go and dig up the bodies and find out who was responsible. I had a very interesting if gruesome experience. I've seen people burned alive and I have seen concentration camp inmates catch the guards and have their vengeance on them. I have seen the inmates—you couldn't tell if they were dead or alive. This had quite an impact on me and I prepared this information for further war crime prosecutions in a concentration camp. I hammered up the first sign, U.S. War Crimes Unit Dachau, 3rd U.S. Army. These were army trials, mostly against camp commanders or people that had murdered allied flyers. The war was over, I was very eager to go home and I was very eager to get out of Germany and never to go back.

I married a Hungarian girl who'd been waiting patiently for me for ten years. Then the Pentagon offered me a civilian rank of a colonel and I went back to Germany to assist Colonel Taylor, later a General, to take on the trials after the trial against Goering and company was finished. There were twelve subsequent trials run by the United States in the courthouse in Nuremberg. The defendants were not just a small clique around the Führer; they included German industrialists and the doctors and the lawyers and the judges and the foreign ministry officials who were equally responsible. I became the chief prosecutor of the *einsatzgruppen* trial—special extermination squads. They came in behind the German lines and killed all the Jews, all the gypsies, anybody else that might cause a potential or future threat to the Reich. Without pity, without remorse, without selection. That was before the days of selection in Auschwitz. The Nazis thought they would win the war quickly and they didn't need to be concerned about labor. If you were a Jew, you were dead—man, woman or child. We captured a set of those *einsatzgruppen* reports in the burned-out Gestapo headquarters in Berlin, covering about a two-year period. I added up how many people had been killed. It was over a million. And where it said the town was cleansed of Jews I put down "one." Sometimes they were

more specific. At Babi Yar near Kiev they succeeded in eliminating 33,771 Jews in two days. That's 15,000 people murdered per day, a rather fantastic record! I flew down to Nuremberg to General Taylor and said: "We've got to put on another trial against these defendants." He said we had budgetary limits, we didn't have personnel, we had to wind up the program. He asked whether I could do it in addition to my other work. I said sure, and so I became the chief prosecutor for the United States in what was certainly the biggest murder trial in history. I succeeded in convicting all twenty-two defendants including six SS generals. There were thirteen death sentences, the others received long prison terms. I was then twenty-seven years old. It was the first and only criminal case in my life.

It had such an impact on me that I have devoted the rest of my life to trying to cure this sick world that I saw. The concept was clear: first you must stop the killing. The second step was to bring to account in a court of law those responsible for the crimes. The third was to try to rehabilitate as far as possible the victims of those crimes. The most important thing was to prevent it from happening again and that has been the goal of my life in America. Since I was a young boy I was interested in crime prevention because I saw crime all around me. The next phase after the war crimes trials was the restitution program, *wiedergutmachung*. I helped to set up the programs and to negotiate the treaty between Germany, Israel and Jewish charities outside Israel. I was a member of a team and now practically the only one left alive. I directed what was certainly the biggest legal aid society in the world to help the Nazi victims—The United Restitution Organization—and all of this was done on behalf of charitable organizations. The German government has paid over 100 billion marks so far under this program.

The photograph is unusual because my parents had been divorced when I was about six years of age and I seldom saw my father. I was already a young gentleman. All of us were dressed up—it was an occasion for us to come together. My parents lived in Transylvania where I was born. It was an area of turmoil. My sister, who is on the photograph, was born a year and a half before me in Hungary. I was born in the same house but it was Rumania—the languages and the nationalities had changed. I suppose that had an influence on my failure to respect nationality as being a thing of tremendous importance, rather than to look toward the welfare of the people and their concerns. My family came to America as poor immigrants, my father had no skills. He was trained as a shoemaker and discovered upon landing here that they didn't need shoemakers, they used machines. They had no money and didn't have any knowledge of the language. Eventually my father managed to get a job as a janitor—it enabled him to get an apartment for his family. My earliest memories are in a basement apartment with no windows, in a district known as Hell's Kitchen which had the highest crime density rate in the country.

America has always meant to me "the land of opportunity." Despite these very humble beginnings I managed to get a very good education by virtue of admittance to schools which didn't charge anything. I attended a special high school and the City College of New York. From there I was able to gain admittance to the Harvard Law School. I am trying to use my education to help create a more peaceful, humane world. I have a world view which looks to the welfare of all human beings wherever they may be. I wrote about a dozen books and hundreds of articles and I make speeches around the world and lobby at the United Nations. People have not yet come to realize that peace is better than war and that the war ethic with which we were all raised is a form of madness which exists on this planet. It is like the flat earth theory. When everybody thought the earth was flat and anybody who said the contrary was burned at the stake, or worse. There was a time when in this country they believed that white men were entitled to use black men as slaves because they were inferior. There was a time in this country, not long ago, when women had no property rights, no right to vote. All of that has changed. I came to America with nothing. I hope to go out a pauper the same way, but I hope to have spent my time in-between trying to leave the world a little better place than I found it.

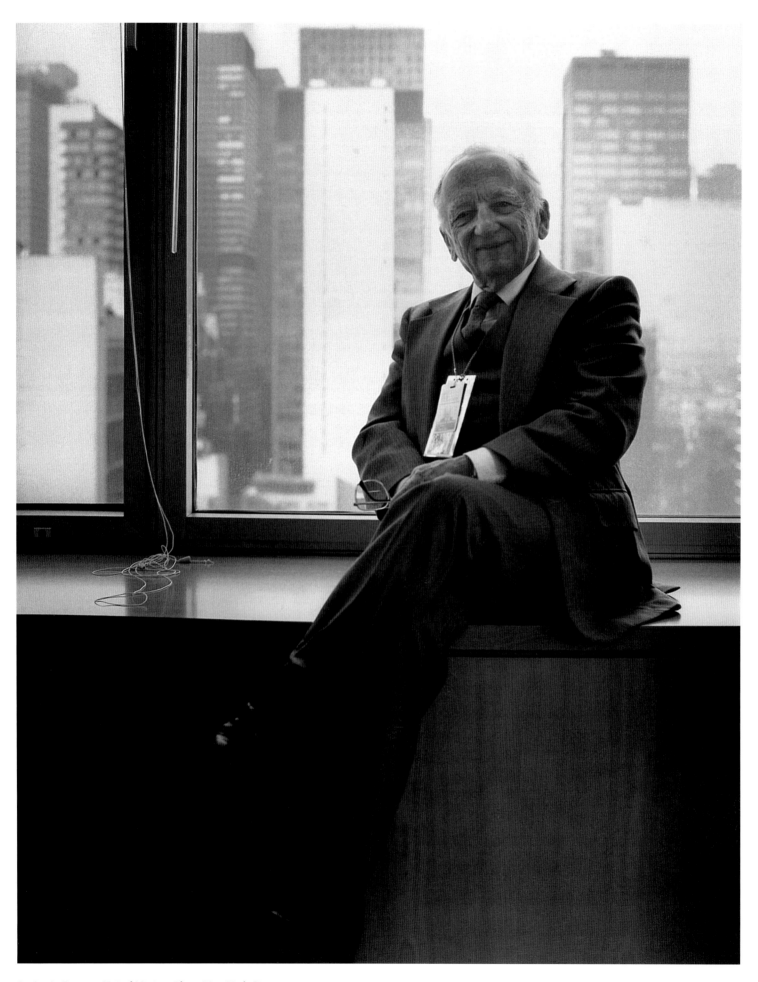

Benjamin Ferencz *United Nations Plaza, New York City 1999*

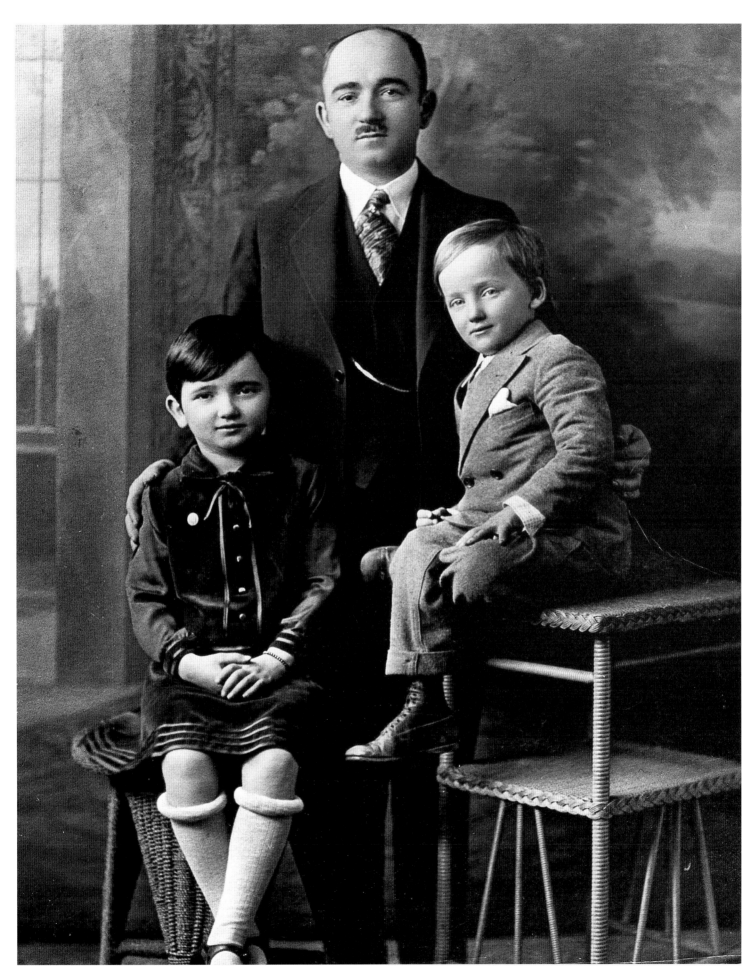

Benjamin Ferencz *Hell's Kitchen, New York City 1926*

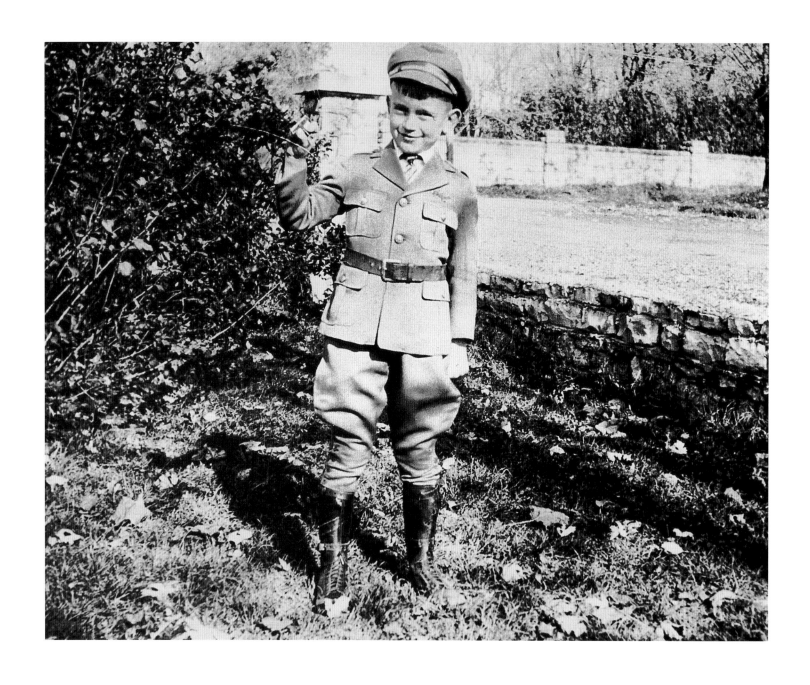

Thomas D. Graham as "Little Lindbergh" *Jefferson City, Missouri 1927*

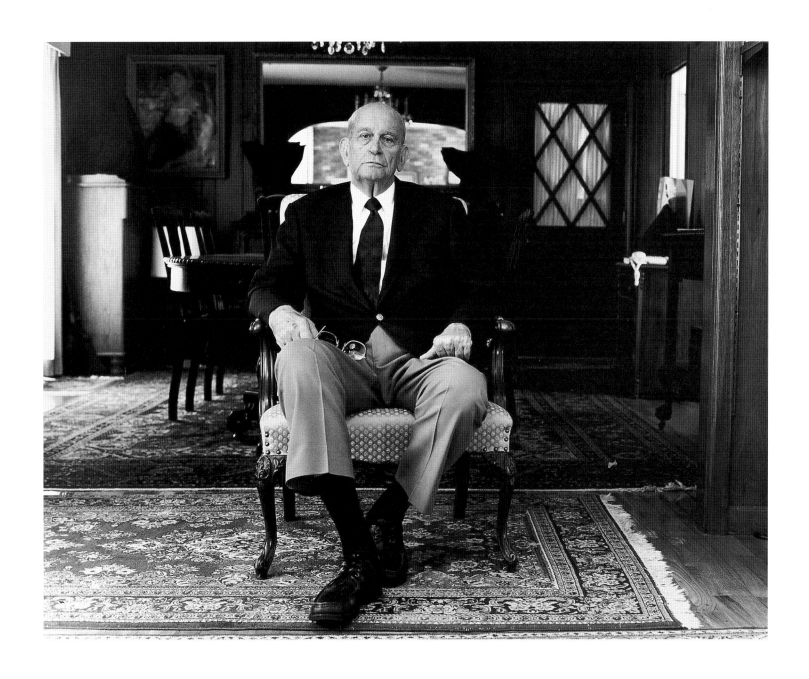

Thomas D. Graham *Jefferson City, Missouri 1999*

 Thomas D. Graham

Jefferson City, Missouri 1927

Jefferson City, Missouri 1999

 Ilya Kabakov

New York 2000

Dnepropetrovsk, Shevchenko Park, USSR 1938

My name is Thomas D. Graham. I live in Jefferson City, Missouri and have lived here most of my life. I was a member of the Missouri General Assembly for twenty-two years, serving as Speaker of the House from 1961–1967. I served as President of the National Legislative Conference in 1966–1967.

The photograph was taken in 1927 out west of Jefferson City. This was my "Lindbergh suit" that my mother bought me in St. Louis at Stix, Baer & Fuller. I can recall how thrilled everyone was when Lindbergh returned to St. Louis from his flight overseas. I recall standing on the corner of Lindell and Kingshighway at the Chase Hotel and watching him go by. St. Louis held a big parade for him—that was as close as I got to him. I had a little plane—a replica of the *Spirit of St. Louis* which I hold up in the picture. We bought it on the street during the parade. I was five or six years old and my mother probably took the photo. Lindbergh was an idol for all of us when he made his trip. It was one whale of an undertaking. That overloaded plane and the fact that he had to lean out the side to see where he was going—that had to be kind of hairy! I admired him for that. But then he got involved in politics and supported Hitler—that's what everyone says—and he fell out of favor for a long time. I don't think he ever came back completely after that episode.

I am sure as a boy, I wanted to be a fireman or policeman. I really wanted to be a judge but I never made it. My son, Christopher is an Administrative Law Judge. I lost my mother and father as a teenager. My mother died in 1939 and my father in 1940. I was still in high school and my aunt was living with us at the time and she continued caring for me. Then I went away to college and then into the army serving during World War II. While I was there I married Christine, my wife of fifty-four years. I think the most traumatic thing in my life was her death.

I was Vice-Chairman of the Missouri Commission which built and operated the Missouri Pavilion at the New York World's Fair in 1964–1965. We had the replica of the *Spirit of St. Louis* which was built for the movie on display at the fair. They tried to fly it to New York but the plane developed motor trouble so they had to take it apart and truck it to New York. Lindbergh's financial backers were a group of St. Louis businessmen—that's how the plane got its name. The replica of the plane hung in Lambert, St. Louis International Airport for many years. The original is in the Smithsonian Museum in Washington, D.C.

There are two different types of boys. One is strongly influenced by the father. The best examples are Kafka and Freud. On the other hand, there are many boys in whose lives the mother directs the child's energy. There are two different types of mothers as well. There is the strong mother, the mother as an energetic force, in the gestalt of a big bird. The second type—and that is my mother—is the very soft and tragic one. She had no say in the family, my father was strict and brutal. My mother was a typical Jewish girl and she stayed in her fantasy world from childhood until her very last minute. She didn't understand life, could not adapt to reality, particularly the reality of Soviet life, there was no place for her utopia. It was hard times, we were hungry. I was still a child when I first went to art school. I was at boarding school, in the company of boys, a new life. My mother washed and cared for me, but that complicated our relationship. These boys were tough, my mother standing next to me with some soup or small meal did not go down well. My mother was an orphan. My grandfather had died at age twenty-three from typhoid. Without the generations there is no history. These are people without roots, people like flies. My mother had no grounding, no money. She was totally alone in the strangeness of this hostile and evil world. I feel that I have to realize my mother's tasks and dreams. She could never express them, she stayed quiet about everything all the time. But it is very clear that she speaks inside.

I didn't live in Russia, I lived in the Soviet Union. This is a different country for my generation, even a different civilization. The memories of my life in the Soviet Union are memories of a double life. That is nothing unique, many people lived two lives: an official one on the outside and one for their families and themselves on the inside. In official life my biography was perfect; I got to illustrate children's books. I experimented very early in my own art making and was very fortunate because since 1958 there was a whole unofficial art world. It was like a complete world on its own, a closely knit group of artists, poets and writers—a few philosophers as well—like an imitation of the larger world. I belonged to this group for thirty years, thank God without prison terms or arrests. In the Breznev era our circle was well known to the police and the KGB but it was also of interest to foreign diplomats, journalists, and curators. So officials were somewhat worried about clamping down on this circle because this would have caused protests in the West.

With the beginning of Perestroika Gorbachev opened doors. I was one of the first who got to see the so-called "real" capitalist world

with official permission. The journey to the moon, the first step into the West took place in October 1987. The West was a totally different world for me, like a fantasy about a beautiful woman that only exists your head. At the same time the western world, in particular its culture, was incorporated in our world, it was part of the Soviet propaganda. In Soviet ideology, the state is the highest point of the pyramid of world history. We are not different from other nations—that would be nationalistic—we are the best! That is narcissistic, not racist. We are a synthetic culture, we incorporate not only western culture, but also the oldest cultures. We only take the realist tradition with Leonardo DaVinci and antiquity, but abstraction we don't include. This is of course ridiculous. But looking back today, I understand that I got a great classical education, a precise knowledge of world history, of Greek history because of the pretense that we were the whole world. So when I came to the West, I was not going into another world, I was going to the castle or some fantastic city, where this dream or fantasy, like the one about the beautiful woman, lives. This idea has stayed in my head until today.

First I came to Graz, Austria. Then I got the opportunity to travel to Switzerland. After two years in West Berlin and another two in Paris, I went to America. This is how it happened, but I must say I did not see this as emigrating. I felt like I was on a mission, emigration was not acceptable to my mind. Kandinsky, Chagall, Prokoviev and others felt the same way. I still feel like I am on a mission today. My whole life is a mission. What does this transition into the New World mean to me? It meant many opportunities to realize my profession here in the United States. In the Soviet Union I did not exhibit for thirty years, for thirty years my work leaned against the wall. I would show it to friends, but you didn't have an audience. Yet when I met a western audience for the first time it was very difficult for me. The Soviet Union was a different world for them, like Africa, like a jungle, where only idiots lived and destroyed the economy. All my attempts to exhibit were essentially catastrophic and without success. In the first phase when the Soviet world opened up, there was an intense interest in Soviet artists and musicians. But after two, three years the interest was no longer there; the art was neither understandable nor radical, it was like cold coffee. When the interest faded many of my friends returned to Russia. Why is this question of place more burning for me then for others? Because the reaction of the audience is my inspiration. I don't agree with the position of modernism where the artist is the genius and the audience is nothing. I accept the position of dialogue.

Life in America is very practical like nowhere else in the world. There is a very short interval between your idea and its realization,

you only need money. You get to see and eat everything there is in this world until you are no longer hungry, until you are only interested in one special dish or cake. When all dishes are known you have to jump to another level to get peoples' attention. Fortunately I had this idea for my first show in New York in 1989. It was like a present from my mother, to work with this new genre, the total installation. People walk into my badly painted and poorly constructed rooms, like into another world. They forget where they are and feel a little bit like a victim in these tragic, depressing rooms. My world becomes the other world, but I build my space in their space. It is a paradox. Thank God I got many invitations to exhibit and gained a reputation as the representative of this unknown but very dangerous world, the representative of Soviet life. This is probably good for me, but not so good in the eyes of my Soviet audience, particularly the Russian art critics. They say I am selling out and give the Russian world a bad reputation, I am treating my home like an ungrateful son.

The problem in America is the problem of being at the top, the problem of the broken communication with Europe and the rest of the world. Until the '70s people were somehow united with the world and Europe, but in the '80s America becomes self-content. Only what happens from morning until night is important. A life without aura, that human and historic element that slows everything down and plays a major part in Europe and Russia. American movies from the '60s and '70s still had sentimental and heartfelt themes. This element of respect and soul has disappeared. It is like a cosmic rocket. First the rocket takes off in two parts, then suddenly, with high speed, the top part of the rocket moves on leaving the cylinder behind. Last year I did an installation, a globe where Europe is on the center plane, the human level. Far below is Russia and America is 10,000 kilometers above Europe, the cosmic level. America has taken off. People sit in different machines and engines moving on and are realizing their projects. When you have a good project, everybody is trying to help you. In Russia, if you have a good project everybody wants to destroy it and you with it. It is the American principle to let things happen, this is upward energy, particularly in New York.

Ilya Kabakov *New York 2000*

Ilya Kabakov *Dnepropetrovsk, Shevchenko Park, USSR 1938*

Senia Croonquist Hart *Red Lodge, Montana 1999*

Senia Croonquist *Rock Creek, Red Lodge, Montana 1919*

Senia Croonquist Hart

Red Lodge, Montana 1999
Red Lodge, Montana 1919

My dad, down on his hands and knees, directing my gaze at a pile of rocks. He was already trying to tell me about geology of this area, some of the oldest rocks known on the planet. I interpret this one as being our early study of different things and my eagerness to learn. I am Senia Mabel Croonquist Hart. Senia is from my Finnish mother whose name was the same. Mabel is for my Connecticut Yankee grandmother who came west when she was only eighteen in 1884 and was a school teacher near Livingston, Montana. My Croonquist maiden name is Swedish.

The little town of Red Lodge was settled by mountain men and traders. It was also the summer headquarters of the Crow Indian Nation. The area has long been a basis for a very interesting multinational group of people. Some were recruited by the Northern Pacific Railroad to mine coal. The railroad was going west. It had arrived in Billings in 1882 so they had to have coaling stations along the route. They recruited people in the Scandinavian countries, the English, the Welsh, the Irish, the Scots, the nationalities that presently comprise Yugoslavia and on down to Italy. By 1920 there were twenty-one different languages spoken. Many people were quite clannish and had their own neighborhoods.

My mother came here from Finland when she was ten and she was very interested in the outdoors. My dad wanted to run a fishing camp, so he and mother hiked up the west fork of Rock Creek here and found a very beautiful spot at the base of Silver Run mountain. My dad was good friends with the forest service people and often suggested names for the various peaks. After World War 1 was over my father and mother were free to go up and start Camp Senia. I went up as early as a year-and-a-half of age, my dad was riding a horse and holding me. My life was broadened and beautified by these experiences out in the mountains and again meeting many folks. In the 1920s it was becoming quite fashionable to take a train from the East coast and end up in Red Lodge, Montana. You'd put on your western clothes and proceed up this canyon by horseback. I was part of this expanding guest ranch atmosphere and my dad made me very conscious of welcoming people and being responsible for their comforts. My mother was the general boss and she supervised well. The Depression in the United States and lack of guests caused our camp to close. My father then worked for the Dude Rancher's Association in Billings, Montana, helping to establish the quality of accommodations on a dude ranch. I took trips to the various ranches with him. Later he worked for Northwest Airlines, which had two flights through a week flying between

Chicago and Seattle. In 1938 he was killed in an airline crash but Northwest asked me to continue the work with the dude ranches and represent them in publicizing western vacations.

My grandfather Croonquist had a store here in Red Lodge. So I was raised being part of the operation of merchandise arriving and being sold. I can still see the women measuring the yard goods by just holding out their arm and putting it to their nose. When I married Russ Hart in 1942, he was President of the Hart-Albin Company. It had been started in 1902 by his father, Ray Hart, and a partner, B. R. Albin. This was during the period when having a nice downtown store was the mark of civilization in little towns. In Chicago they had Marshall & Field, in Seattle they had Frederick & Nelson. We were trying to be another Marshall & Field in Billings, Montana. Although the streets were mud and there were only boardwalks across, it was our pleasure to do as nice a job of decorating as possible. It was very hard on us all in the late '50s when there was such a turning toward the development of malls. The Hart-Albin Company in Billings finally decided to go out and try a mall store. I can't say that it was highly successful. We still very much worked at keeping the downtown store modernized. We did not go into an Old West theme type of decor at all: we considered ourselves a modern oil city because we had lots of oil people come up from Texas to headquarter in Billings. A lot of our business came from little towns where the folks came in to do their weekly shopping. We had fine, loyal employees, but in '88, just before Christmas, there was a fire on the main floor and we didn't recover from it and went out of business in 1990.

I enjoy photographs and newsprint more than the average person perhaps because I watched ideas being promoted and built on a story in the newspaper, a picture. Photographs tell us a lot about the kind of houses we are living in, what our dress is, what our activities are. They are an extremely valuable component of our history. I have seen most of the whole hundred years when people were intensely identified with the American flag and so called virtues. The motto was "we accept you as you are until you prove otherwise." It's been a feeling of trusting, integrating and doing the best we can. I think that television has and is changing the younger generation. America is still easily identified as a place in the world, but I don't know how we will turn out in the coming years.

Kaye Malins

Marceline, Missouri 1956
Marceline, Missouri 1999

We are sitting in the living room of Walt Disney's boyhood home in Marceline, Missouri and my name is Kaye Malins and I currently live in the house. I've lived here about twenty-five years.

The photograph was taken in 1956 and it was at a really special occasion, not only for myself but for the town of Marceline. Walt Disney was coming home again and you have to realize 1956 was the year after he opened Disneyland and he'd been a pretty busy guy. We had a little swimming pool built and the City Fathers contacted Walt Disney and said, we would like to name it after you. He said, "I'd be thrilled, I wanna come to the dedication!" I was six years old and they had a beauty contest at the swimming pool. Walt and Roy were the judges. So the photograph is of me, carrying the pillow that held the queen's crown and Walt is placing it on her head. Her name was Diana Kelly. Not only was it the first time I ever met Walt Disney, but he was staying in my house, because we had the only air-conditioned house in Marceline. I knew that he was just like me, a small-town kid and that he had the same heart, and as I grew older I knew that it really was because he came from a small town. Walt Disney felt sorry for people who had to live in cities their whole life, who didn't have a little home town to go to. Everyone seems to be searching for a sense of place and for Walt it was small-town America.

He came again in 1960 to dedicate the Walt Disney School. He sent an artist to design the interior of the school. At that dedication that day he said, "You know, I am not a funny guy, I am just a farm boy from Marceline who hides behind a duck and a mouse!" Maybe other places perceive us as a corny part of the United States because we still do have a lot of ideals and morals. That's the gift we give to our children, the sense of place. I grew up in the best of places in the best of times. There was an incredible innocence about the rural way of life in Missouri. We got to be children longer. I remember waking up in the morning, seeing the sun coming through and thinking, this is it, it doesn't get better and it hasn't ever. I feel like people truly do miss part of life if you never experience the closeness of a small community and how we interact with each other. I think we create our own destiny and so anywhere I've ever lived I need to do something to make it better in some way, and so that's why I am here.

He and my dad just clicked. We would go to California and have Walt Disney take us around Disneyland and we got to eat at his special table and never had to wait in line. It was an unfulfilled dream of his to buy his boyhood home and so they formed a corporation here, and my dad was the president and Walt was the vice-president and Roy was the secretary-treasurer. Walt said he never wanted to be caught without enough land again. He had just opened Disneyland the year before. So they start purchasing quite a lot of land including the boyhood home farm and had options on several other farms in the area. Walt had envisioned a turn-of-the-century working farm. He said there would be a time when young people wouldn't know what a baby animal looked like anymore, what an acre of ground looked like, they would have lost vision of what their heritage was. So that's what he'd hoped to recreate.

I have always been proud to be an American. It was not so much that I thought we were the best, but that a true American knows that we have a responsibility to our country and to ourselves. I think again that comes from us being so large and so basically rural, it's our small communities, farmers brought civilization and the sense of responsibility along with us. We are not the caretakers of the world, but we have a strong responsibility to be true to the ideals of our forefathers. We carry it well in some ways and very poorly in some ways.

I kind of felt like the steward of Walt's Marceline for a long time and we had people coming here from all over the world and it was almost like a holy pilgrimage of true students of Disney. They want to feel it, see it, hold part of it in their hand. I am very pleased to do it, but I can't do it every day. We have high school students that do the downtown tour and the Walt's history part. We have the elementary students do the Walt Disney Elementary School tour and it's given them an incredible feeling of pride. I am from Marceline, Missouri, the boyhood home of Walt Disney and yes, he received his inspiration from here and it's absolutely wonderful.

Kaye Johnson with Walt Disney *Marceline, Missouri 1956*

Kaye Malins (born Johnson) *Marceline, Missouri 1999*

Sue Davidson Lowe *Connecticut shoreline 2000*

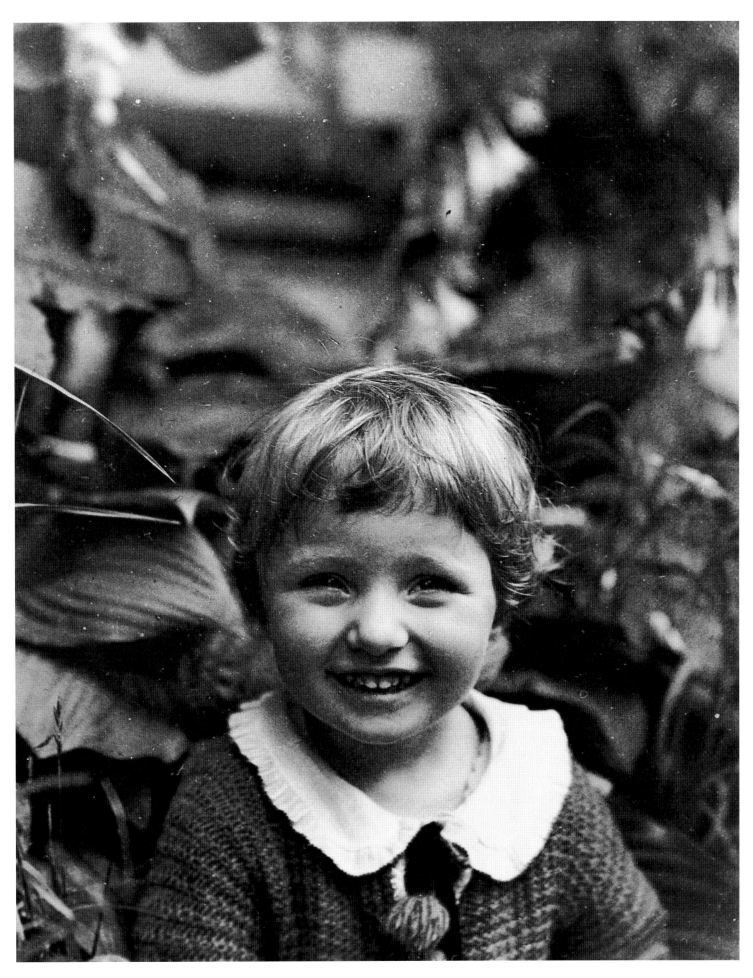

Sue Davidson *Lake George, New York 1925* (by Alfred Stieglitz)

Sue Davidson Lowe

Connecticut shoreline 2000
Lake George, New York 1925

Stieglitz took this photograph of me on the porch of his house at Lake George, in front of grapevines that produced the sourest grapes ever. We had gotten past the stage when I scowled in his pictures, perhaps because he'd decided to put me on the porch instead of in the middle of prickly grasses where I was plagued by insects. By then, he'd decided too, I think, that I was not quite the brat that O'Keeffe said I was, and we had a pretty good relationship; his poking fun at me had changed to gentle teasing. I remember this shot with pleasure, and still chuckle at the loosely expandable sweater my grandmother knit for me.

In 1925, when Stieglitz took this photograph—and most of those of my sister and me together—I was not quite three years old, and still felt like a pinned bug in front of his camera; he was not always very patient, and I rebelled against being an object. But even when I was little I was aware of his photographic eminence: his prints hung in my grandparents' New York apartment, and, if my hands were well scrubbed, it was a special treat to turn the pages of *Camera Work*, under my grandmother's nose. I felt awe looking at his landscapes and street scenes, and sensed "truth" in the portraits he made. Later on, I absolutely bought into his insistence that photography was as much an art in the hands of a fine photographer as is painting in the hands of a fine painter. It can even be an epiphany, like a spine-tingling moment in the performance of an extraordinary actor. (Olivier's Oedipus comes to mind.)

I was not particularly aware of America beyond school lessons until I heard Stieglitz talk passionately about it. He criticized shortcomings in American attitudes and society, insisting that it should emulate the "modest" diligence he had admired (and romanticized) in Germans during his nine years of study and work abroad in the 1880s, but he cherished his native land. Until my early teens, the Depression was still heavy in our lives, even though we as a family were not at risk. The poverty in the rural community we lived in until I was nine was extreme. People survived on what they could grow or share with others; there was nothing to "earn." I believed what I heard, that ruin had been caused by greedy robber barons and bankers, and coming out of that period, I saw Roosevelt as the country's savior; later I campaigned for him. I was very idealistic about America's potential: accepting everyone for what he/she was, guaranteeing everyone a living, dignity. That was only fair. Like many liberals during our World War II alliance with Russia, I thought briefly that communism might offer some answers to ills in our society, but its denial of individual rights—most important to me—turned me off.

I felt myself blessed always by the parents I had and by their open view of life. Native New York artists who ideologically tried farming for six years, they deplored materialism and hypocrisy, and had individually adopted Hinduism's Vedanta even before they met; finding each other was magic. My father, whose wealthy family had lost everything when he was fifteen, had since worked in every conceivable job, gaining a breadth of American experience unknown to my mother's well-traveled but insulated Stieglitz world, but it was from her that I derived an intellectual thirst. Back in New York City in 1932, we went to a Hindu center on Sundays as other people went to church, instilling an unshakable belief in me that divinity resides in everybody and everything, a belief that probably explains my love of nature and even, oddly, the theater (my first passion), where the interdependence of performer and audience is so immediate. In any event, my certainty of the dignity and worth in everybody has always been very sustaining to me.

My first husband was a pilot in World War II, stationed in Hawaii, where he tested planes that had been downed and repaired for return to combat. A few days before Hiroshima, one crashed, killing him. When he had gone overseas, I had gotten my first job on Broadway, the world I adored, but after he died that world seemed narrow, superficial. Seeking work that counted more, I became involved in a live-in coed educational project with a cumbersome name, Encampment for Citizenship, and soon became its executive secretary. Its students, in late teens and early twenties (I was 23), came from every reachable background for six weeks of intense study of the principles and functions of democracy. Jews and Christians, blacks and whites, from cities and suburbs and farms—among them a coal miner from West Virginia, two Navajo shepherds, garment workers, Ivy League graduates, veterans studying on the GI Bill—were more or less forced by proximity and shared interests to open up to each other. The experience was very illuminating, and very touching. Eventually, missing the theater, I went back to it—with a reinforced faith in America, a faith that remains rock-solid. It is questionable that this country's potential will ever be reached. In many ways it seems even narrower-minded than it was in my twenties, and I find that very discouraging.

The death of my first husband was a major turning-point in my life; it took me some years—with the help of a wise man who was also a psychiatrist—to find my balance. Since then, and in spite of a few other severe knocks, I have been essentially forward-looking, an optimist curious about tomorrow—even now, in the difficult process of growing old. I've had so many paths open to me in my

life: travels in Europe, the U.S. and Japan, and fascinating jobs that paid little but brought me richer rewards. I worked with "guru" Joseph Campbell on his first mythology books. I was a Broadway producer, translated and adapted French plays, wrote for TV. I gave occasional assistance to a U.S. ambassador at the U.N., was a freelance editor, spent twenty-three years on educational boards, wrote and published a biography, was Managing Trustee of the estate of Piet Mondrian's heir for six years, and continue to design landscapes and lecture. Everything I've done has affected me, of course, but I have been changed most profoundly, I think, by the four major "happenings" that included my husband's death.

World War II, monstrous for the entire world, was one, arousing a sense of community in America, a common effort, that was deeply satisfying, even exhilarating. That common effort turned me for some years into a political activist; no longer. Having a child of course changed my life utterly. I married a second time, I think, primarily because I wanted a child. That wasn't perhaps very good for the marriage (we were divorced after only four years), but with all its single-parenting worries, it's been a total joy for me to have the daughter I have. And the stepson who has provided me with four loving grandchildren. Finally—a kind of epiphany?—a near-death experience after major surgery nearly thirty years ago ended my fear of death and brought me new purpose.

 Christian Boltanski

Grand Central Station, New York City 1995
Parc Montsouris, Paris 1964

I don't care about myself or my image. I don't collect my image at all. That picture, it's a work only, it's no more to me. That's memory. I am more unhappy now, I am much more unhappy than I was then. I was much more happy then. I am dead you know, really, I am dead now.

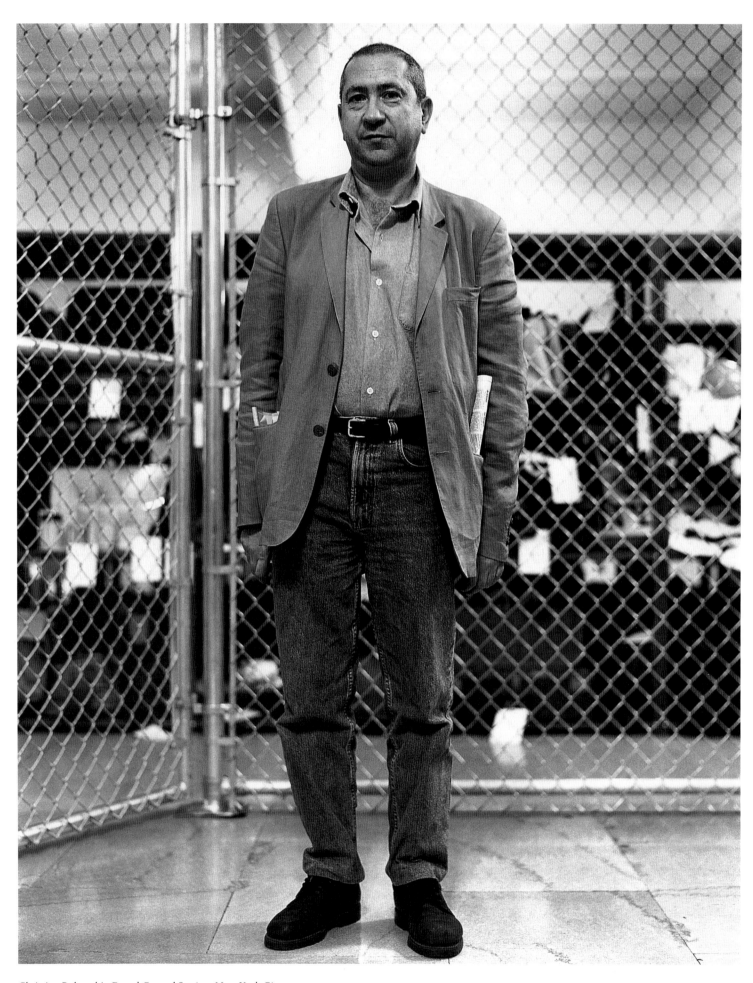

Christian Boltanski *Grand Central Station, New York City 1995*

Christian Boltanski *Parc Montsouris, Paris 1964*

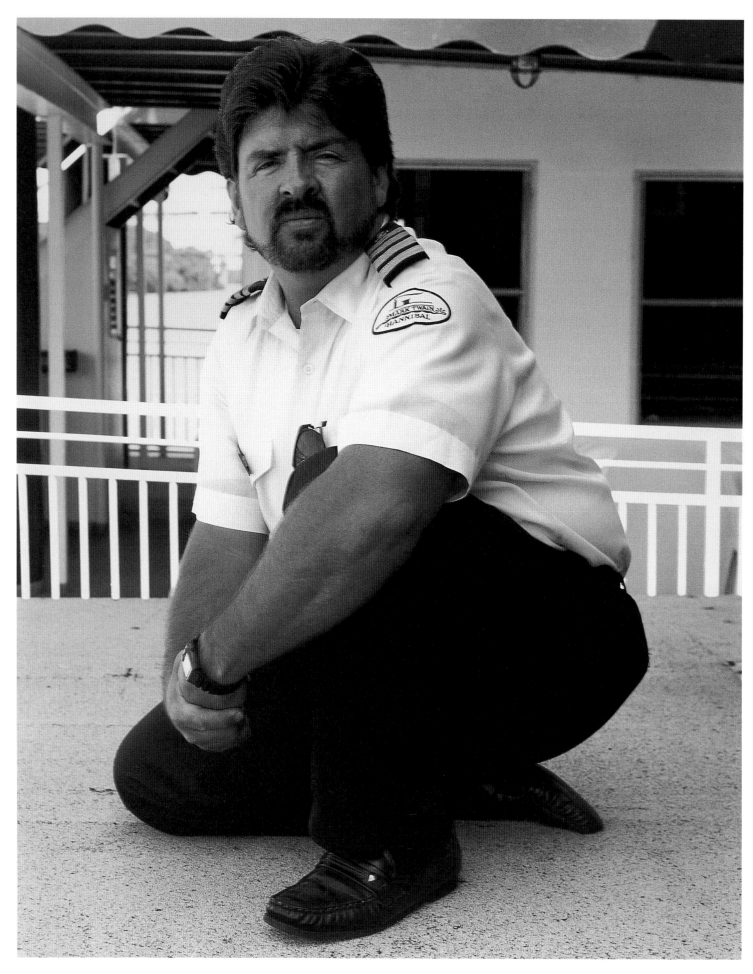

Steven Terry *Mark Twain Riverboat, Hannibal, Missouri 1999*

Steven Terry *Clear Creek, Hannibal, Missouri 1968*

Steven Terry

Hannibal, Missouri 1999
Hannibal, Missouri 1968

We are here in Mark Twain's boyhood home of Hannibal, Missouri, right on the Mississippi River. He had dreams of being a steamboat pilot like every boy in town. Riverboat pilots made the same money as what the Vice President of the United States made, but it was not so much the money they were after, it was the glamour of the job and the power, if you will. Sam Clemens, or Mark Twain, was only a river pilot for four years and then he became a writer.

I didn't really find out about the river myself until I graduated high school at seventeen. I was a deckhand on a summer job, when I realized there were opportunities here. I was expected to go to college, learn enough that I could get into the family business in accounting and taxes. I have always been a kind of a doer, if something breaks I fix it and I don't hesitate to jump in and get my hands greasy and dirty. Two days into the job I was in love. This was great. I am doing something that I like and yet I am still around people, I am not inside all the time. I liked it so much that I worked in the summertime so that I could train. Two years later, in 1979, I became one of the youngest pilots on the Mississippi. I worked real hard at it and here I am piloting the boat and that was a dream. I don't care what it takes but I want to be a pilot and then I realized the dream.

The technical term of "Mark Twain" meant "safe water." It didn't mean a whole lot at first, but it means a lot more to me now. I still think of it in its proper term of safe water. Mark Twain is read all over the world, people know about him and that keeps me and the crew that I've chosen safe and keeps us in the water. There are some bad points in his life, everybody has a few things in their closet, but at the same time he is very widely read and respected across the world and people want to see what he was writing about. *Tom Sawyer* and *Life on the Mississippi* are based around this river. The Mississippi, on a grand scale, it's an artery, it's a lifeline for America. Whether you are looking at it for transportation, recreation, or history. I am trying to show people old America, old stories, and at the same time I'm trying to show them today and the future of the river.

When you see John Wayne movies, the war movies and so on, you understand what America is about. The American dream is to own your home, to have a family, own your own business and prosper in that. I am living the American dream and I am doing what other people want to do. America is the opportunity and I see why people from all over the world move here to get a part of the American dream. You are taught to love your country, they sort of force-feed that, if you will, in school. I didn't even realize it was there until I got older, until you start seeing how other people around the world are treated. Kids don't understand it, even today, what it's about. Everybody's a little different, but in this country you're allowed to dream your dream. Fifteen years ago this was not my dream. I have had a lot of reasons to be thankful just to wake up in the morning. I do appreciate the freedom that America offers and the abilities that we are allowed to pursue. There have been many reasons over the last twenty years not to love your country because of all of the wrongdoing that goes on even in the White House. But if you look back at the basics as to why America is even here today, how can you help but not love the country that you're in?

Supposedly in this picture I am catching a frog to be a participant in the frog-jumping contest on the Fourth of July holiday in Hannibal in 1968. I can't stand to touch frogs. I can't stand frogs, I never grabbed a frog, I never was in the contest, but if there would have been a frog there I wouldn't have been there. This was a promo. Notice that good haircut and everything. I live about a quarter mile away from where that picture was taken now—what goes around, comes around. We waded down through the mud and the weeds of Clear Creek. This guy right here in this picture, he wanted to be a fireman, maybe a police officer but never dreamed of doing what I do now.

Mitch Cohen

Far Rockaway, New York ca. 1934
Central Park, New York City 1995

I was a pampered only child, soon to become fat, unattractive, klutzy and decidedly unpopular with the other kids. I wanted so much to be accepted but all I knew was rejection and ostracism— not by my parents who were loving—but by the world outside. And, even as I grew tall and not bad-looking, I remained an alienated, fat little kid in my heart. But gradually, my way of thinking changed. I came to embrace the world outside. Indeed, except for a few excursions in my adult life, it was all I ever really had anyway. So soon I began viewing this life from the perspective of an alien. Why not? I was. And I found it fascinating. This world, this universe, the wonderful accident of man in its midst. I developed a genuine fondness and admiration for that little creature of which I was one. How with the limited awareness and scant tutelage of but an eon or two's evolution from nothing or near-nothing—how far he's come. How well he survives. That he survives at all and even prevails—this mere infant—in the dark and dangerous jungle of history and existence. How his marvelous curiosity and creativity triggers his development as he discovers things his intellect can't yet assimilate. Struggles with them. But inevitably achieves another lumbering, hesitant step forward. Not immediately. Often not without great pain and disastrous backslides—but inevitably. For, to be sure, evolution is a spiky upward graph. And it goes so far beyond the physical. I'm frustrated that I can't live at least 300 more years' worth.

That picture was, if what they tell me was correct, a prize-winning picture. My folks got a year's supply of milk because of that picture. As I look at that wonderful, innocent, healthy child, really scared about teetering on a rocking-chair—I seem to remember that—I think a lot about where he went, and could there have been a different path. Should there have been. It's truly a miracle what a child is. Magnificent. At least until it begins to contract that progressive disease called maturity. I am specifically aware of this because of my show. The children are frequently the ones full of curiosity and interest. The adults have to be reached and worked for. With brighter audiences it's no struggle. Much of my show has the sophisticated and absurd kind of humor that appeals to adults on an adult level. But sometimes when I get a group that is dispirited or humorless or suspicious of anything as far out and unexpected as my performance with the turtles—people who don't understand that comedy or entertainment or theater doesn't have to be presented just one way—it is the children who initiate the contact. It's the children—and this is uncanny—who laugh at parts of the show that is meant for their less aware parents who won't listen and just

don't understand. They, the children, seem to genuinely, intuitively, appreciate the humor and satire that is or should be years beyond them. What is that? I couldn't begin to analyze it. But it's wonderful. And the fact that I was once one of these intuitively aware and open little people, this makes me happy. And I realize that what a child is must never, never, be left behind. That we must retain as much of it as we can, for all of our lives.

I first became aware of my nation when it was enmeshed in one of the few just wars in history. It was a time of heroism and glory. A time when a child grew up in a heady atmosphere of patriotism. A simple time when common people were heroes. An exciting, dramatic, child-like time. And as a child here I was insulated from the destruction and devastation that we learned since is the tragic basis of all wars—even just ones. And America was leading the crusade against the evil-doers. I was proud to be an American kid. We all were. Few people questioned Cologne or Nagasaki or the fire-bombing of Tokyo. Gave it hardly a judgemental thought. But emphasized were the excesses of the other side—the extermination of populations, the reign of terror on London's civilians, the Rape of Nanking. As a child, an adolescent, I thought the way I was supposed to think. I was to become more objective and critical as I grew.

America is undeniably one of the great nations of history. And, like all humanity, that history is at once exalted and marred. At its best America is as good as it gets. At its worst, not as bad as some. America filled a huge place in the development of democracy, which really is I feel, the highest form of government yet devised— but a little too early for the world's level of education and sophistication. Arriving late in the history of traditional empires, America had none, really. But it became an empire of a different kind. A philosophical and economic kind. Unique. But most unique was the fact that it was the first colossus in history whose technology had developed to the point where it could annihilate its adversaries with virtually no threat of retaliation. It had this power exclusively for a long enough time to do this—people forget. And it did not. Almost not. Sometimes I flush with excitement at being part of this very special historical phenomenon. And sometimes it embarrasses me. Sort of like escorting a beautiful but headstrong woman to a dance. At times we disagree—but I'm happy to be able to do that. That's part of America at it's best.

But withal I think we are rapidly coming to a point in history when we should acknowledge that we are basically, fundamentally, the citizens of our time even more than our nations and maybe that single fact will save us for more history. And there will be more history. Lots of it.

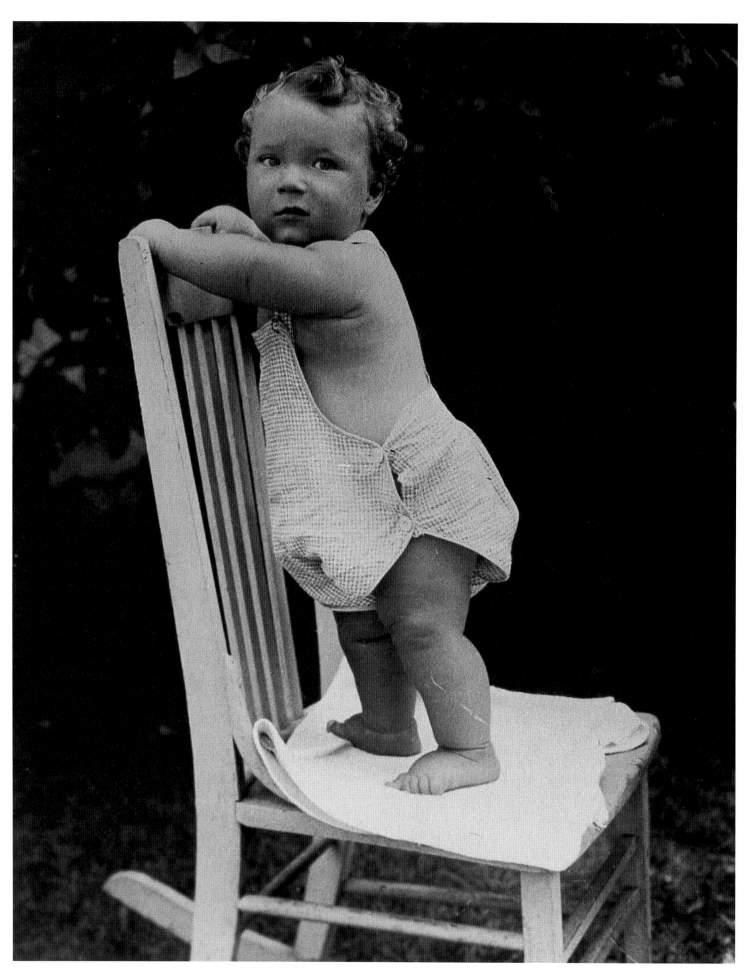

Mitch Cohen *Far Rockaway, New York ca. 1934*

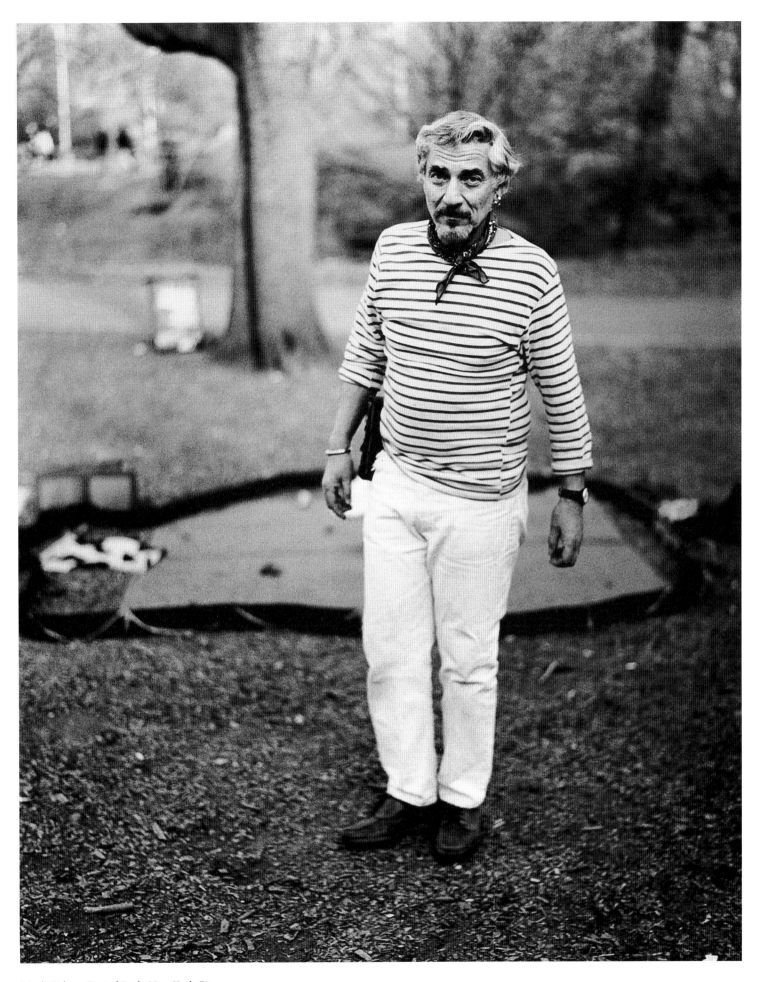

Mitch Cohen *Central Park, New York City 1995*

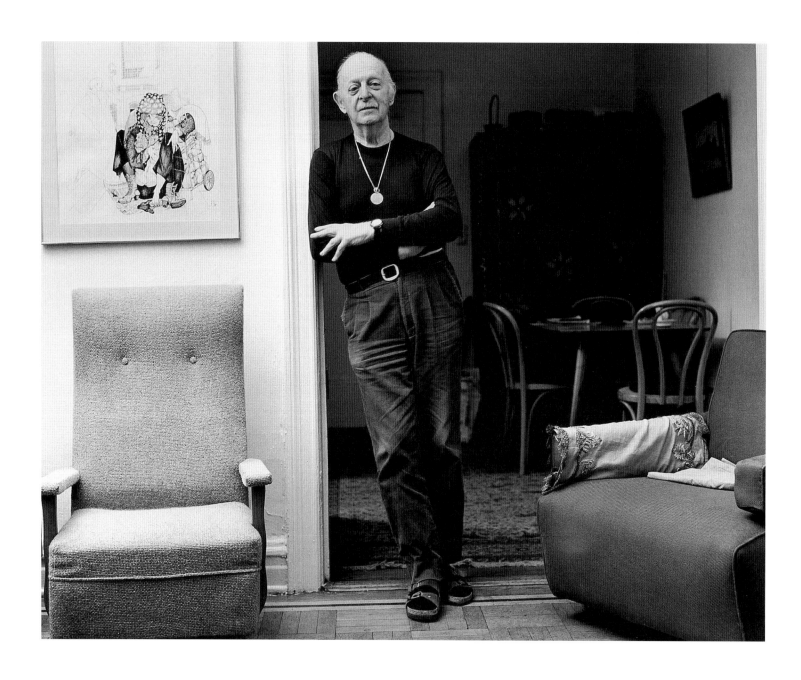

Leo Glueckselig *Haven Avenue, New York City 1995*

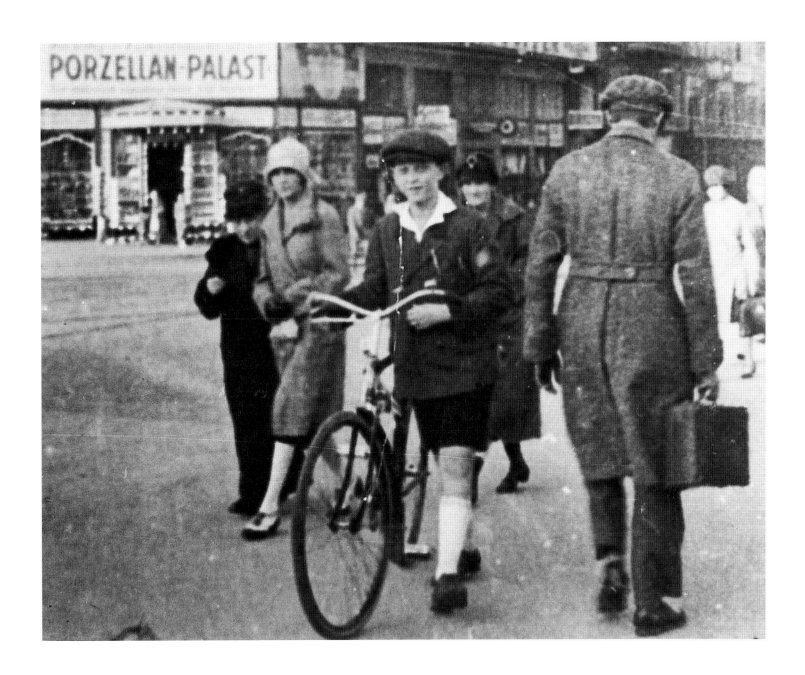

Leo Glückselig *Schwedenbrücke, Vienna, Austria 1927*

Leo Glueckselig

New York City 1995
Vienna, Austria 1927

I didn't know what I would get as a present for my bar mitzvah. It wasn't like it is in America today. Nobody even thought about giving money. I still have my first German Shakespeare that I got from an uncle, the first pen, the first golden watch. I was hoping for the bicycle. I was doing homework and heard the clinging of a bicycle. I didn't dare to go outside for five minutes in case I was wrong. When I found it I immediately pushed it up along the whole street over the Danube canal to a large park. There I taught myself to ride. This bicycle was very important in my life—it was my vehicle. I went to school with it and later on I traveled a bit through Austria. This picture shows a very important moment—I was exactly thirteen years old.

I graduated from a wonderful high school in Vienna. Anybody who had some sense politically—or who was an idiot—was a radical. If you weren't a communist or socialist you were a Nazi. As a rich kid with a wealthy father you were a Christian-Democrat. I was a confirmed socialist at the age of about seventeen. Without knowing it really, Vienna was very poor after World War 1—pretty run down. There were constantly political upheavals and people really did something. You were a supporter of Karl Kraus or not. I still attended his lectures. One didn't even know in what exciting times one was living. I immediately wanted to go to the Kunstgewerbeschule, now called Hochschule für Angewandte Kunst. My parents tried very much to influence me and they succeeded. "Do you want to become a starving artist? Why don't you study architecture, there you have great teachers!" Austrian architects already then were well respected all over. But deep down I wanted to become an artist, a painter. I was good at architecture, but it was a compromise. A few weeks before Hitler marched into Vienna we got our final exam. The *diplomarbeit* coincided with Hitler's conquest of Austria. From one day to the next, one of my colleagues—who was a fool and always needed help—marched into class with an SA uniform and told everyone any contact with the Jewish classmate was *verboten*. One girl, she was a super-Nazi, didn't understand it and almost clashed with him. Her belief in Hitler collapsed within a short time, experiencing the terror that came to her country.

We had a new professor from the Bauhaus who had moved from Germany to Vienna. The poor devil, he fell out of the frying pan into the fire. He called me in and told me the atmosphere was very bad. Only because I'd been here for five years, I would be allowed to complete my exam but I had to work at home. All that was very upsetting, after all I loved my school. I planned to design a sport hotel high up in the Alps. I made all the plans and also built a perfect model with the help of a friend, a cellist of the Viennese Symphony Orchestra. On the day of the exam I had to sit in the back and talk to nobody. A colleague I used to be really good friends with kept telling Jewish jokes right next to me for five hours. My heart was truly bleeding and I was scared to death. The Professor finally came and read out the results. I was the last one: "Glueckselig, I am terribly sorry but your work was not looked at." That's what I called the Nazi jokes, they did cruel things. Everybody turned around and looked at me—I know I smiled, packed my things and left. I cried on the street. I later smashed the model into pieces. That was 1938. Vienna itself was a nightmare. On the third day after Hitler marched in, I went to the American Embassy and there were already 500 people in line. Thank God the Austrian quota was not exhausted. It helped us a lot that we had these numbers so early. In Vienna hell broke loose very early. It started with the infamous sidewalk cleaning. There were still graffiti against fascism and they forced Jews, particularly women in furs, to wash the sidewalk on their knees.

The plans I still brought along to America, but I burnt them before I went into the army. This is how I got stuck in my development. I had to think of a career and European graphic artists were a novelty in America. If you were only vaguely good you were in. One of my friends was already with *Time* and *Life*, but those of us who went into the army, got in later. I started out as an office boy in 1947 and muddled my way up. It barely kept me alive. My father came with $10 to his name—an antique dealer. I was thirty years old when I started with graphics and drawings seriously. In the army I had started a little bit—watercolors. I could have just as well gone into photography, I had the talent and you need the same eye. I did the one or the other fine photograph but didn't continue. Somehow drawing and painting interested me more because I never learned it formally. I started very late, the Americans call that a late bloomer.

Never again in life you will get to know America as well as if you survive the army—one sleeps, eats and goes to war together with people you'd never meet otherwise. Where will I ever meet a coal miner from Pennsylvania again, hillbillies who can't write or read? Fabulous young people. America is huge—a continent. What has a man from Maine to do with a Southerner? I tell every European—forget everything you think you know—travel. You will find not only different landscapes but also very different people. The country still has a "starting out" character, very little is made for long term. You will find the best things next to the worst. Americans brag with their tragedies, their crime, their scandals and everything—nothing is hidden.

I have lived in New York City for almost fifty years. The cities are like amoebas, changing constantly. Wonderful buildings are torn down to give way for bigger ones—it means nothing—that is strange to me. I myself have changed fundamentally since I moved here, but not enough that I had to Americanize myself completely. Thank God you can have your own ideas and opinions as an immigrant—your own culture and God knows what. We weren't regular immigrants. We simply went where you could go first and then you reacted to your environment. As a young man I had a crazy interest in America, the whole modern literature—Woolf, Hemingway. I had a better taste for America because my father was a successful art dealer who went to America often for five, six months. When I was sixteen he sent me the first Jazz recordings; it was a sensation. When I arrived in Manhattan I immediately knew my way around from all the descriptions and maps, movies and books. It was a great experience when the ship slowly came up the Hudson river and we saw yellow cabs on the highway. "But they were gray in the movies! Look at them, the yellow taxis!" But I was very unhappy when I first arrived in New York. Not because I was in America, but because I got away and was free. I didn't get a chance to fight this dirt, the Nazis. I was totally heartbroken. My girlfriend and all the very dear relatives we wanted to get out and couldn't in the last second. I had a very guilty conscience and I didn't even think of a career until I got through this.

So I got into the army and one memory sticks out in my mind. German infantry soldiers had given up, they were shell-shocked and I got the assignment to bring them behind the lines. That shows the inexperience of the Americans. You don't send one soldier with eight German captives back alone from one second to the next— that is madness. I had a terrible weapon, the first hand-carried machine gun. Suddenly I felt my trigger finger twitch. "Now I can pay them back!" The thought was so clear and I didn't understand how it happened and something inside of me came out—I don't mean to sound heroic at all—"If you do that now, then Hitler has won over you." This sentence was on my mind. Later on when I thought about it—to massacre a living being that can't defend himself, is simply perverse. I think my life would have gone a different path, perhaps I would have forgiven myself, I don't know now, but I might have developed differently.

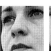

Celeste Fichter

New York City 1995
New Jersey 1969

My Uncle Tom took the childhood photograph in the summer of '69. We were in the backyard of our New Jersey home and I had just killed a guinea pig with my bare hands. I remember the adults laughing and I remember feeling proud of myself. I'm guessing from the look on my face that I didn't understand the difference between life and death.

My outlook on life changed rapidly as a child. When I found out that my mother was Santa Claus, innocence was replaced with suspicion. When my grandmother died in spite of my incessant praying to the Virgin Mary and the Holy Father to keep her alive, I became an atheist at age twelve. The idea of a heaven where it rained M&Ms and the belief that I could fly at will were shattered. I wanted to be a stewardess until I learned about the height requirements the airlines had and realized that I would never be tall enough. By the time they did away with height discrimination and called themselves flight attendants, I was no longer interested. I wanted to be a pilot. In high school, the army came and tested us for the ability to think spatially. My test results led me to believe that making a living in the friendly skies wasn't in my future. As an adult, I came to realize that what I was to become was what I already was.

As a child, America by definition meant the world. Other countries seemed as alien as heaven. Over the years, my concept of and feeling towards America changed radically. I experienced America in terms of personality types. At certain times she was certain people. Sometimes "she" was a "he." Sometimes she was an embarrassing drunken aunt at Christmas dinner. These days I have come to think of America as home to people with a particular style of ingenuity, self-determination and creative survival instincts. I find myself attracted to those people who have spent their lives devoted to fulfilling their individualistic oddball dreams.

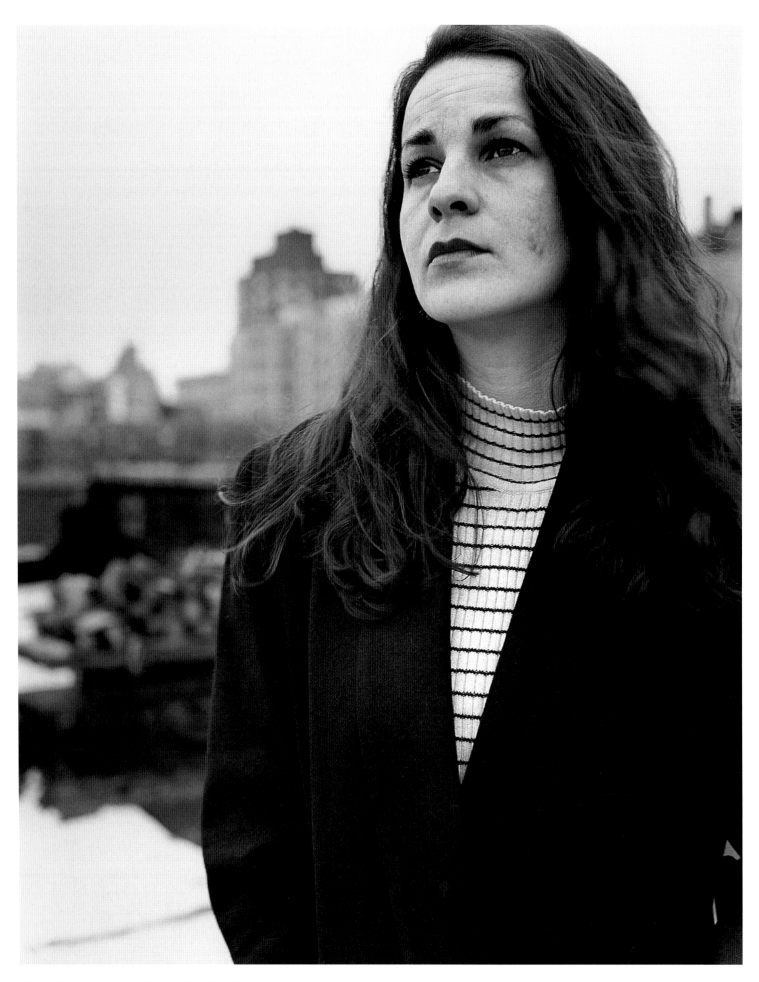

Celeste Fichter *Amsterdam Avenue, New York City 1995*

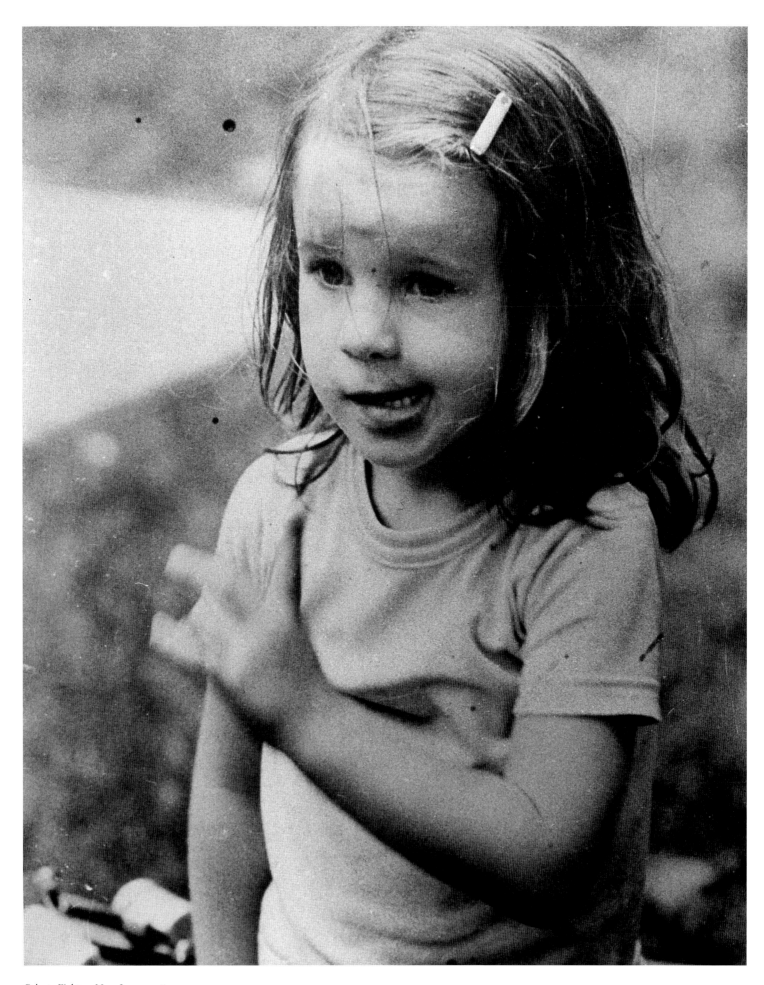

Celeste Fichter *New Jersey 1969*

Darwin John *Brooklyn Bridge, New York City* 2000

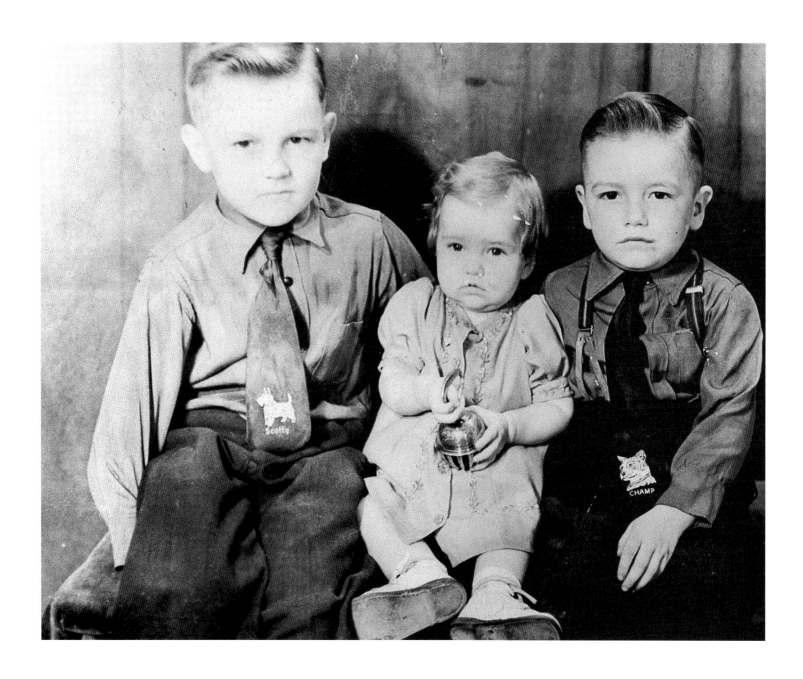

Darwin John *Tremonton, Utah 1945*

Darwin John

New York City 2000
Tremonton, Utah 1945

We are Christians and believe that Christ is the head of our Church. We believe he was on the earth and established his church. Over time there was a falling away, an apostasy, if you will. The process of the Church being restored to the earth started with a vision—to Joseph Smith, who was our founder—in upstate New York in 1820. Ten years later, it was legally organized. Joseph Smith was guided to find records that had been stored and he translated them. It is a set of scriptures that we call the Book of Mormon, the second witness of Christ.

The Church grew rapidly. It is a very missionary-minded church with 60,000 missionaries currently serving around the world. The Church came under a lot of persecution and moved from New York to Ohio. From there it was established in Missouri, but was eventually driven out of those locations and went back to Illinois. The persecution continued and in 1844 founder Joseph Smith and his brother were murdered. They really needed to move some place where they could practice their religion without persecution and came to the Salt Lake Valley, now Utah. At that point of time it was not part of the United States. It's a pioneer story with covered wagons, oxen and hand carts. They established here in 1847 and then colonized the whole Rocky Mountain West under Brigham Young's leadership. The Church is very prosperous in many ways and has grown to ten million members with more members outside the United States than inside.

This photograph was my first formal exposure to being photographed. It is a symbol of our parents' love for us and wanting to capture us in a way that would be a memory for them. My mother had a strong sense of her children breaking into a broader experience. She was always encouraging us to work hard, to learn more, to realize there was opportunity beyond the farm in Tremonton, Utah. The economics of that experience were probably not easy for my parents in 1945. Just the fact of going and paying for that experience was probably a manifestation of what's important for them. As I look at it, I see myself as shy but determined. In some ways I characterize my life being more shy but yet very determined to learn, to achieve. I am on the left there with my brother and sister. The picture reflects the closeness, the love for each other, the support for each other. I know I could ask them to do anything—no question in my mind. Photos are a key part of the decor of our home. The refrigerator door is literally covered with pictures of grandchildren. Room dividers have provisions for family photos, a wall is covered with framed pictures of our ancestors, pictures

of my wife at the Sea of Galilee, pictures of my wife's ancestral home in Denmark. We think of photos as capturing memories and relationships.

Part of our belief is that families are eternal, and if you take the right steps in this life, you can be with your family in the experience after this life. I had the opportunity as a young man to speak to audiences, to be a leader, to be president of the young men who were in my age range, to conduct meetings and direct programs. For my whole life I stayed very active and with my own family in the Church. I had the opportunity to be the lay leader for the greater Philadelphia area. As I've come into my current assignment, in many ways my whole professional life and my commitment to my faith have merged and go together in today's world. I have responsibility for information and communication systems, leading that effort for the Church worldwide since 1990. We look at the mission of the Church and then look at where and how that information technology can help. We are the largest genealogy provider in the world. I just helped to put up a family search site on the Internet. I have helped put in place a worldwide communication capability so that we, in most of the countries of the world, can connect and communicate and manage the operation of the Church using information technology and this information capability. My role is to help anticipate the future and create a vision to realize that opportunity.

My great-great-grandfather, Thomas John, was living in South Wales and was a shoemaker by trade. He would go out and measure people's feet and then manufacture shoes for them in his shop. He had a small family and it is probably fair to say he was looking for a better life. He came to the United States in the early 1850s. He settled in Philadelphia, did not bring his family, and worked in Philadelphia for a year or so and was discouraged by what he found. "These are really not very cultured people," he said and headed for home. When he landed in Liverpool, England, and got off the ship, there was a group of people getting ready to board another ship. It turned out they were new converts to the Church. He became acquainted with them, joined the Church in South Wales and then came with his family to Utah. He changed his occupation from shoemaker to farmer in the northern end of the state of Utah. His son, my great-grandfather farmed in the same community, and his son, my grandfather, farmed in the same community, and then my father was also a farmer. He moved a short distance but was basically in the same profession, in the same community.

I grew up being taught by my parents. They taught me to work hard and to have faith. They were very religious people and I have

lived my life being faithful to these basic principles they taught me. I believed, within that context in those growing-up years, if I worked hard and had faith then I could accomplish whatever I chose to. America is the land of opportunity, the land of freedom. It was the idea that we were masters of our own destiny and it was our choice what we would want to achieve. In my teen years I was very active in music and was able to have some achievement there and win some trips—to California, to Chicago. I had travel experiences that my parents never had and I was starting to see the world in a bigger picture. I farmed when I was first married and then decided it just didn't work for me. I went to university and things unfolded from there. I was the first member of my family who went to college. Each of those ancestors' faith and commitment to the Church is a strong motivator to do things differently.

It's the pace of change that has changed the most. Technology ranging from transportation to communications, to the information technology as we now know it. In the profession I am now in you can be out of date in months. Whereas if you were farming, there was technology change but a lot of things were very consistent through your whole life. Albert Einstein's definition of insanity is "to repeat over and over again the same process hoping for a different outcome." Technology allows us to change the processes and we can get different outcomes and learn more and change. We can realize more of our potentials as humans and as a human family. Now there is a downside to that as well because the same technology can perpetuate all that is not good. That ranges from pornography which can destroy individuals, like instruments of war can destroy nations, but there is a real upside to it too, and I have a tendency to focus on the upside.

Minnie Spencer

Navajo Reservation, near Indian Wells, Arizona 1995
Navajo Reservation, near Indian Wells, Arizona 1952

I am Minnie Spencer. I have been living here since I was small. I was born here and raised here. Here is the Navajo Reservation and I just take care of the livestock, that's all I do, right now. The picture was taken about 1952. I was born in 1949. At that time we didn't live like we used to. It's the clothes that we do have now. At the time we didn't have any. Most of the Navajo people had to go onto a wagon to go to town. So that's what changed mostly. Most of the houses around here, they are getting electricity and stuff like that, water. For us we haven't gotten any yet. I guess in the future we'll be having it. So that's all I know that's changed. And most of the kids nowadays they hardly know their language like they used to. They don't really know their tradition like they used to, not anymore. I guess the parents are not teaching them, that's the main thing. Navajo means "the people." I guess it means what you are, what tradition, everything you know about.

I suppose, going to school was the most important experience in my life, because I went to a mission school all these years, until I got out of high school, that's when I came back, that's the one thing I know. I learned all the things that I can. America means freedom, I guess, I don't know about other places and other countries. Some people don't have as much freedom as we do here. We have freedom here in America. I love living out here. I like it better than living in town. But the only thing is how you can survive. Right now I am depending on the tribe, you know, they give out money to the people who are not working, that's how we get help from them. That's about the only thing I know.

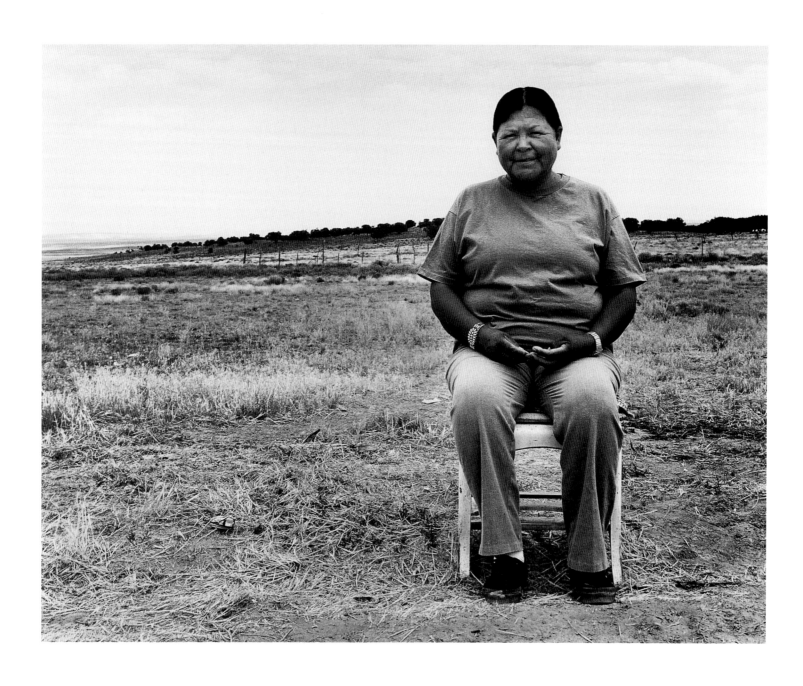

Minnie Spencer *Navajo Reservation, Arizona 1995*

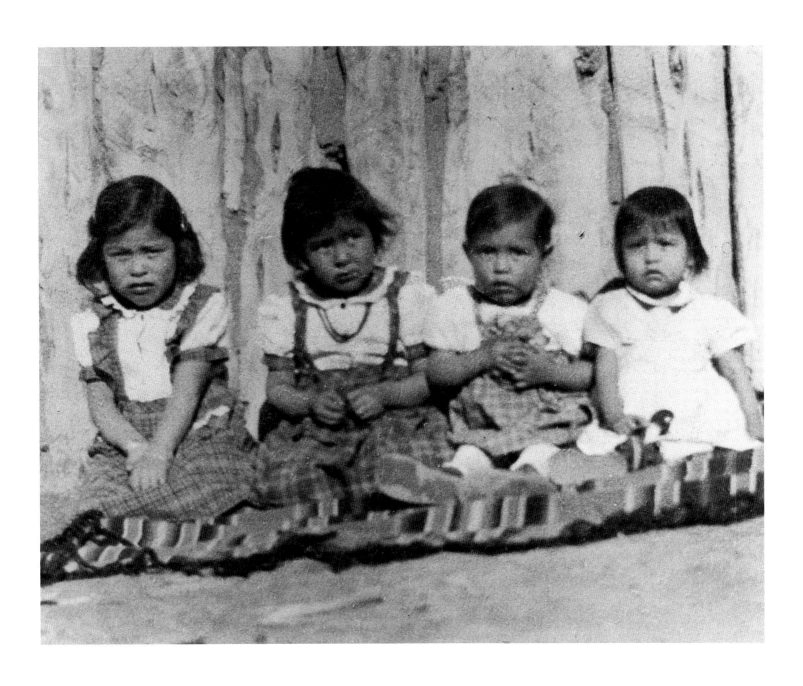

Minnie Spencer *Navajo Reservation, Arizona ca. 1952*

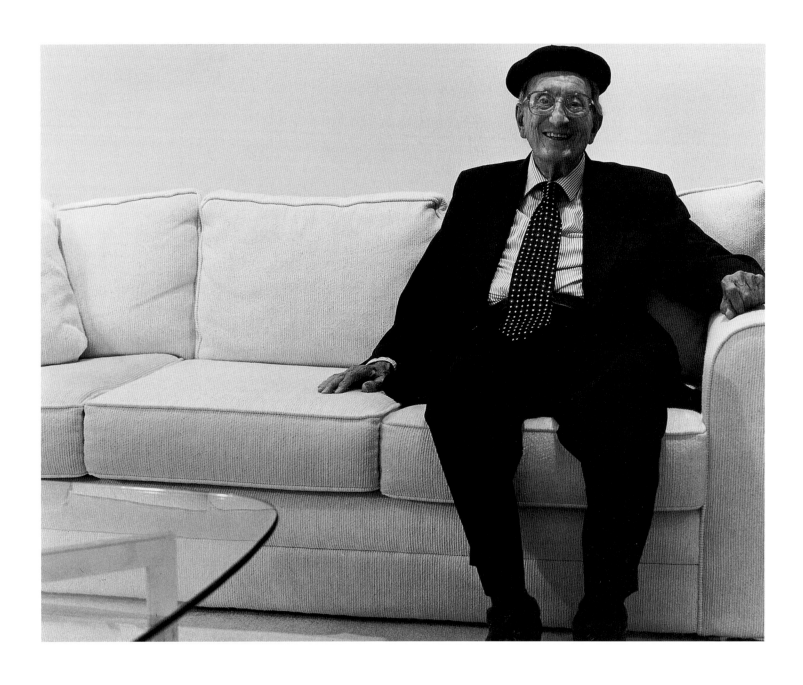

Simon Noveck *Toms River, New Jersey 1999*

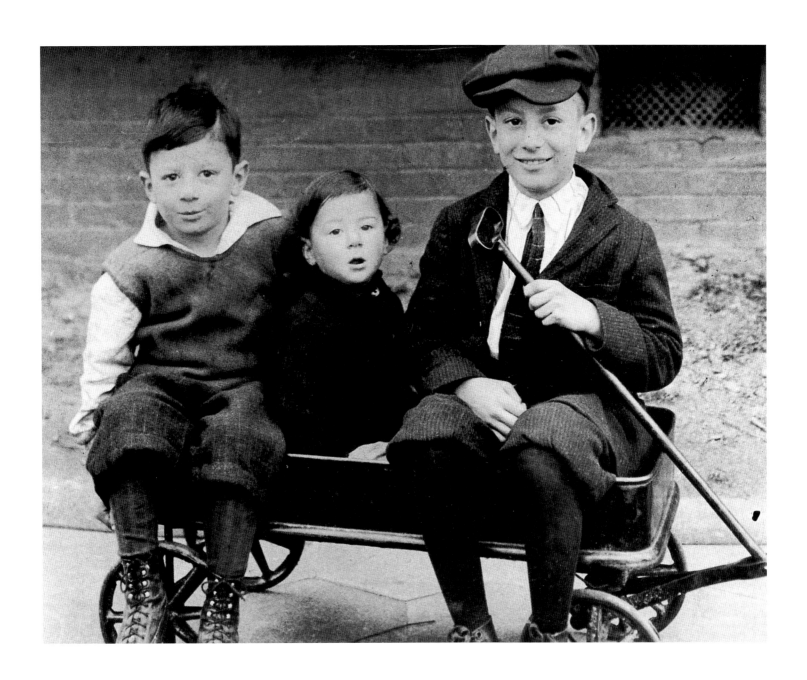

Simon Noveck *Atlanta, Georgia ca. 1923*

 Simon Noveck

Toms River, New Jersey 1999
Atlanta, Georgia ca. 1923

This is the only picture I have of myself as a child. My mother who came from a small village in Lithuania never had a camera and, in any case, with four children to take care of, had no time to take photographs. Fortunately a neighbor seeing the three Noveck boys, sitting in their little wagon in front of the house, snapped this one. I am about nine years old, my brother Harold on the left is almost six and Sidney, the little fellow, is one. Harold and I and several kids from the neighborhood played baseball in our backyard. That is, we did so until one of our friends from across the street hit a foul ball which broke two windows in our back bedroom which cost $7.28 to repair. This young man today is a successful businessman. Recently a cousin jokingly suggested that I submit a bill to him which, with compound interest after eighty years, would add up to hundreds of thousands of dollars. I doubt, however, if the culprit, rich as he is, will respond favorably to such a bill!

My father owned a grocery store in a mostly black neighborhood that kept him busy from 6 A.M. to 8:30 P.M. each day. Unfortunately, he was forced to sell much of the merchandise on credit. The customers would accumulate large bills and when dad would remind them of their indebtedness they claimed that they had no money to pay him. However, on Sundays he would see them riding about the neighborhood in their fancy cars while he could not afford one; and he would become depressed. My mother was devoted to her family but being an immigrant with no formal education in American culture would often send my two younger brothers or my younger sister to me as the oldest to make decisions or to help them with their homework. I gradually became a kind of substitute parent. Even after I had left home for college they would continue to ask my permission about various school and family projects. If I didn't have a good childhood it wasn't because of anti-Semitism, but feelings of alienation and loneliness that had to do with my parents.

At age six I became observant of Jewish rituals. The most important of these in Judaism is to keep the Sabbath. I refused to work on that day throughout my youth and until today. In my father's store the main day of business was Saturday when he was open until midnight and I was really needed. But my father respected my religious conviction and never asked me to work on that day. In later years, as the Sabbath ended, I would walk the three miles to the store to be of help. One Saturday night a man came in with a gun and held us up taking all the money in the cash register. From the loose way he held the gun it was clear he wasn't accustomed to

staging a hold up. Having read many books about American heroes I was tempted to wrestle with him. Fortunately I didn't make such a foolish effort for the result may have been disastrous.

When I became six years old my parents wanted me to have a Jewish education in addition to attending the local elementary school. I began to go to the Hebrew school every afternoon for two hours as well as on Sunday mornings and to religious services on Friday evenings and Saturday mornings. Unfortunately all the landmarks of my early youth—the synagogue, the Hebrew school, the public school, the kosher delicatessen, the kosher butcher, the house where I lived from the age of eight until eighteen, in fact, most of the south side of Atlanta—have all been replaced by the stadium of the Atlanta Braves. My interest in my Jewish studies in no way affected my interest in the general school subjects. Until thirteen I was more or less an ordinary student; then, whatever the reason, in the summer of 1927 after my bar mitzvah I became intellectually more curious and ambitious. I put up on the wall of my bedroom a large placard with the words "Lost time is never found again."

In high school I had an outstanding scholarly record graduating second in a class of 250 and the faculty elected me to be the class orator at graduation. It was 1932 and the topic I selected for my address was "Education and the Depression." Later that night at a dinner at the Atlanta Athletic Club the chairman of the Board of Education quoted from my speech and then predicted that Franklin D. Roosevelt would be elected President and "Simon Noveck will, in due time, be elected Governor of Georgia." For me such recognition, even if exaggerated, was a high point in my early life. But my father literally couldn't afford the $300 for tuition for me to attend Emory University. Fortunately two members of the synagogue which I attended, knowing of my situation, when in New York, went over to Yeshiva college and said to the authorities there, "For many years Atlanta has been raising money for the Yeshiva. Now we have a young man who wants to come here as a student. You must give him a scholarship." It was the heart of the Depression but they promised to make every effort. For several weeks, however, nothing happened; so I registered for a course in typing and short-hand at a commercial high school. Suddenly a telegram arrived that I would be granted a scholarship and I must report to the dean's office in two days which gave me only 24 hours to say goodbye to everybody. The train ticket was too expensive so I arranged to go by car together with six other passengers. I will never forget that ride.

Tolstoy says somewhere that when people go on a long trip, the first half is usually devoted to thinking of what they have left behind and then they focus on the future. This was true for me too.

For the first five or six hours I kept thinking about my siblings—Harold, Sidney and Sylvia whom I wouldn't see for ten months and, of course, of my hard-working parents as well as of a girlfriend and of the Hebrew class for young adults which I had organized, of my office at the Jewish Center as treasurer of the Southern Young Judea Association and of the Bible school where I was still a student. I was in a turmoil until I finally emancipated myself from all these memories and regrets and began to think of what I would find in New York. Would I be able to adjust to the strict orthodoxy of the Yeshiva? I had grown up in a traditional home but more liberal than what I would probably find at Yeshiva. The ride ended on the corner of 181st Street and Wadsworth Avenue in Manhattan around the corner from the young lady I would marry twenty-five years later. With my two heavy suitcases I walked over to 186th Street and Amsterdam Avenue. As I entered the building I said to myself: Simon, when you cross the threshold your whole life is going to change, and it surely did.

After graduating from Yeshiva in 1936, I studied at Columbia University earning my Ph.D. at the Jewish Theological Seminary from which institution I was ordained and at the New School for Social Research. I wrote my doctoral dissertation on the history of the Democratic Idea in the U.S. I've taught in the Political Science Department of City College, in the Judaic Studies Department of Brooklyn College, lectured throughout the U.S. and in South America. In 1949 I received a call from Rabbi Milton Steinberg asking if I was interested to become his associate at the Park Avenue Synagogue in New York, regarded in many circles as the most prestigious conservative congregation in America. Steinberg treated me like a brother. He had charisma, charm, and was a brilliant intellectual, regarded as the outstanding Rabbi in our movement and he opened many doors for me. When he died of a heart attack at age forty-five, a year of trial followed after which I was elected for a five-year term as his successor. At no time have I felt any problem because of my interest in two different academic fields. This is the greatness of America, its openness to diverse cultures, its freedom, its pluralistic ethos; America is not a melting pot as immigrants were once told but a mosaic which welcomes artistic experimentation and literary effort of all kinds.

Susan Rogers and Alice Nix

Washington, D.C. 1961
Alpharetta, Georgia 2000

When we were children, our father decided the time had come for a family vacation to our nation's capital. We drove for what seemed like days and days. After visiting several sites, we decided to tour the White House. After standing in line for about two hours, my mother was asked, by some very official-looking men, if the three of us were her children. She replied very hesitantly "yes," all the while thinking that perhaps we had done something wrong. We were escorted inside the White House by some other officials and a group of photographers. My brother, Tom, and us sisters all had our Brownie cameras, but had been told that we could not take pictures inside the White House, so we were a bit perplexed as to why these other people could. My mother was then informed that she was the one-millionth visitor to the White House and that there had never been a million people to tour the White House in one year. We were then escorted through a maze of hallways, the Cabinet Room, into the Oval Office and President Kennedy was standing to greet us. He presented our Mother with a signed photograph of the White House and autographed one of his photographs also. Several doors flew open and what seemed like dozens of photographers entered and stopped at an imaginary line. The President then escorted us outside on the porch to show us the dog, Pushinka, that Premier Khrushchev had sent to his daughter, Caroline. He then apologized that Mrs. Kennedy and the children were not there to greet us. He commented to Alice that he had a daughter quite close in age to her. It was truly our "15 minutes of fame" and a memory that has not been dulled by the long years that have passed since. When we look at the pictures, we are amazed we had the opportunity to meet one of the great leaders of the twentieth century.

When we were children, life was very simple. We never traveled except for a week vacation to the beach. Susan took dancing and Alice studied the piano. Susan expected that she would grow up to be a professional ballerina. She is now a dance teacher, instructing children in ballroom dance. Since our mother was a teacher, Alice assumed she would enter that profession too. However, her husband's career in banking and real estate interested her and she has been a residential real estate appraiser for the last fifteen years.

As children the word America only referred to the expanse of land where we lived. We had no idea what other parts of the world were like except what we saw on TV. As adults, we associate the word America with being "the land of the free." We have come to realize that people in some countries don't have the freedom to choose. Having this freedom to choose is what makes America stand out.

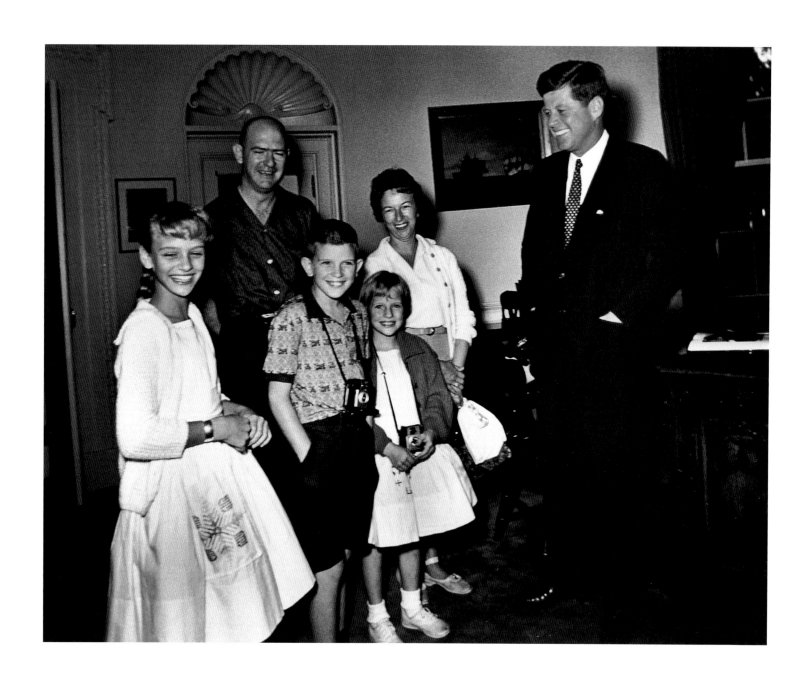

Susan and Alice Sprayberry with John F. Kennedy *The White House, Washington, D.C. 1961*

Susan Rogers and Alice Nix (born Sprayberry) *Alpharetta, Georgia 2000*

Jula Isenburger *Vienna, Austria ca. 1929*

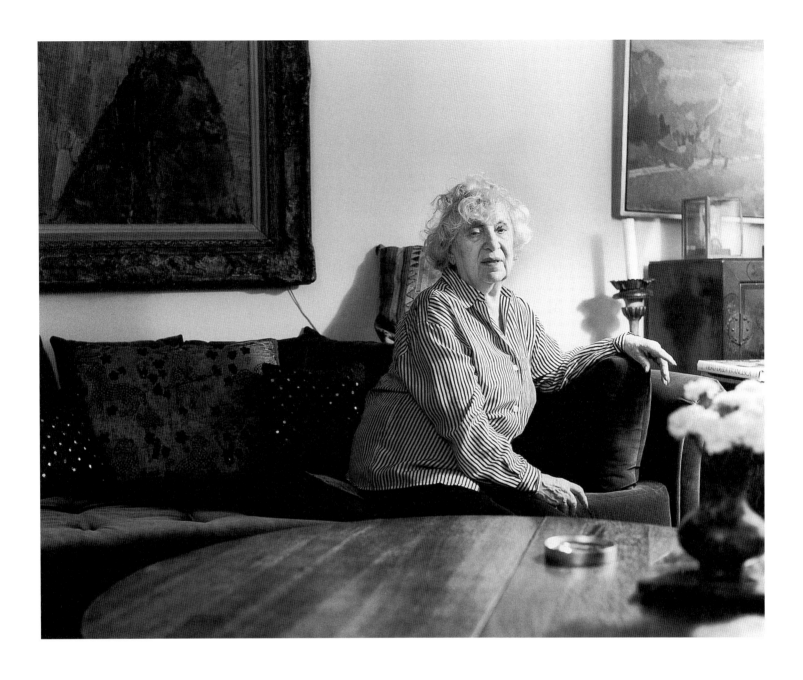

Jula Isenburger *New York City 1998*

 Jula Isenburger

Vienna, Austria ca.1929
New York City 1998

In 1929, I was seventeen. We lived in Vienna in a studio at Spittelauer Platz. We had just got married with the permission of my parents, because I was underage. Eric came from a very rich family and they were very angry that he married this little girl from Poland. Since they were a successful family of bankers, they thought Eric could do better. So we went to Vienna, because his family cut him off and Vienna was the cheapest place to live. I went there to dancing school and later became quite successful as a soloist at the Salzburg Festival, and later in France with a solo program. The man in the boat next to me is Fritz Klingenbeck, a choreographer. Together with Alfred Schlee he founded the famous magazine *Tanzschrift*. We had an outing somewhere in the Wienerwald and it was probably Eric who took the photograph.

I don't think I cared much about the future at that time. I was very young, full of vitality and totally immersed in dancing. Eric was a wonderful painter. We were living for each other and for our work and were very naive about the changes in the political world until they finally happened. In Vienna we met a lot of interesting people from the art world. Actors, dancers and writers. Friends would come to the studio and brought patés and Slivovitz. Fritz Klingenbeck mostly came with *leberwurst*. Each of us gave some *groschen* and we had a wonderful little meal. On other days Eric and I ate hardly anything. All that was not important to us. Eric suddenly inherited. His mother committed suicide because she was foreseeing what was coming. We decided to move to Berlin, because at the time everything in dance, theater, art and music was happening there. We made many very close friends there, like Warschauer, a famous photographer. The architect, Josef Neufels, would design the interior for Eric's studio. It took him a year and by the time it was finished, Hitler came to power and we had to leave everything behind.

Eric had his first exhibition at Gallery Gurlitt in Berlin in 1933. It was a shock when a very nasty article was published in a Nazi magazine. Wolfgang Gurlitt, who had become a good friend, gave us the advice to better go to Paris for a couple of weeks and to see what would happen. He convinced the French consul to give us a visitor visa but it turned out that I didn't have a passport to put the visa in. I must have told an Irish friend about it. She said, "I never told you, but my uncle is *polizeihauptmann* in your precinct." A day later a man in a police uniform rang: "Frau Isenburger? Here is your passport." That was her uncle. We left everything there: paintings, books, our cats, you name it.

After a while Paris became too difficult and we moved to the Riviera because the French only went there in winter and so in summer it would be cheap. Then the authorities in the south of France started to put all men who came from Nazi-occupied countries in camps. The plan was to find out who were the Nazis, who were not, but they never got to it. So men were sitting there for years till the Germans picked whom they wanted when they finally occupied France. Eric luckily got out and we were hiding, till our American visas arrived, in a French *pensione*, which was a nucleus of emigrés from Paris. We were the only German Jews and they were terribly nice to us. The writer, Jean Vertex, would go once a week to the police to find out if Eric was on the list to be picked up.

When we finally arrived in the United States in 1941, after an odyssey through Spain to Lisbon, we had to start all over again. I gave up dancing, because it would have been too difficult to work on two careers at a time. We didn't know anybody, but were lucky to meet wonderful people in New York. Eric became represented by the Knoedler Gallery a year after we arrived and became very successful as a painter and teacher. We were always traveling a lot. I was organizing our life and very often was Eric's model for his painting.

When I was a young girl, I just took everything that was coming without thinking, in my stride. I went away from Poland because I didn't like that country—the straight trunks of the trees, no leaves, even in the landscape was a certain feeling of animosity. The woods were full of white crosses. Poland always was a battleground. Instinctively, I wanted to escape it. Just get away from the wrong place! After all those years, all the horrors of Hitler and the terrible war, it's very hard to project yourself into a mind of a young girl who just wants to get away from where she is, because she feels that there are better places. America was a total absence to me, even in 1941. The movies were all that I knew: Laurel and Hardy, Charlie Chaplin. I always loved to read a lot, but I had never read any book by an American writer. In France, people said that America would be a cruel, vulgar and uncivilized place. I just hated the idea of coming here.

America now means heaven to me! If you are in New York, you are at the same time in Berlin, Paris or London. All the cultures melt here. Before Hitler, a great evolution in art and music was taking place in major cities in Germany. But now here it culminates! Europe needed centuries to develop what New York embraced in fifty years. They take over, they just consume everything. A lot of very good people from everywhere live and work in New York. Of course there are bad people too, but that there are so many good people here is the important thing.

Harvey Shapiro

Brooklyn, New York 1940
Santa Monica, California 1996

When the Vietnam War broke out—I had been in the army—and they started sending regular divisions to Vietnam, I understood. Things sort of came together. I understood that the United States was not only an imperialistic, but a criminal state. I got involved in politics, back then. I started teaching again. When a sort of little revolt broke out in New York in 1965, 1966, I joined the revolt to try to overthrow the school system. I formed my own teachers' freedom party. In short, what I found out was that it was hard to do. It wasn't hard to overthrow the school system, but it was hard to get people to overthrow the school system.

The vanguard was the person who I always wanted to be. How distant I was from that person. I came back to university—they never forgave me. So when I got back into politics I again became that person roaming the schoolyard for the Kaonstadt Soviet. They rebelled against the communists. They were the ones that started the revolution and then again were destroyed by Trotsky in 1921 because they demanded freedom of speech, freedom of expression. So they were really marvelous and I knew about them somehow when I was a teenager. I went to political groups before the Korean War. It wasn't that I couldn't speak but everyone would walk away from us in California. You could say something, but you were just a mad man. It was like Celine yelling out of the window of his hotel in Manhattan. Oh help, because he is all alone, there is no concierge and nothing.

I always had a comrade, a mentor; it was Hannah Arendt. I felt that she sort of gave me courage. And people kept saying to her, "Write something about this community control panel. We have the people control their own communities, the children won't become agitated." And she said, "No, you write it. I am in enough trouble as it is." I started writing that stuff and from that point I got into the political machines, the FBI. I am talking literally now. Mayer Kahan, the rabbi in the West Bank, a section of the Zionist fascists plus a black representative and others all working for the FBI, all the police agents—that's what you are up against in this war against the Federal government. That's when I started a magazine with an old friend of mine called *A Public Light* which was very successful and then I did book contracts in New York. I would write books and stuff like that. The minute the draft ended and the bourgeois kids were no longer going to Vietnam, the shades closed. Overnight all protests ceased. All of a sudden it was dead like a fish—you wouldn't believe it.

Schleiermacher, a German philosopher, was important for us. We started newspapers in Brooklyn and we kept pushing the theory that we would start a series of newspapers which would just call for things like a community center, a public space, you know, things like that. They weren't going for any political aim, they were just going for a nice place in the center of each community and we had hundreds of chores, like a plan without a master. We got everybody to sign up for these things, but of course it was no longer feasible to move anything. The bourgeois had become conscious of the fact that the rebels had been defeated. I am not talking about the right-wing bogus, I am talking about the left-wing bourgeois. The left-wing bourgeois became conscious that there would be no rebellion. Like Jason Epstein at Random House, who had given me a book contract. If they put him against the wall someone will say don't shoot Jason because he gave me a book contract. So he gave book contracts. I got a book contract and once they saw it was ended they didn't come through. The first anti-communist group in America was the liberal bourgeoisie. And back in the '70s the same liberal bourgeoisie closed down the shop. It was, I quote: "fascist" to write for them, you see, so it could no longer be published. The "lost intellectuals" claim that there hasn't been a public intellectual of note since 1970. That's true because there hasn't been any possibility of ever publishing any one. So the theory is closed. The end of the Cold War fundamentally destroyed any "rational resante" to these monsters. There is a monster state and nobody wants to say anything against it.

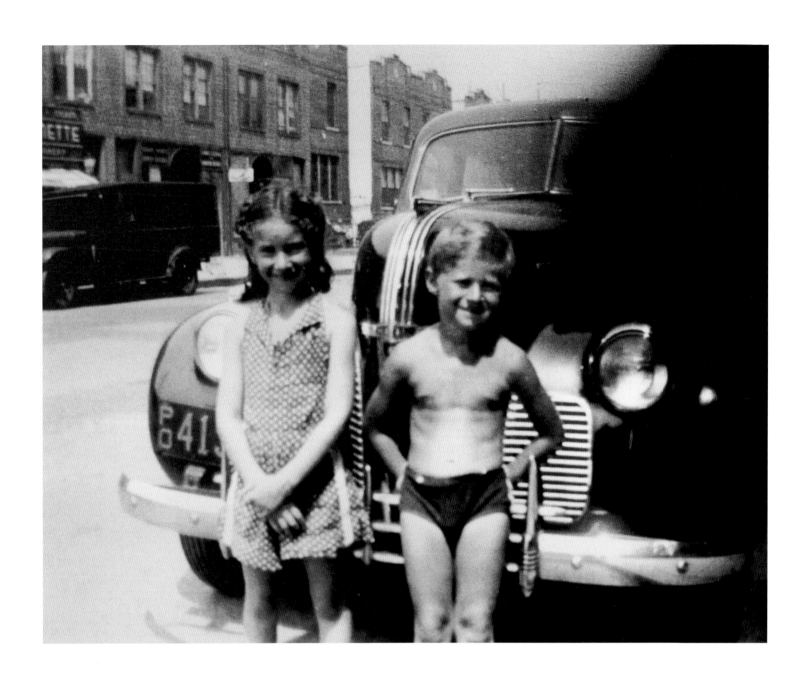

Harvey Shapiro *Brighton Beach, Brooklyn, New York 1940*

Harvey Shapiro *Ocean Avenue, Santa Monica, California 1996*

Duane Michals *near Gramercy Park, New York City 1996*

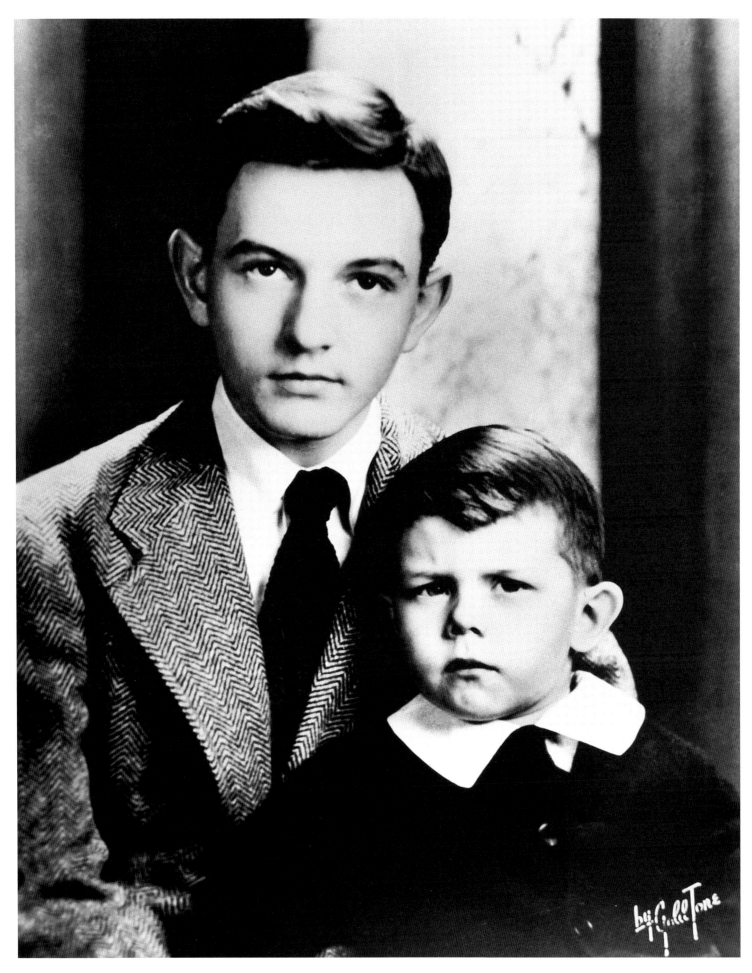

Duane Michals *McKeesport, Pennsylvania 1945*

 Duane Michals

New York City 1996
McKeesport, Pennsylvania 1945

I am not quite sure how I see myself anymore. I know I am well-known as a photographer, but essentially I don't even know who is talking now. I don't really know who I am and everything is falling apart. By that I mean all those definitions that had defined who I was. The Catholic church on one side, the United States Congress on the other. They don't stand up anymore and I am like walking in a cloud, while before the boundaries were definite. The rules were Jesus, Mary, the Virgin birth, and you got to belong to the country club. You get the big house, you have three kids, you make so much money. These are the things you should want. I seem to be an event, an experience. I don't identify with the body anymore, it changed so much. That picture when I was young is of my brother and myself when I was thirteen and he was four. It's startling to see how we changed. I was a freshman in high school. My mother was in hospital and my father had the photo taken for her in a professional studio. I remember very well my life at that point. My father was a steel worker in a little town where the rich people lived on the top of the hill and the poor people lived at the bottom. My grandparents were immigrants and came from Czechoslovakia. They discouraged people from going to college. I was very smart and so I got good grades, but I worked all the way through school. The idea was if you want something, go get it, nobody is going to give it to you. I was just beginning to mature, not ever dreaming I would be the person who is here now, and I love that idea.

I started in photography in a traditional way of taking portraits. When relatives would come from Chicago my mother would get her Brownie. It would be noon in the bright sun and we are all squinting. So when I went to Russia I just had people stand there. That's how you take pictures. August Sander, Lewis Hine, that traditional kind of way of taking the picture. Then other needs began to surface which were very important. I am very verbal and I am a storyteller, and so I started out by doing the sequences which were so liberating to me because I found a vehicle to express myself. I didn't have to look for a photograph, I could invent the photograph and that's a whole different activity. I became the source of my work. I could sit in my living room the way any writer would and invent the world.

I am really not a pure photographer. In fact I find most photographs excruciatingly boring because those photographs tell me what I already know, they don't contradict me, because photography reinforces all our prejudices about what reality is. That's why Avedon's portraits fail for me, because he describes somebody and the assumption being the description is this person. Nobody is what they appear to be and the biggest scoundrels can be the most attractive looking people.

I like one-to-one things. I like books because you can sit on a toilet and read. You go to an exhibit, works are on the wall, they are behind glass, they are saying "look at me, I'm expensive." I hate that. You can do 5,000 copies and you don't realize—5,000 people looking at that on the toilet simultaneously. I have a real "See Dick, See Jane" brain and that's essentially how I write. I am not capable of grand literary illusions or flight of fancy, I wish I were. I'd say I am an expressionist. I express myself whatever way I need to and I have written pieces that had no photograph at all. That's the first thing you have to realize if you are defining yourself narrowly with fictitious rules; you will be bound by those rules. You can write with a photograph and you can make six pictures and make a little series, but nobody can duplicate that kind of quirkiness that I have. I always thought I am just like the guy next door. I have never been the guy next door.

America meant "home" to me when I was a child. Now "the universe" is home. I thought I would grow up and have great adventures and that's exactly what I did. I think America is probably the country with the most freedom in the world, although it is terribly flawed. It's a racist country. It's not a perfect country, but it's an imperfect world and anything that human beings are going to be involved with is going to be imperfect. In 1948 the racist Senator Eastland from Mississippi complained that black children were getting free milk for lunch. He was being paid $200,000 a year not to grow cotton on his plantation as a government subsidy. That wasn't socialist, but giving black children a nickel a day free milk was socialism. So it's not a matter of who gets it, it's a matter of the amount. The more you are a pig of the government pigsty, you are not a socialist. I grew up with the illusion of the government being right. What brought the deck of cards down was Nixon in Watergate, and you began to realize how corrupt the government was. Many senators are a bunch of fucking crooks and it's totally corrupt. But America is still by and large the best country in the world—all the other countries want to be like us. They say America is so money-grubbing. The Orientals are just as bad, see what China does in the next century. Man's fatal flaw is his greed, but I can understand it, because as we evolved man could not be altruistic. When you brought down a deer and people from the other tribe showed up on the top of the hill, you don't say, "Oh, listen; come on, there is enough here"—no, no, no. You saw them coming and that is *my* fucking deer. You're dead when you come near *my* deer. Man is still very territorial and those instincts of acquisition and territory and greed helped them survive, but they are still there.

Steven Varni

Modesto, California ca. 1967

Madison Avenue, New York City 1999

Steven Varni. I was born and raised in Modesto, California—about 90 miles east of San Francisco, in the San Joaquin Valley. Modesto is considered a part of Northern California, but it looks pretty central on the map. I have a book coming out in March of 2000 from William Morrow, called *The Inland Sea*, a novel of connected stories, mostly set in California. Before I sold this book, I was a book buyer and manager of two New York City bookstores. Before that, I was in a Ph.D. program in English literature at the University of California at Irvine, and got a master's degree in 1988. I left the program before taking the Ph.D. examinations, but after finishing the coursework.

The main thing that strikes me immediately about this photo is that my younger sister is not in it. She was not born yet. She was born when I was five-and-a-half. In a way, it seems like a different family than the one I'm used to. My younger sister's absence shifts all of the dynamics. I was probably three years old in this photo, and there were a lot of animals around our house at that time: ducks, chickens, there was a sheep, horses, dogs. As I got older, we lived less and less in the country—things developed around our house. It became a different place. When this photo was taken, most of the attention at home was focused on me, because I was the youngest child and my siblings were all still at home. When my sister came along, I became like the older child of a second family of two kids. I was no longer the center of attention, whereas in the photo I am literally the center.

From about the time of the photo, I remember a great uncle, Zio Sam, who visited from Brooklyn. When he was leaving, we were at the train station, and I remember the train pulling away, and all the adults talking too much to notice, and their complete surprise when they did. I wasn't surprised at all. I was aware of it leaving. So I guess I remember this because I liked that sensation of knowing more than the adults. I also remember, from about that time, a slot-car racetrack near my grandparents' house. The huge cars, and how fascinated I was with them. It always struck me as one of the great places I'd been during all my childhood, even though I was too young to be allowed to actually race the cars. I always wanted to go back, but never did. I also remember, perhaps a little later, a friend of my sisters and brothers. She was probably nine or ten. I had a very big crush on her, and she hated me, of course, and her name was Louise Lyons. She hated being chased around by a four-year-old. I didn't really have any other ambition then besides catching Louise Lyons and doing what my older siblings did. If my two

brothers played baseball or basketball, I liked to be around them. I also used to draw a lot, just for something to do. The only thing I remember as being at all related to writing, was when I was about nine. I realized for the first time then that I liked being separate from the rest of the class. I don't mean it in a self-aggrandizing way; it was nothing astounding, in any way. I was in Catholic school, and after school one day, a nun and I were putting together a model of a California mission. I realized, consciously, I liked this isolation, this quiet, whereas before I always had to be active and mixing it up with other kids.

My earliest memory of America was the 1972 Olympics. I was eight. That was a famous Olympics, because the American basketball team was playing the Soviet Union and America seemed to win the gold medal. But it was decided, at the end of the game, that a second had to be added onto the clock, and the Soviets got the ball out of bounds, and they scored the winning basket. So the Soviet Union won the gold medal, and I was outraged. I was thoroughly on the side of the Americans, and I hated the Soviet Union, of course, and it was so clearly unfair. I was very chauvinistic.

America now seems to be an overwhelming and devouring presence to me. There is nowhere you can go to get away from the influence of the worst aspects of American culture—consumerism, consumption. A society in which the only value is money. The final measure—regardless of how much they talk about God, for example—is always money, and I just see this spreading everywhere. I am trying not to overstate it, but I am thoroughly disgusted with America in many ways. Christianity is used as a weapon against people. There is a distinct punitive streak in American culture. We really love violence, and we love to punish people. We are bombing areas of Yugoslavia right now, theoretically, to save these poor refugees. But we are bombing with depleted uranium bombs we know causes birth defects and cancer—from using them in the Middle East—in this area to which we are supposed to return these refugees, about whom we are supposed to be so concerned. I think it's quite transparent that this is all about justifying an increase in military spending for the United States. There are some good things to be said about America, but I am always suspicious of any place which insists that you say only good things about it, and which always has to keep saying good things about itself.

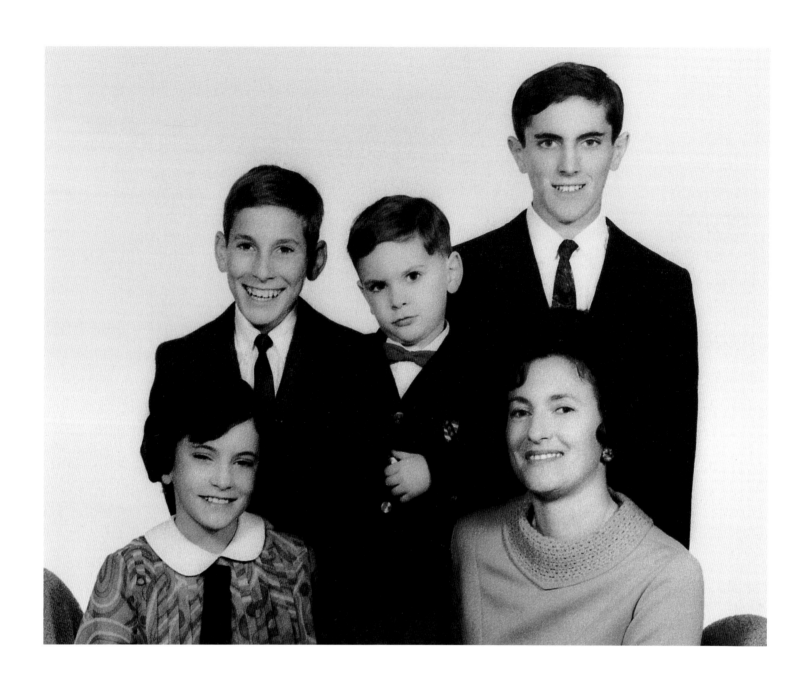

Steven Varni *Modesto, California ca. 1967*

Steven Varni *Madison Avenue, New York City 1999*

Fritz Scholder *Scottsdale, Arizona 1995*

Fritz Scholder *Wahpeton, North Dakota ca. 1946*

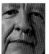

Fritz Scholder

Scottsdale, Arizona 1995
Wahpeton, North Dakota ca. 1946

I am a painter and sculptor and I have lived in the Southwest for 35 years. I was born in North Dakota and so I am a Midwesterner, but I also have roots in California. The Scholders were an old pioneer family. Around 1850 four brothers fled Germany and they all came to New York City. Three stayed in the East and one walked across the country and he had many adventures. At one point he ended up in Fort Apache and enlisted in the army to try and find Geronimo. When he got to San Diego County he had a wounded leg and he put himself under a big oak tree to die. He woke up in an Indian camp and an Indian woman was taking care of him. He married her and he discovered a gold mine and became a patriarch of San Diego County. In fact Scholder Creek is on the map and in the history books. He was Fritz. I am Fritz the 5th. My father, one of nine children, decided to have a career in the Bureau of Indian Affairs. He and my mother met at the Hopi Reservation, where both were working. From there he went to North Dakota where I was born in 1937 in Wahpeton. I had a regular Midwestern childhood, a very ideal time. I listened to the radio after school, Tom Mix. I looked at Superman comic books. I wish I had the first issue now. When my father got transferred to California, I really thought I would become a California artist, live in the Bay area, maybe Sausalito on a houseboat. But that didn't happen. I had a young family early. I got a scholarship to the University of Arizona in Tucson and discovered the Southwest and liked the climate much better than Northern California. I resigned after five years of teaching in Santa Fe. I realized I just wanted to paint.

I had some great experiences. I realized that one should live out one's fantasies. Early on I found myself in Transylvania doing a vampire series. I thought that I would become an Egyptologist and I have been to Egypt many times, but found that that's hard work and truly that all I wanted to do was to paint. I was very shy. Also I realized that I was quite a rebel, the bad boy in the faculty and I don't like to take directions, I usually do the opposite. I needed to be able to do what I needed to do and live off it some way. The odds of achieving that are against you. Today the artist has to live in a dichotomy of being true to himself in the studio and do exactly what he must do. Once it leaves the studio you have to become a businessman and protect that work. Today art is big business. I had a charmed life in many ways because early on I knew what I wanted to do and most people are not sure what they want to do. This helped a great deal. I wanted to live with walls around my house, very quietly making my own world. I am not a reclusive. I love to go to films, concerts and I am an avid collector of just about

everything. On my travels I especially look for things of the bizarre. You must bring in to put out and to make a statement no matter what medium. I tell young artists to travel. Don't worry about art schools. I was lucky. When I was growing up there were no drugs. It was a very pure time, especially in the Midwest. I wanted to live the kind of lifestyle that I felt was civilized. I don't put myself in danger. I like to read and just take life as it comes. I have been known to make crises for myself but it is one thing to have a crisis come to your life you are not prepared for. It's another thing to make your own crisis, essentially what you are doing almost any day in the studio.

I do believe America has an ingredient that I haven't found anywhere else. And it sounds trite, the so-called American dream, meaning no matter who you are, you may be born very poor or wealthy and any race and there is this possibility if you are tenacious, if you are talented, if the timing is right. I often say I come from absolutely nowhere. North Dakota is only one straight horizontal line. When I was there they knew nothing about art. I felt like an alien, truly. My father was a super sportsman, a champion tennis player, a champion golfer. He would go out and get his full line of duck, or deer or elk on the first day. And he had a son who just wanted to stay in his room and paint. He was so supportive. I have two sisters who are musicians. A pianist from Julliard who went on to get her doctorate from Stanford in musicology. A kid sister who is a violinist. In America you can do whatever it is you want to do. I am one quarter German—a very German name of course—I am one quarter English and one quarter French and one quarter Indian, or Native American as they like to say now. I am Luisenio, which is a little-known tribe in San Diego county. The Spanish renamed everybody—King Luis was the king at the time—so it was Luisenio. The natives were known as California Mission Indians because they were the ones that were forced to build the missions for the Catholic fathers, they were chained at night to the pillars so they wouldn't run away. So I am truly an American. I have a great cross-section of histories. The United States unfortunately has exploited many countries and has used its power in various ways. The atrocities the Americans did to the American Indians and how they wiped out the buffalo very consciously knowing that that would kill the Plains Indians, because from buffalo they got everything. A little-known fact is that it wasn't Indians that invented scalping, it was Americans. Early on in the East there was a bounty for Indian scalps, you brought them in and you got a certain amount of money. But Indians on the other hand would cut off your fingers to get your attention. Sadly, people who see someone else who is different so often think that they are either threatened or they want to take what those people possess, and it's the dark side of human nature and it's unfortunate.

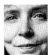 Wanda Wilson

Parsons, Tennessee 1952
Memphis, Tennessee 1996

My name is Wanda Wilson. I was born in a small town called Parsons halfway between Nashville and Memphis on the Tennessee River. Life has been very good to me, and I am enjoying living it in Memphis, Tennessee where I own a neighborhood bar called the Poor and Hungry Café. It's a place where very different kinds of people feel comfortable together. Of course, being exposed to so many people has allowed me to get involved in a lot of things I wouldn't have gotten to do otherwise. I was in a movie—an honest to goodness *big* movie. It was called *Walking Tall–The Final Chapter*, and I played a not very nice lady who informed on Sheriff Buford Pusser. I was in two music videos, and was also in an IMAX film promoting Memphis. You see Wanda up there on the screen, two stories high. There is an artist from Hungary named Paul Penczner who has sold pieces all over the place. He's in museums, and he has work in the Vatican. I think he's just the best artist in the word, and I'm his favorite model. That is one of the things I am most proud of.

I grew up in rural Tennessee, and we were very poor. I still have calluses on my feet from shoving pieces of cardboard down in my shoes when the soles started to wear out. All we had to wear for the longest time were clothes made out of flour sacks and I'll always remember going to the store with my sister and picking out the sacks that had the prettiest print on them. I didn't even know that we were poor. Most of our social activities were in the church, and you develop certain outlooks on life, morals, and character that are different than if you had grown up in the city. I am concerned about other people. If I see someone who needs help, I help them. I am really compassionate. My husband says that's the reason why he married me. I thought it was because he found me irresistible.

America just gets better. Freedom! Freedom to do anything I want, to say anything I want to say, to curse Bill Clinton when I want to—which is often. I haven't traveled enough to make much of a comparison, but I have always been proud of living here. It's just a feeling, a feeling of being, for lack of a better word, "free." I don't think a lot of other people I've known have had that feeling. People have the right to choose what they want to do. The communist movement always scared me. Ever since that day when I hid in my room because Kennedy was going to shoot somebody in Cuba because they had these Russian ships that wouldn't go away. What was that called?—oh yeah, the Cuban Missile Crisis. I never really knew anything about the Communist Party other than to know that I was afraid of it. And all of our fears stem from things we

don't understand. Then one day a couple of fellows from communist Russia came into the bar, and you know what? They were perfectly nice people. They weren't bad guys; they were just regular folks, like anybody else.

I've smoked cigarettes for over thirty years. I always ran with an older crowd—my first marriage was to a man twenty-five years my senior. He had enough money to squire me around, and buy me cigarettes. I'm sure though that the reason I started smoking is because I thought it made me look older. I became addicted to smoking before I had any idea how addictive and harmful it was, and sometimes I resent that we were not as knowledgeable about that then, as people are today. I've tried to quit several times, and the last time I tried I gained thirty pounds. Now my sister, who never smoked, is wearing all of my fine clothes. I sometimes feel like I didn't have much of a choice about smoking. Who knows, even if I had known how harmful it was, I might have smoked anyway. If I make a choice to kill myself, hey, that's fine too.

My entire family has always been big on pictures and we take thousands of photographs when we get together. And now everybody makes movies with their video cameras. I guess it's the same as keeping a diary—keeping the memories alive. I didn't have much choice about which childhood picture to use. My family's house in Parsons burned, and when the house burned, all the pictures burned. This is the only childhood photo I have. I like it because it has a look that says, "Don't do me wrong, okay?" But every time I look at it I think, "Oh my God, that is the ugliest kid I have ever seen in my entire life." On the day it was taken, my mother went through a great deal of trouble to make my hair look real pretty. She rolled it, and fixed it just so, but when I got to the playground at school, I started playing on the monkey bars and messed it all up. Needless to say I got a scolding.

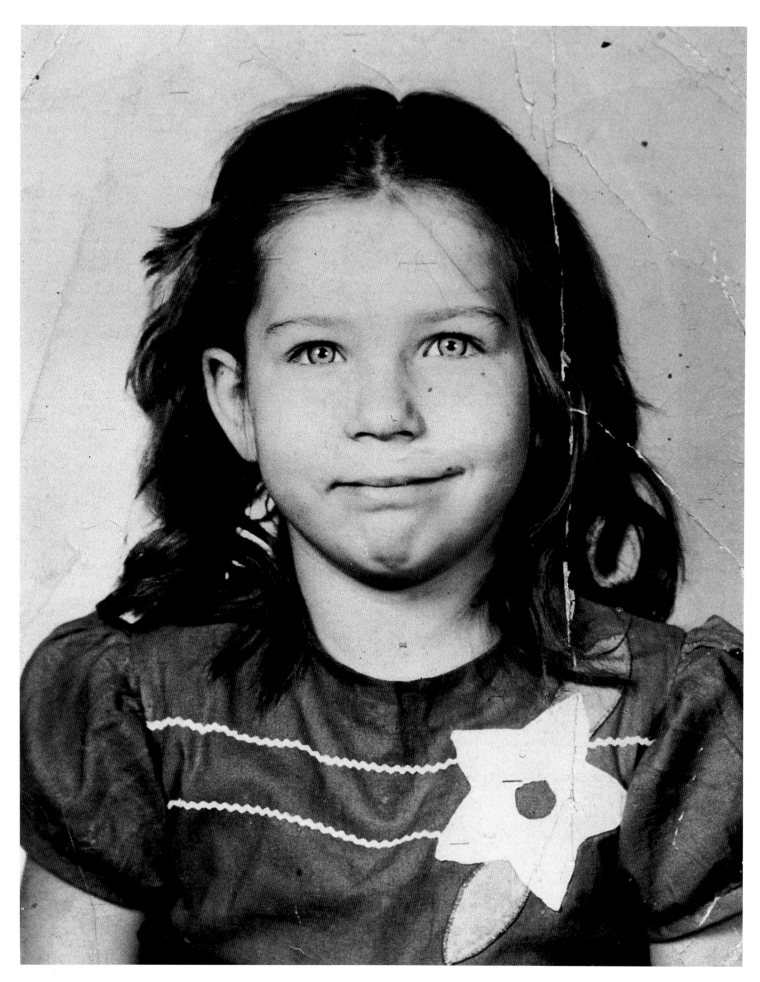

Wanda Wilson *Schoolhouse, Parsons, Tennessee 1952*

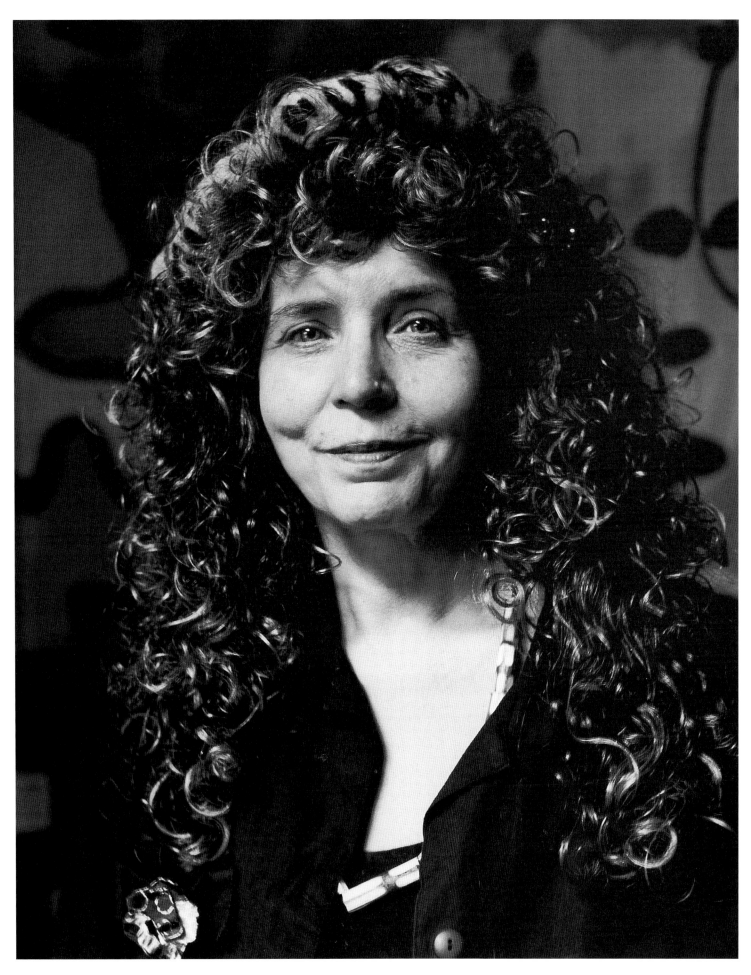

Wanda Wilson *Poor and Hungry Café, Memphis, Tennessee 1996*

Eliza Patterson (born Henry) and Clair Patterson *Mount Rushmore Memorial, South Dakota 1999*

Eliza Henry and Clair Patterson *Mount Rushmore Memorial, South Dakota 1946*

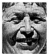 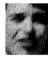

Eliza Patterson

Mount Rushmore Memorial, South Dakota 1999
Mount Rushmore Memorial, South Dakota 1946

The picture of Clair Patterson and Eliza Henry was taken June 1946. My sister Tillie, her future husband, Wilmer Grover and our friend George Kesterman all went to visit Mount Rushmore. Two months later Wilmer and Tillie and Clair and I were married on August 20, 1946—a double wedding. I have lived all my life in Keystone and am very proud of our town of Keystone, South Dakota.

My dad, Ernest Henry Sr., was working at the Sunshine Mining Company in Sunrise, Wyoming for the Bureau of Mines. The Bureau of Mines offered him a very good job in Mexico. He spoke English and Spanish fluently. He declined the job and then decided to go to Keystone, a mining town. He headed for Keystone in his brand new car, Chris Vranich went with him. Dad found a job right away then he sent for his family. Dad had a house and everything ready for us. It was around Thanksgiving time and on November 22, 1927, we all had a big turkey dinner.

We went to every dedication at Mount Rushmore. We saw the unveiling of all the faces of the four Presidents. Dad was a good patriotic man. Dad had a reputation of being one of the finest powdermen in the Black Hills. He worked for Gutzon Borglum, the sculptor of Mount Rushmore. Both Gutzon and dad had tempers. Gutzon would tell him how to drill and blast. The two would get into an argument and Gutzon would fire him. Dad would say "No! I'm not fired, I quit!" Dad would say "I am a powderman, I know what I am doing is right." He was fired so many times, and each time Gutzon Borglum's son, Lincoln Borglum, would talk dad into coming back. He was fired about eight or more times. My dad was a very ambitious man. He worked as powderman on the Keystone-Hillcity Road Highway number sixteen for Birdsall and Sons Construction, they had the bid. He had mining claims that he worked. Cut down trees for stove wood, took the wood to Wall, South Dakota on his truck and sold all of it. Dad built the log house on the original "Spencer Smith Homestead" that we bought from Fred Fisher. Dad did all the work. We all helped manually, also Chat Wagar, when dad was stumped on the windows for a log house. The log house is still in excellent condition. He worked in Barstow, California in the Betonite mine for Harold Eyrick. Dad was forty-four years old when he died. He was working at Holy Terror Mine in Keystone, a gold mine. Dad and Pete Jensen were through for the night. They were in the car when the cable in the shaft broke. They fell 750 feet and were killed. I was fifteen years old when the accident happened in 1942.

My uncle James LaRue, dad's brother-in-law, worked for Gutzon Borglum. He started in 1934 as a junior pointer. He had a mathematical head on his shoulders, three years later he was made senior pointer, which was the most important job on the mountain next to the sculptor. He was responsible for all the measurements and approved all drilling and blasting. He constantly laid out new work to prevent the delay and placing the workmen to their greatest advantage. He was the one able to tell the sculptor how much stone had to be removed at any point. Jim LaRue resembled George Washington. He was asked by Borglum to be the model for George Washington and Jim said yes. When we look at George Washington's face, we can clearly see Jim LaRue's nose.

Borglum had a temper. When gathering in the studio when Borglum wanted to talk to them, most of the time it ended up as an argument. He would get so angry and frustrated and would throw his shot glass in the fireplace and watch it explode. I have always felt proud and still do about Mount Rushmore, that's part of America, as far as I am concerned. The four faces on the mountain are precious and special. We were always anxious to see the unveiling of each face. We lived two miles, as the crow flies, from Mount Rushmore. We would walk up the Lafferty Draw with our lunch and stop and eat at the spring below the mountain. Then we would walk up to the mountain and watch the dedication. Our brother Private Ernest Henry Jr. joined the army and became a paratrooper. He was killed in battle action in France on June 8, 1944. He was the first Keystone man to give his life in World War II.

My husband, Clair Patterson, worked at Mount Rushmore and retired at the age of sixty-two. He was the water and waste-water treatment plant operator. I have been real active in different programs for Keystone. I was the first finance officer for Keystone; was secretary for the Consolidated Feldspar Corporation, a Feldspar mill; was clerk for the Keystone independent school district; was secretary for the Gutzon Borglum Museum; and was secretary for the Parade of Presidents Wax Museum. I am proud of Gutzon Borglum's creation of Mount Rushmore. Proud of the four faces of the Presidents who reflect the dignity and heritage that belong to Americans, and I am proud especially of my family that helped to make Gutzon Borglum's dream a reality.

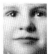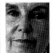 Devereux Marshall Slatter

Natchez, Mississippi 1929
Lansdowne, near Natchez, Mississippi 1997

My name is Devereux Marshall Slatter. I live at Lansdowne, my family home near Natchez, Mississippi. The childhood photograph was taken by a photographer named Earl Norman in Natchez about 1929. He, and his father before him, probably photographed most of the families in Natchez at one time or the other. I think parents would periodically have children's portraits made, since good cameras were not generally available then.

Life has changed tremendously since that time. It is not even close. Life was much simpler when I was growing up out here in the country. We didn't have electricity because only the cities had electricity until the rural electrification program came in the late 1930s. We used kerosene lights. We did have a deep well, so we did have indoor plumbing, but we still preferred the cistern water. My father was farming, using mules. I can remember when he was first able to buy a tractor. The telephone was a four-party line. You could listen in on other people's conversations. If each family had one car, they were fortunate, and you didn't run back and forth to town all the time, you might make one trip to town and bring back a block of ice for the icebox, because we didn't have a refrigerator. We had a vegetable garden, cows, and we made butter. In looking back, I now realize life wasn't so terribly different than it had been for my great-grandparents who lived during the Civil War period, except the blacks, or African-Americans, were no longer slaves. There is a plantation bell my father used to ring at the time for work to start in the fields and time to knock off for dinner and quitting time.

Growing up, when I was very young, I still had grandparents and great-aunts living who kept us excited about the Civil War; so we were kind of brought up on that. I think Southern women of that generation harbored more resentment than the men. They were still talking about the Yankees and the Northerners, so I thought they were some sort of breed of devils, I guess. Of course we considered ourselves Americans, but we were really Southerners more than anything else. I still think America is probably one of the best places to live, though there are probably smaller countries that do not have as many problems as we do. It's the one place where people who are having a hard time making it in other countries want to come to, and can make it if they really want to.

Integration changed my outlook a great deal. Of course, we are not as parochial as we were then. For many years in this area there were only two races, black and white. At one time there was a Chi-nese family living in Natchez, but they didn't stay. So that's really different now. You see all different races now. My husband and I recently married. He was a widower and I was a widow. His son was married in Natchez recently. He doesn't live here. He married a Filipino girl, and there were all kinds of different people at the wedding. So that's different. When I was growing up we still had house servants. We really did not learn to do any work around the house, so in that way we were sort of spoiled. When I grew up I soon learned cooking and other household chores, but I would never have dreamed of such as a child. Children all had nurses to take them to the park, to the movies, to Sunday school. In fact I loved my little nanny. I think she loved me, too. People in the South are very family-oriented. We live in the house that my great-grandparents built. They are all buried out in the family cemetery on the place. We are very attached to family things and try to keep them together. The house was built in 1853. There had been an earlier house here our ancestors built in 1780. It was probably just a small two-room house. Most people don't have many things left that belonged to their ancestors, so it's a special situation for us.

When I was a child I always wanted to be married and have a family and I did that, but I regret I did not finish college and have some sort of career. At that time in this part of the country girls were not especially encouraged to do those things.

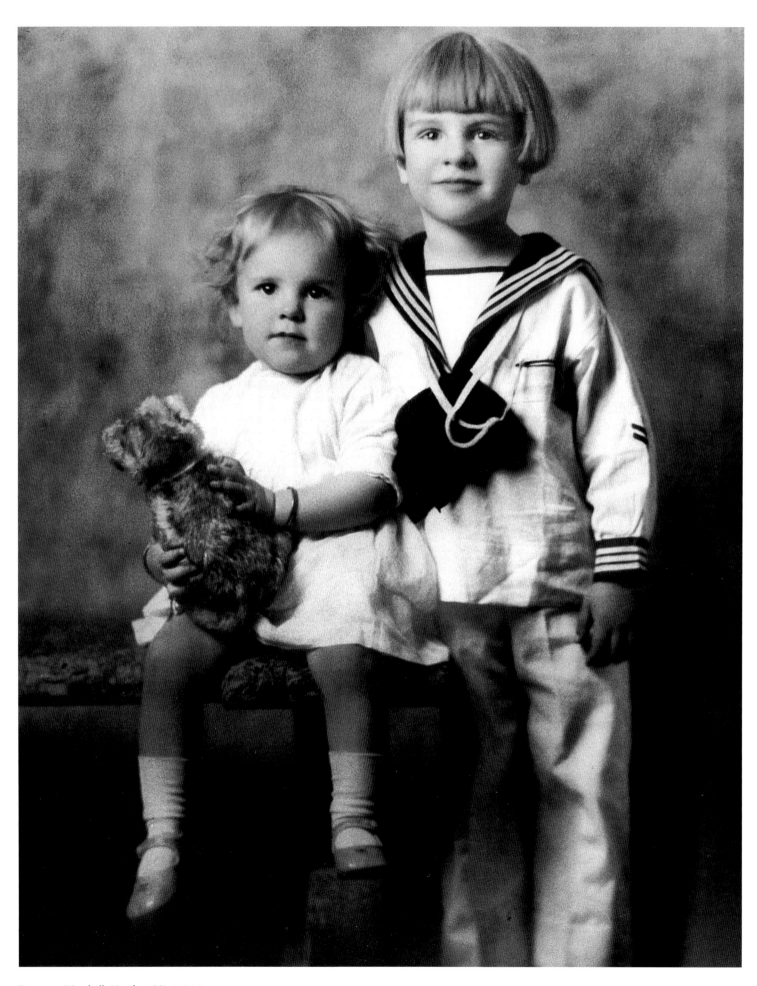

Devereux Marshall *Natchez, Mississippi 1929*

Devereux Marshall Slatter *Lansdowne, near Natchez, Mississippi 1997*

Philip Bergen *Cambridge, Ohio 1910*

Philip Bergen *Youngtown, Arizona* 2000

Philip Bergen

Cambridge, Ohio 1910
Youngtown, Arizona 2000

When I say I am the best authority in the world about Alcatraz I am not speaking lightly. I have outlived everybody who knew anything about the place. The media refused to see the truth because when it's good, is not saleable. Inmates like Al Capone and Machine Gun Kelly gave it the most notoriety because the press made a big thing out of it. Actually these big names are the least problem in the operation of a big prison; it is the non-entity who thinks the way to be somebody is by making an ass of yourself. The basic principle of Alcatraz was the same as of all the other federal institutions: rehabilitate these people come what may.

You are not going to have any beneficial effect on people by beating on them; they have been beaten on all their life, they beat on each other. The administration at Alcatraz didn't beat on them anymore, they respected them as human beings, the first step in rehabilitation. After I had graduated from the Alcatraz scene I became a prison inspector and traveled all over the United States. I was a hotshot, an undercover operator, all those things, stuff you wouldn't believe. I met ex-convicts from Alcatraz in jail and on the street and I never, never, had an unpleasant meeting. You can straighten them out but the best way is to treat them right in the first place when they are in their mother's womb.

I was born into a nineteenth-century world and I was probably more fortunate than most of my young peers, because my mother was an educated woman, a certified school teacher. That all comes back when I look at that picture. It was probably taken as a memento of my mother's visit of her sister Anna in Cambridge, Ohio. It was probably Anna's husband who commissioned the photograph. They were pretty well off and they came to our assistance more than once during the great Depression. I was five years, my brother six months old. I have a very scant memory of the train ride. I remember, from my mother telling, that we were welcomed back in Chicago as celebrities.

Nobody traveled then apart from taking a trolley to work. That was in the days before women's suffrage. For my mother to take her children to go 300 miles cross-country was unheard of; women and children were chattle in those days and didn't go anywhere without their lord and master. We felt pretty important and that made an impression on me. It was also the first time I had ever been away and had discovered that there was more to America than the streets I lived on. America went on forever and ever, and I was gonna see it all.

I had to earn my own money to buy a bicycle because my parents had to watch every penny that was spent. Round about 1922 the Chicago police department used to buy new Ford Roadsters and to economize at the end of the year they would just buy new chassis. I would buy one of their old ones for $60 and before the year was out I had a body on it for about $15. The Bergen family had an automobile! My mother decided that this was a remarkable accomplishment she was going to put to good use. She had always wanted to see Boston because her father's ship had landed there when he came over from Belfast round about the 1850s. So we all took off in my little worn-out car. There weren't any real highways in those days. Traveling by my eighth-grade geography book we made it all the way to Boston. Would you believe I tore that thing down in the vacant lot next to the apartment where we were staying, put in new bearings, new piston rings and ground valves, put it back together again and drove it all the way back home? I had the reputation of being a person that could do anything. I just had nerve enough to try, became recognized as a chance taker and never failed in any of them. Good luck or wisdom—that's the biggest thing that I remember about my life and the prison service gave me plenty opportunities to take chances.

In 1933 we heard that the Bureau of Prisons had plans to put together all the troublemakers from the existing institutions. The Attorney General came up with the idea of using Alcatraz Island. It was notorious even when the army had it. It was a place where we didn't want to work, period. I was working for the federal government as a custodial officer at the federal prison in Morris Park, Pennsylvania. Being the brash young man that I was I got into a nose-to-nose argument with one of the assistant directors of the bureau. I won the argument, but I lost the battle because I was going to be transferred to Alcatraz because they had a crying need for somebody just like me to help them solve their problems, ha!

When I showed up in Alcatraz in 1939 I found out that the rumors about the place were totally false. The discipline was a lot better than where I was working. The longer I stayed there the more I liked it and my family liked it too. Alcatraz just suited me. In 1946 an escape attempt happened. I was able to establish a principle of remaining cool-headed throughout and submitted reports that were conducive to the cessation of the battle. I was doing what I was trained to do and it turned out to be the right thing both for the institution, for me and for my peers. One inmate by the name of Jim Grulet said in his opinion I was a courageous character that saved his life and the life of other convicts. The then Captain had been badly wounded by gunfire and was never able to come back to work. The warden saw fit to promote me, a junior lieutenant, over the heads of all the senior lieutenants—a battlefield promotion.

We were always operating shorthanded; for dinner one lieutenant was supervising four officers for 300 convicts. On one of many occasions around 1952, I got word that the inmates were refusing to leave the dining room. Since I was the emergency relief, I asked the officer in the armory to give me a machine gun and tell the warden what I was doing. I went into the pathway outside, the lights of the dining room were showing full on me. Bergen just took the nozzle of that gun through three planes of glass and released the safety catch with a loud click. It was all very dramatic, that was part of the plan. I let that nozzle arch from one end of the dinning room to the other until it came to rest at the table nearest the door and called the lieutenant in charge to blow his whistle. They got up, one table after the other, and walked quietly back to their cells. The warden was at the armory when I returned the unfired weapon and he was not happy. He said, "You ruined your career, they will kill you next time you go in there," and all that. I said, "Warden, I am scheduled to be in there for breakfast tomorrow morning. Why don't you come and see what happens." Nothing happened the next morning and the warden just sheepishly grinned at me. That's Bergen.

The 20th century saw the American prison system being elevated out of the hands of the ignorant into the hands of professionals. A case of slowly growing up and adopting the principle of rehabilitation as being the only economically viable proposition to justify the operation of the prisons. The people in the business are beginning to realize that they have to put their money and their faith into the cradle instead of the grave. Not just nationally, but internationally we are all involved in the operation of, metaphorically speaking, a big factory for convicts. They are building prisons so fast and they are full before the last brick is mortared in place. It just doesn't make sense for intelligent people to bankrupt themselves, putting half of their fellow citizens into penitentiaries. In every country in the world the poverty question is paramount and it is paramount in this country. Any good country that really wants to handle the problem is going to solve it by curing its roots. I am not going to see that, but I think it's going to be reached.

Peter Truong

Seattle, Washington 2000
Hue, Vietnam 1970

I was born in central Vietnam in the 1950s. The only picture I have of my youth was taken when I was 16, getting ready to enter the South Vietnamese Air Force. I knew nothing of life or death yet. I went to school and church, then home to eat and study. I didn't even know the difference between male and female. My old picture has a worry-free face, except for the fear of the fighting that would come.

While I was in Vietnam I saw the way the U.S. government spent so much money on the Vietnam War. I thought America was so rich, there was gold in the streets. I felt very bad when a young American soldier died or was wounded. It made no sense to me when the U.S. government allowed our President Diem Ngo to be killed when they were so deeply involved in the Vietnam conflict. He was the one my family thought could lead us through this war to victory. Why would the U.S. government sacrifice all that money and all those lives for just politics? Why wouldn't they want to get the job done and get out instead of playing a game with the communist leaders?

When I came to America in 1975 I discovered all that money poured into Vietnam came from taxpayers. I felt very hurt when I saw students working for low pay but still paying taxes. Then their government might spend it on something they were against. Most Americans are so generous. I never will be able to repay Americans for the freedom they gave me. I love America, the country where I found freedom, and became a citizen.

Sometimes I think about the person who created the camera and wonder that it can bring to a human being such a range of memories, from happiness to sadness. A picture could be worth a million dollars. Today I see a totally different person when I look at my picture. My eyes, hair, and skin have all changed, but especially my brain has changed. It seldom stops working. In the sheriff's office I am responsible for many matters in the Vietnamese community as well as our community in general. Finally, I am thankful to God for all the good things he gives and the great life I have.

Peter Truong *Seattle, Washington 2000*

Peter Truong *Hue, Vietnam* 1970

Dixie Evans *Helendale, California 2000*

Mary Lee Evans *Maricopa, California ca. 1934*

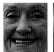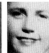

Dixie Evans

Helendale, California 2000
Maricopa, California ca. 1934

Hi, this is Dixie Evans and I am in my museum, the Burlesque Hall of Fame between Los Angeles and Las Vegas. I was the Marilyn Monroe of Burlesque and I loved Marilyn with all my heart. I didn't mean to make fun of her. Once she was going to sue me over a poster but then she realized I would be the only one who would gain from that publicity and dropped it. Of course when she died, I died too. It was over, my career was over, it was terrible. So I went to New York and of course in New York you can do a show every hour on the hour, because someone is retiring after thirty years and gets the golden watch in a fancy hotel like the Waldorf. First the agent would usually say no stripper and of course they would have a stripper anyway. I loved show business, it was really great.

The childhood photograph was taken in the middle of the oil fields of California in a little town called Maricopa. I was about ten years old because my father was killed on an oil rig when I was eleven and this was taken just before. I was happy and my future looked wonderful. My daddy was a very prominent oil man. I was going to go to university and have a yellow convertible and my sister was going to have a maroon one. It all went down the hole. We were not left with anything. My sister got married to her high school sweetheart. Mother and I moved to Hollywood and it was very depressing. My mother absolutely could not cope with my father's death because he had planned everything. He was a take-charge kind of a man. My mother could not find a job, at that time in history women did not work very much, it was difficult. We went to court, but a woman in court with two children, against these high powered men—we believe they cheated us out of everything. They did give us $2,000 but it wasn't sufficient for the enormous amount of holdings my father had in the oil business. I was bitter, angry, hurt and mad at God and everybody else. I was facing the same shock as my mother; she never stopped crying for I don't know how many years. I just wanted to go where there were lights, where there was music, where people were laughing. Every time I went past a bar in Long Beach or in Hollywood somewhere some sailors would come out and they were always laughing, having a good time. I thought, gee, if I could ever get inside one of those places, that's where they laugh. Well, I found out there is a lot of laughs and tears in a bar.

I did start drinking kind of early and then I modeled. In World War II they hired a lot of girls to pose with a sailor hat here and an American flag there. The pin-ups were coming up in 1942 so it wasn't difficult for someone who was seventeen to pose. I was making pretty good money and of course I was telling my mother I was posing for the Sears catalog. I was nude but they were not explicit in those days. It was all cheesecake and cute. I made $25 and sometimes $50 an hour, some honky-tonk movies with a little story to do a little strip. I got the feel for show business. Even when I was a child, I would go in the backyard and would lean against a tree and sing *Blue Moon* or some song that was popular. I actually dreamed I was someone and then I found out how difficult it was. You learn from other girls, you learn from musicians. Even though it may have been in burlesque theaters it was strictly show business. I worked maybe ten years without a day off, just performing and traveling. So burlesque was my father, my mother, my home, my money, my life and it was better than holding down a job at a store.

There were lots of nightclubs in Hollywood in those days and every nightclub would have a chorus line. I used to form little show troops myself. Four of us would come out with, "Everybody loves a baby, that's why I am in love with you, pretty baby." We would copy the movies. Whatever song was popular at the time we put in our little act. We played the border towns and Alaska and then when your booking is over you are out of money and you have to scramble home. The scramble was part of life and I am glad I had to endure many hardships. In my museum there are thousands of photographs on the wall and every one of those people had to wait at a lonely platform at five o'clock in the morning for the milk train to take you to the next town. You'd be very despondent if the audience didn't respond to you and then all of a sudden you go to the next one and everyone is nice. It was a roller coaster and it was the best ride I ever had. It was show business, even though you took your clothes off, but today it's really just boiled down to sex and money.

Burlesque was a theatrical show and each and every girl tried to be different. Lady Godiva came on with a real horse from the Roy Rodgers stable. Tempest Storm burst through the curtain to *Stormy Weather*, she'd come out screaming with wild red hair. With Lily Sincere the curtain would open up and she would be nude in an enormous beautiful bath tub. The legs were gold and crusted and the stage was bathed in colorful lights. The maid would hand her one gown after another, so she could to do an act with changing all the different gowns. Of course at the end she would do a lot of legwork on the couch until you'd see a gentleman's white gloves at the end of the stage and she would go off. We had a Latin girl do a Latin number. We had a real princess from Oklahoma, a Cherokee Indian. She had a tiny waist and her *derrière* was kind of large. She had a way of swaggering like no other with long black hair and of course she would come out of a big

tepee. It was a creative time in history. The newpaper ad may say she does a navel spin on an ice cube while her hair is on fire, I made that up of course, but you would go and see that act. The burlesque ads were bigger than all the other ads, beautiful and enticing. Many people don't realize that there was a world out there before television and in every major city in the United States they had two or three burlesque theaters. It provided the bulk of entertainment for the working class and there would be twenty, thirty, maybe forty girls marching forward to the latest song of the day. The comedians and comics doing stupid, silly shows, but very funny.

The big curtain would open up, the woman would iron the clothes and the husband would be puffing away on a big cigar. "If you don't buy me new clothes, I'll take off my blouse," she would say. She would take off her blouse but he wouldn't pay any attention, just puff on his cigar and read the newspaper. So now she would stomp her foot. "If you don't buy me new clothes, I am gonna take off my skirt," and she would wiggle out of her skirt. He wouldn't pay any attention, just puff on the cigar and read the newspaper. Now she is pretty mad and she is ranging up and down in front of the kids in the front row, preceding to take off a few more things and then she says: "Allright, if you don't buy me any more new clothes, I'm gonna take off all of my clothes and I'm gonna go nude in front of all of your friends, down to the post office." He'd jump up and throw that cigar down and the newspaper and shout, "What, you gonna take off all of your clothes in front of my friends and go down to the post office?" "Yes!" "Here, mail this letter!" The kids were waiting for this 10 or 15-minute build-up with lots of cute jokes and lines.

The success of the burlesque show depended on that next act coming out like fire, because once you got that audience you don't want to loose them. Sometimes you would be treated almost like a celebrity. A lot of people ask me today, weren't you embarrassed, weren't you ostracized in those days? No, we were not, if we were we didn't feel it because there were so many of us. The theaters controlled downtown and it was accepted. The stores were tickled to death to have those theaters. I just performed at the Orpheus Theater in downtown Los Angeles, where they are trying to bring downtown back and, believe it or not, the burlesque show is a way to bring L.A. back even though the girls are younger and they don't quite know what it is. When I stepped out on the stage and this thunderous applause came on I was thinking: "Who is walking out on the stage with me?" But you know what is was? Those people are desperate to see something alive, live entertainment, because you see a lot of canned things. It was a lot of fun to play that theater.

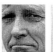 Robert Adams
at the mouth of the Columbia River, Oregon 2000
New York 1945

A month earlier I'd watched a parade of warships on the Hudson River, a victory celebration at the end of World War II. On the day of the snapshot my family was taking a ride on the Staten Island ferry. Among the sights I remember was the Statue of Liberty.

My father loved ferries. They were for him the best part of a three-hour daily commute between our home in New Jersey and his work on Manhattan. By 1947, however, the ferry he rode was discontinued, forcing him to take a tube train under the Hudson, a lurching, flickering, screeching transit. It was part of the reason, I think, that he and my mother decided it was time to move west.

I was taught to love America, and why to love it. I still do. It startles me even now to see contempt for it, to see a man fail to remove his hat, for example, when the flag is carried by in a parade.

In the 55 years that separate these pictures, however, I discovered that I could not, and still cannot, fly an American flag. The Vietnam War taught me that. I owned a flag that belonged to my grandfather, but I gave it away.

Life seems to me tragic. Reasonably well-intentioned but prideful people do terrible things. The generation that bravely led us through World War II, which was a just war, went on to drag us into a half century of mostly unjust wars and ecologically ruinous "progress."

What are photographs for? If they're made seriously they can begin a reply to Schopenhauer's aphorism, "Life is a business that doesn't cover its costs." All art is a search for an alternative accounting.

Family snapshots have a serious use too. The poet Charles Simic has written that examination of them brings about a nostalgia that, by its pain, leads us back into engagement with the present moment.

A short way upriver from where we're standing now there used to be a ferry that crossed the Columbia. It was a pleasant three-and-a-half-mile trip now replaced by a car ride across a sometimes crowded bridge. I know of a woman who, before the bridge was built, used to consult a tide table and at a promising hour pay her 25 cents and hope that the ferry would go aground on a sand bar. If it did, she enjoyed an afternoon of tea, quiet and fine views.

159

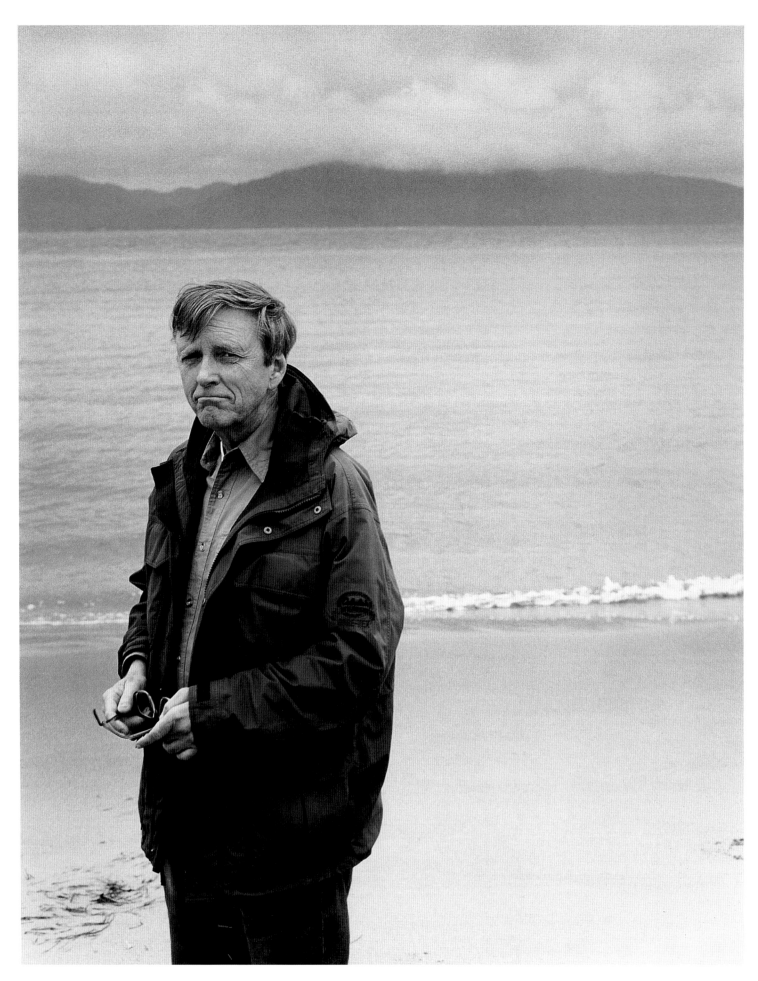

Robert Adams *at the mouth of the Columbia River, Oregon* 2000

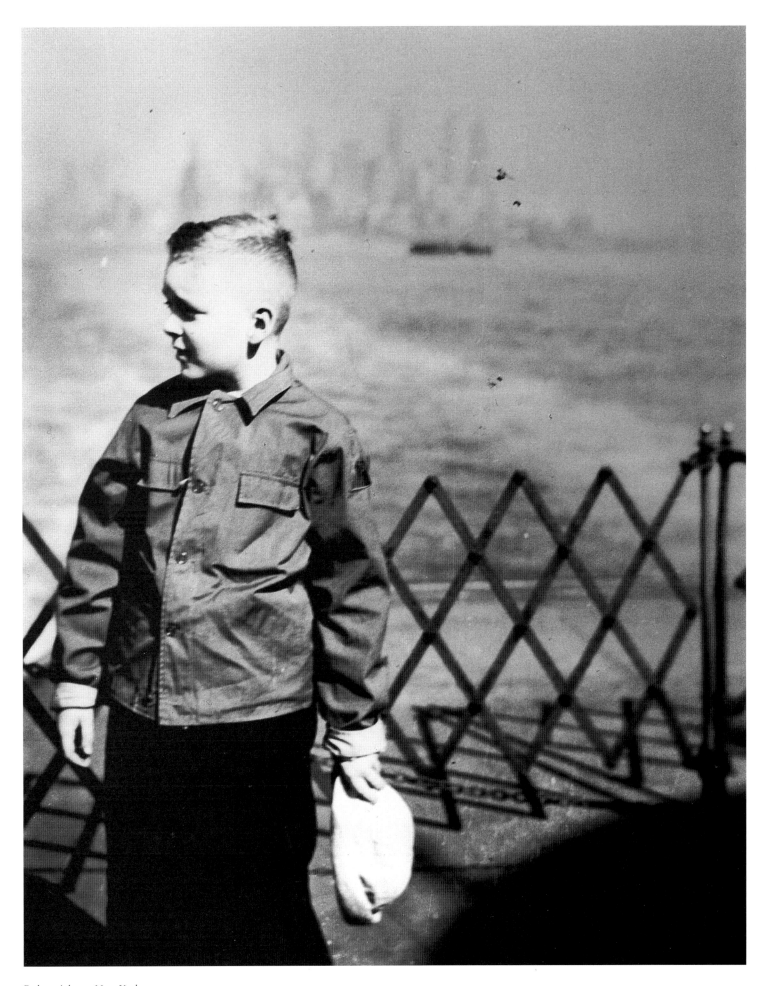

Robert Adams *New York 1945*

Stephen Savage *Mobile, Alabama 1997*

Stephen Savage *Ocean City, Maryland, Memorial Day weekend 1974*

Stephen Savage

Mobile, Alabama 1997

Ocean City, Maryland 1974

Barry Lopez

Finn Rock, Oregon 2000

Cliffs of Moher, Ireland 1962

My name is Stephen Savage. I live in Mobile, Alabama and I was born in Washington, D.C. My early image of America was from books. I was very optimistic and thought America was a pretty wonderful place, although I wasn't particularly happy. I had a difficult childhood. I was the eldest of four boys and my father worked late shifts, was always tired and therefore irritable. I loved my parents but my father and I were not compatible. My first thoughts of America were the result of very large events. The Beatles on the Ed Sullivan show, men landing on the moon, the deaths of John F. Kennedy, Robert Kennedy, Martin Luther King Jr., the Vietnam War. Those things—the assassinations—showing the horror that can be America, also focused me on my country and what was right and wrong. Even with the horror, this is a good and wonderful country. I think people are basically good. It's unfortunate the bad can sometimes be really bad. When I was sixteen, I did get my independence. I thought my future was my own and I think that's one of the great things about America. You can create your own future and there is literally nothing to stop you except yourself. The photograph of me as a teenager was taken on Memorial Day weekend, the day we honor the people who have died in wars. It is the start of the summer holiday season in America. This photograph was taken in the early 1970s, in Ocean City, Maryland. We are here, my high school chums, the young woman next to me was my girlfriend then and she is still a friend. The other woman was my best friend's girlfriend. It was probably my best friend taking the photograph. She's telling him to "Wait!," as you can see, waving to him. We were on holiday, drinking beer and it was fun. We were free and young and happy.

I took some photographs when I was young, but my parents didn't take many. That's why it was difficult to find a picture of me. But, when I went to college, I began to study television and radio which led me to photography and a degree in art history. I studied photography, because by then images were very important to me and are a huge part of my life now. I own a photographic lab and gallery and do commentary about the arts on public radio once a week. When I think of America today, I think about the freedom I've had to make my life my own. I am married to Emily, a wonderful woman. My life is very fulfilling and I am thankful that I have been so fortunate. I know there are many extraordinary places in the world, but I don't know that my life would be as good if I lived there. I think America is wonderful, a glorious place. We make mistakes, but so does everyone. That's the story of my life as well. I love life.

I was seventeen here, in the last days of a two-month-long trip across Europe with classmates from a Jesuit prep school in Manhattan. The photograph was taken in County Clare in western Ireland, looking over the Atlantic toward America. Probably the most lasting impression of the trip for me was seeing the devastation from World War II. Mile after mile of small white crosses in northern France, the great open spaces in German cities like Munich, the aftermath of saturation bombing. In my history books it was all about principles and tactics. When it was immediate to my senses, it was about tragedy, the catastrophic loss of human life, much of it the life of innocents. I think of these experiences as the first counterpoint to my experience of life in the United States. Something got fixed in my imagination then. I came from a country I loved, but I had not gotten the whole story there. I quickly came to believe that if we didn't get these other stories, we'd be imperiled.

When I began reading English history in college, I began to see the outlines of a deeply imperialistic country, one that would be eagerly and completely involved in the destruction of indigenous populations all over the world, but a country that had escaped condemnation almost completely in the West. For me, the United States is like nineteenth-century England in this way. It listens to no counsel but its own. We export a way of life that creates great hardship for many people and which fuels the social disintegration of communities. If you travel in Africa, in India and China, you see how severely human life is compromised by the aggressive promotion of consumerism. You can't help but wonder, doing the arithmetic with natural resources, how long it is going to last, and what we can do to mitigate the cruelty. Life in the United States, the mania for manufacturing and consuming, is a circus act. It's perpetuated by children who love the circus. They love the risk and thrill of it. They want to run away from home to join it. The adult who walks in under the circus tent to say the show has gone on too long, the dead and wounded are too many, is ignored. The issue for us, I think, is not how to protect the freedom of the adolescent to keep the circus going but to act on the obligation of the adult to shut it down.

In 1962, I never could have grasped any of this, but I know in those days, traveling in Spain and Italy and Germany and France, that I was very serious about my direction in life—and probably a bit of an irritant to my classmates. I entered the University of Notre Dame naively, intending to be an aeronautical engineer; but my true leanings were actually toward painting and language, toward metaphor. I made the switch and eventually became a writer. Dur-

ing those university years, I came to have a kind of constant anxiety about the fate of my country, a feeling, however, that I would still call patriotism. The only time I ever thought about getting out of the country was during the Vietnam War. Even as a moderately-informed youth I saw it as emblematic of something insidious. "Cultural Imperialism" was a term we used. America wanted to make the world over in the image of itself.

The United States is, as we all know, a nation of staggering material and financial resources. Is the best we can do a plan to make everyone a millionaire? Carry that message forth into every village, enforce it in every city? The one thing worth pursuing is that reciprocal relationship we call love—love of community, love of place. How deep into mystery must we go to discover this? And yet we seem as a country to honor material wealth above all else, treating it—if indeed these ideas are ever taken seriously—as a sort of beachhead for healthy spiritual and emotional lives. Reducing people to their roles as consumers, an unquestioned tenet of our economic "progress," is a derogation of human life. It is potentially the fatal flaw in American culture.

When I am asked about my life, what I imagine is not a sequence of unique incidents, an historical line, but something like a symphonic line. An idea that surfaces in the first movement finds a more informed or complex expression in the fourth movement. Also, we forget that much of music's impact comes from the silence between tones. I published a collection of stories, *Winter Count*, some years ago in which the characters' lives changed around incidents that an observer nearby might hardly have noticed. Life for most of us is like this—undramatic; but if you grow up with television programming you become accustomed to that half-hour measure of life completion. You are always watching for climactic moments and for closure. This isn't life, or if it is then it is possibly a nightmare.

The stories I know from oral cultures vary greatly in length, and some don't seem to have any obvious point. The intent here, I believe, is to convey the idea that our lives are not always at the stage of having a point, they are not punctuated on a regular basis by clear dramatic event. I think this is good guidance, from the Paleolithic forward, and that our obsession with making a point with our lives, with scrutinizing the steps of the career ladder, striving toward a place of recognition, that all this keeps us in the perpetually anxious state that advertising feeds on.

If you were to ask a man in America who loved his family what it meant to provide, he would probably answer to have an income. In traditional societies, in my experience, grown men have another

answer here: to provide is to be in love with your family. The social fragmentation indispensable to economic growth in American society, the subdivisions of the family and even the self in order to constantly broaden the consumer base, is extreme. In a nutshell, a high rate of divorce is essential to what we call a healthy economy in America. There's a lot of darkness, of course, in what I am saying; but I go back to that boy on the Cliffs of Moher and can tell you that I spoke then and speak now out of a love of my country. I want to do something to help.

It was right around this time, 1962, that I began trying to write stories. Many of them were set in the American West, where I grew up. The kids I went to prep school with in New York had ideas about the West they got from the movies and pop culture. I tried to write against the grain of that. When I was nineteen, I went to work on a ranch in Wyoming for the summer, a set of experiences that had a profound impact on me. I draw on those images almost daily—physical labor, wild animals, tame horses, distinctions in social class.

I also began photographing then, work I quit in 1981 because I couldn't manage the intensity of the two desires. And I had also come to feel that for me photography created too much separation. As soon as the shutter clicked and I lowered the camera, the landscape resolved itself again into an animate, unbroken place.

When I came to New York City as a boy from rural California, I was exposed to high culture and I was given an excellent and bookish education. Now, thirty-five years later, I live in the woods, far from the city, in a house filled with books and art. My life as a writer has been a drawing together of these two realms, long days in the library or the museum, days afield in a remote wood. I don't trust the one untouched by the other.

When I am writing about a place I've been to, I incorporate what others have said with what I have learned by going there; but what I write also grows, quite indirectly, out of conversations with my own community, the unending conversation about what we truly value in life. Daily social intercourse, I believe, enhances rather than undermines the individual vision of the artist. And I also believe the artist has a moral obligation to give back to that community in his work, to reciprocate. If the community invests its energies in you, you need to bring home from your journey something useful to the community. The young man in this photo doesn't know it yet, but he has an obligation to say, as well as he can, what it was like that time on the Cliffs of Moher.

Barry Lopez *Finn Rock, Oregon 2000*

Barry Lopez *Cliffs of Moher, Ireland 1962*

Joseph Weizenbaum *Pariser Platz, Berlin 2001*

Joseph Weizenbaum *Gendarmenmarkt, Berlin 1934*

 Joseph Weizenbaum

Berlin, Germany 2001

Berlin, Germany 1934

Weeks ago I was introduced to President Rau of Germany as the inventor of computer technology. I am certainly not the architect of computers. I'd like to be known as an experienced computer scientist who has become a dissident in the field. I am not a critic of computer technology, rather a critic of society. Computer science is a very convenient hook because the computer is involved in so much of what we do today. My view of the United States and its role in the world is consistent with that. The use of technology and particularly the computer in warfare is a disaster. I wrote a book called *Computer Power and Human Reasons–From Judgment to Calculations*. I often thought it should have been the other way round. The tragic thing that has happened, especially in the elite, is that where we once made judgments based on what one might call gut perceptions we now apply "rationality." In warfare computers are the perfect instrument to pick the target. There is much to be dissented about in this world.

My major was mathematics at a relatively minor college where the professor thought that the university should have a computer. In the 1950s if a university wanted a computer they built one. It was one of the major experiences in my life to build a complex instrument like that. One had to invent it and it was a terribly wonderful adventure and it helped that we were successful. The exchange of ideas was absolutely great, nobody thought about patents. We practically got to know everybody in the small computer community and there wasn't any computer science then.

My first real job in the computer industry was on the navy base Point Mugu, California where the development of the Cruise missile was in its absolute infancy. It wasn't at all clear that it could actually do what it was supposed to do. The computations that had to be done were done with flying experimentally. It was always a big deal when they would test one and quite spectacular when they blew up. Imagine here is a missile that navigates by vision and when it finds the target it goes in the left door. You are sitting on a hill and see that place is full of people. If you wish it didn't work, then you should find some other work. If you believe that the Russians, the Chinese or whoever are a mortal threat to civilization I have a quite different argument with you. I believed in the missile gap, that was much talked about at the time. It took a while before I got a more realistic picture of the world.

Eventually "you become what you pretend to be" and in 1963 after communicating very clearly what needed to be said at a com-

puter conference I got an invitation to teach at the Massachusetts Institute of Technology for a year. They were just starting with computers and I was finished with developing a computer for the Bank of America. So I went to MIT and it was like putting a little boy in a toyshop full of electric planes—just wonderful. It wasn't all play and fun, but it was a good twenty-five years and I eventually became a professor.

The picture is taken at the Gendarmenmarkt in Berlin shortly before we went to America. It is 1935 on the steps of the Schauspielhaus and pretty much across the street from where we lived. My brother and I are both identically dressed in short pants. When we came to Detroit, Michigan we were practically laughed out of the place. I remember the embarrassment once we got to school, and we never wore short pants again. My brother Henry, or Heinz at the time, seems to embrace me spontaneously more than I him. I don't think it was a typical pose for us, we were often rivals as is the case with brothers close to another's age.

The Jewish boys school that was established after Jewish kids were not allowed to be in the Gymnasium anymore I remember very well. Herr Reich, the teacher, looked a little bit like Professor Unrat in *The Blue Angel*. He also had some of his manners. I am now ashamed of how we teased him. His wife having a baby brought forth sexual ideas and by age twelve boys no longer believe that parents had intercourse exactly once for the baby. I remember walking by an office supply store and one of the things they had in the window was a little rubber thing that you can put on your finger to turn pages. I remember speculating that's probably a condom. Obviously I wasn't fully informed, but I think there were evidences of sexual awakening. On the way to school I had to walk to the Alexanderplatz and I passed by the Rote Rathaus which became famous when John Kennedy made his speech "Ich bin ein Berliner!" One of the buildings there housed a newspaper and they always had today's paper in the window. For some reason I remember that one day they had a big spread that the American gangster John Dillinger had been killed. I had very little idea what America was, I was looking forward to an adventure.

The Atlantic crossing with the fastest ship, the Bremen, was a wonder. I remember going across the gangplank and all of a sudden you are in a big spacious hall, a building not a ship. I "knew" about America out of books like *The Last of the Mohicans* or detective stories with John Kling. He worked in Manhattan so I wanted to see skyscrapers very badly, but when we landed in New York we immediately went to the railroad station where we took a train to Detroit. We had to transfer in Buffalo and I thought surely we would see Indians. The name Honolulu was familiar to me and I

discovered to my astonishment that it was actually a city. I remember also finding a chewing gum wrapper on the floor and it was green and I thought it was money. I had heard stories that one could find money on the streets.

I soon learned that President Roosevelt was a very great man who did good deeds for the people. This idea stayed with me until the war was over. I was in the army as a weatherman when a black soldier told me that was not a true picture, that he had done essentially nothing. It was a reversal in my mind, namely it taught me that such reversals were possible. I had subscribed to Dwight MacDonald's critical magazine *Politics* and learned a lot from this brilliant writer, so this epiphany that Roosevelt was really not the angel that I had taken him to be was already prepared. I think that America is an imperialist nation. We more or less bought countries, perhaps all of South America. A disproportionately large percentage of our black population is either in prison or on probation, especially young men. The corporations are ruthless. The depth of poverty in America is largely unknown to most people, especially Europeans. I leave the dark side at that. On the other hand the white individual in America is as free as anyone on this earth. Unfortunately the freedom of the press isn't used to a large extent. In 1973 Henry Kissinger and Henry Ford happened to be in Indonesia and the people there put it to them that they attended to East Timor. They were told we have nothing against it. In the first year of that conflict one quarter of the population of East Timor was murdered. It was a terrible tragedy, but contrary to the occupation of Cambodia not a word of it was published in the American press. It was largely self-censorship and so there is a lot about America that America itself is not conscious of.

I started photographing before the war when I realized very quickly the important thing is to learn to see. You can make a little frame out of your fingers and you don't need a camera for that. I often photographed my four daughters who are an important part of my life. I am very happy about them and very happy with them. In 1973 in Palo Alto, California I was a fellow for behavioral sciences and got into a mode of doing portraits. I learned then that every portrait is to some extent a self-portrait, that the photographer is in it. I did a very successful portrait there of a famous psychoanalyst. I made one exposure. Then his wife came to me and I wasted two roles trying to photograph her. There was another fellow there, a bear of a guy and a very successful sociologist. I told him, "you are two entirely different people, which one do you want me to photograph?" On the one hand, the famous professor, top-ranked in the nation and on the other hand a little boy who doesn't believe in himself. I finally did two pictures, one of each.

Hoai Huong (Julie) Pham

San Jose, California 2000
Tacoma, Washington ca. 1983

My Vietnamese name translates into "one who remembers her country," but I've always wanted to be American. In America, though, you can't avoid the first half of your hyphenated identity. My last name instantly identifies who I am, often invoking in older Americans memories of a war that happened 25 years ago.

Growing up, I didn't know what the war was about. My parents and I left Vietnam when I was two months old; I had never asked them why. It was in college that I first learned about the war and also discovered how little was written from the South Vietnamese perspective, from Vietnamese émigrés like my parents. I came to understand, through research, that the absence of a South Vietnamese perspective stems from how America views the war as being between the North Vietnamese and the Americans, with South Vietnam as its sidekick. Americans, I think, are obsessed with getting over the "wounds of the war." One of the best ways to get over the war is to realize there are other sides to the story too.

So, for my undergraduate history thesis at UC Berkeley, I'm researching the South Vietnamese military perspective through oral histories. I wanted to know what veterans now living in the States had to say about the war. Most said they fought for freedom, for democracy; others blame themselves for the loss of the war; it's a complicated story. Honestly, it wasn't until I began talking to these men that I began to understand my parents more and what it means to be Vietnamese.

Americans, including myself, are preoccupied with ethnic identity. Sometimes I doubt if I'm the right person to be doing this research because I don't speak Vietnamese. I wonder if other people have the same doubts. I am very conscious of how my own identity plays into this research. Is my research supposed to be better because I have a personal connection to it? Or am I too biased to be doing this? Do readers expect what I have to say to be bitter and angry because the narrative that I offer has been previously ignored by Americans?

I'm not bitter or angry though. Americans often cite the Vietnam War as exemplifying what is wrong with this country. But there is a lot right with this country. My parents didn't want to leave Vietnam; they had to. We're lucky we're here. But what do I know? I'm just 21 years old, I've never traveled abroad, my views are provincial. I don't think it really matters where I am though. I'm still learning what it means to be Vietnamese and to remember my country. I'll always consider myself an American.

Hoai Huong (Julie) Pham *San Jose, California 2000*

Hoai Huong (Julie) Pham *Tacoma, Washington ca. 1983*

"A fragmentary map"

Susanne Baumann in conversation with Reiner Leist

How did you first get the idea for this project?

I wanted to learn something new. After seven stimulating years spent in South Africa before the first democratic elections, I was curious to see new surroundings. My work often involves long-term projects revolving around a particular location, a type of research that demands that I get involved in the new place in a fundamental way.

Does this project reflect your own life situation in a certain way?

Yes, in that I attempt to familiarize myself with my new surroundings by questioning how other people came to live where they do, and from what situation in life. It interests me how our surroundings influence our worldview. But also how a place has its own associations and how the effect of it on us changes, even if we don't leave it all of our lives. I think of Benjamin Ferencz, for example, who was born shortly after his sister in the same house but in another country: Hungary had become Romania. *American Portraits* is the work on a type of fragmentary map, a "new world," that is laid out in geographical breadth and biographical depth. Here the new world is the geographic representation of a hopeful beginning. As a country of immigrants, perhaps the United States holds this idea most strongly. I link that to each individual's childhood and the hopes associated with it. But I also use this outmoded phrase ironically since this once uncharted territory has become a standard against which the whole world measures itself, one that is not always associated with progressive ideas.

Please describe your idea for the project and how you went about realizing it.

The starting point was a collection of sometimes clichéd concepts and themes associated with the word "America." At first I began collecting from my own memories, from the time when I was growing up, but I also gathered ideas about this list in many discussions over time. In that way it became a list of references and names which Europeans who grew up with radio and TV in the '60s and '70s would probably have arrived at, or something similar. Ideas which do not necessarily contrast with American notions: "Cowboys and Indians," the Statue of Liberty and Vietnam, racial discrimination, the Civil Rights movement, baseball and boxing, James Dean, Marilyn Monroe, World War II and the Holocaust, Hollywood, motels, and so on. I tried to travel as far and wide as possible, from Rochester to Key West, from Seattle to Los Angeles, following this broad geographical orientation scheme. I spoke to about 100 people.

Did you try to create a typified picture of a society, as the photographer August Sander tried to do, for instance?

The work is not based on a static model of society, as is the case with Sander's portraits in *Citizens of the 20th Century*. Without a doubt my idea of the United States was influenced for the most part by the mass media and books, and this project is an attempt to compare and combine these references with my own personal experience.

You were most probably interested in representing a broad cross-section of society?

Yes. My memory of America was only the starting point. The various social roles interested me too. For example, as a child I was of course not aware that freedom of speech played such an important role here. That's clear to me now and a topic that I have tried to address.

How are the portraits created once someone has said that they are willing to participate in the project?

I ask the participants to choose a picture from their childhood, one that has a special significance for them. In many cases there is only one! Now I draw an imaginary line along the contour of the person in the picture, thus separating them from the background. That is the starting point in my search for corresponding pictorial elements in the new portrait. I consider the composition of each of these new ones individually.

The childhood picture of the person, and thus their past, is juxtaposed with the new portrait. Are these two visually represented time factors bridged in a narrative way by the text?

The work achieves tension through this juxtaposition, which is decisive. If we read the accompanying text, this dialogue continues since our perception is influenced by what we know. The relationship between the images is extended to a play between the photographs and the texts.

I find it interesting that you worked with pictures of children in this project, since many Americans are immigrants and have spent their childhoods in other countries—their life stories, then, are marked by change. Was this also a criterion in your use of childhood photographs?

I am responding to existing photographic material—just as if I was meeting someone for the first time. When something new is added, it influences how the original material is perceived, and vice versa, like the way we gain new insights through a conversation, for example.

What do you hope to achieve by contrasting the childhood photograph with your photograph?

Discoveries. The things the two photographs have in common and their differences. The starting points of every comparison are then especially clear to see because I take the photographs from a similar perspective. In many of these childhood photographs there is

simply a power and energy that has come with time. It's intriguing to me to start a dialogue with that, and its uncertain outcome. Both pictures could be seen as part of an imaginary chain of images. You could imagine pictures before, after and in between both of the photographs. Each individual picture legitimizes the other in the sequence, but the photographs also lose their autonomy. The same is true for my role as photographer. On the one hand I willingly submit to what is given, on the other, one could accuse me of distorting the original material.

Is it a coincidence that the gestures and poses of the people in your pictures reflect those in the childhood photographs?

I try to let the participants act for themselves. At the same time I look for the connection between the images. I don't just leave everything to chance, but I also don't attempt to control everything. I asked Jerry McIntosh to let me photograph him standing up, for instance, but I in no way influenced the almost eerily identical pose in both images.

You put the childhood photographs on a par with your own photographs by printing them the same size.

It is of fundamental importance to me to present the pictures in a similar format. That creates a comparable picture area, as does the homogeneous coloring. There are many elements of separation: the type of photographic material, the condition of the picture surface, different photographers, and so on. I want them to approach each other so that they can enter into a discourse that is more differentiated than a "then and now."

What questions did you ask?

There were three fundamental questions. The first had to do with the childhood photograph: "Which memories do you associate with it? Which life circumstances are connected to it? Has the medium photography played a role in your life?" That is also the starting point for the questions concerning the participants personal history. "What were the essential changes?" All the questions are so basic that not only the content of the answers is interesting, but also even the emphasis given when questions are being answered. "What did America mean to you in the way that you grew up? What does America mean to you today? What has changed for you?" The questions themselves are not repeated here, but all of the responses are to be understood as the answers to these.

You had to be convincing so that the people would open up to you in the way that they did. I'd like to hear more about your research and how you got into contact with the various people.

That has ranged from drawn-out planning to spontaneous encounters. With celebrities, the preparation time often went on for over a year. Letters and phone calls were a test of patience until a meeting was finally arranged. The search for a theme at a particular place could happen quite spontaneously, within a few days or weeks. At Mount Rushmore park rangers helped me find two locals who had been photographed with the monument as teenagers. I found the legendary treasure-hunter Mel Fisher based on a description of him given to me by a waitress in Florida: "You can't miss him, he's covered in gold!" The catchphrase "Indy 500," led me through research on the history of that famous car race to Tom Carnegie, who has been the official announcer there since the '40s. A museum curator helped me. There is no one else alive today who has had a longer connection to that race, and is still actively involved in it. For the Charles Lindbergh topic, I first came across an archive photograph from 1927. It shows a boy dressed in a pilot's uniform, holding a model of the legendary airplane the *Spirit of St. Louis* in his raised hand. That photograph led me to Thomas Graham, a former member of the Missouri General Assembly. His biographical tie with Lindbergh's story through this photographic sketch fascinated me.

So the original story, in that way, gained many more stories?

The path leading from a reference to a person can turn out very differently. For a long time I wondered how I could include people who are no longer alive, like Marilyn Monroe or Walt Disney. I tried to find people who had themselves been photographed with those people as children. Sometimes it was an almost detective-like search! The connection could be a direct family relationship, or a fleeting moment such as in the case of John F. Kennedy. The Sprayberry family had been invited to the office of the President in the White House, having been the millionth visitor in the year of 1961, a popular destination for a family excursion in the '60s.

Are there other more general ideas behind your choice?

There is a fragmentary series of representatives of photography and art from Alfred Stieglitz to Ilja Kabakov. First generation and Jewish immigrants are other more general themes.

Do you try—in order to maintain objectivity—to acknowledge an opposing position to a political, religious, or social standpoint?

Taking sides is not in the spirit of the open structure of the work. At the same time I make no attempt to create a static equilibrium or something of that kind. The texts are edited as sparsely as possible, and are then read by the participants themselves. It's important to bear in mind that these assertions are about self-representation and not about answers to critical journalistic questions.

It is astounding to me how the people you interviewed often speak so openly about their lives, like Christian Boltanski: "I am more unhappy now, I am much more unhappy than I was then. I am dead you know, really, I am dead now."

As a matter of fact, the frankness in many conversations really touched me too. Your remark also reminds me of a statement by Leo Glueckselig, an emigrant from Vienna, in whose opinion America hides nothing and even celebrates its tragedies. It's a bit

more complicated in the case of Boltanski, a European who is often in the U.S. but only stays for a short time to work on art projects. One of his strategies is to play the clown, and he likes to make fun of our readiness to believe in the reality of photographs and captions. In this case it's also a game when he animatedly and smilingly speaks about being dead.

> *The interviews shed light on the people's various personality structures and developments. I wonder whether a spontaneous type of photography wouldn't have corresponded better to the authenticity of the language.*

Only when both pictures were lying in front of me as prints could I decide whether the ideas had worked. The images, and not the subject matter, are the basis for judgment. Sometimes a picture that is too personal or of high technical photographic quality cuts itself off from the childhood image, something I wanted to avoid. Altogether I often assume the approach of a slow snapshot photographer in order to open up the photograph to the other image. But a procedure that aims to build on the composition of the childhood photograph is at the core of the work, something that would be impossible to achieve with spontaneous photography alone.

> *Your questions, which are fundamental questions, prompt us to reflect on where we come from, where we are going, and what social context we live in. I'm sure there were also people who felt that the project was too much for them, or who were afraid?*

There were tears, of course, and also some cancellations because the people felt it was too personal. I think the questions leave it completely open as to how personal someone wants to get.

> *What does history mean to you?*

History is simply presence for me. You look at a house differently if you know which house stood on that property before, who used that building, and for what purpose. I don't believe that we could live with the same depth without it.

> *I'm sure your understanding of America developed during the course of the project. I imagine that what you now think about America no longer corresponds to your views, when you first began the project.*

I feel exceptionally enriched by the experiences that I have been able to have, in many cases thanks to the participants' trust. But anything that I could say in a few lines would necessarily sound flat and deficient. I consider this work itself to be the better, albeit indirect, answer to your question.

New York, October 26, 1999